DATE DUE

FEB 0 9 2014

WITHDRAWN

AMERICA'S CHILDREN

W · W · NORTON & COMPANY NEW YORK · LONDON

America's Children

PICTURING CHILDHOOD
FROM EARLY AMERICA
TO THE PRESENT

Edited by

KATHLEEN THOMPSON

&

HILARY MAC AUSTIN

Foreword by Ruby Dee and Ossie Davis

Since this page cannot legibly accommodate all the copyright notices,
pages 296–301 constitute an extension of the copyright page.

The text of this book is composed in Monotype Bell with the display set in Copperplate Gothic Bell
Book design by Antonina Krass
Composition by Carol Desnoes
Manufacturing by South China Printing Co., Ltd.
Production manager: Andrew Marasia

Library of Congress Cataloging-in-Publication Data
America's children : picturing childhood from early America to
the present / [edited] by Kathleen Thompson and Hilary Mac Austin.
 p. cm.
 Includes bibliographical references.
 ISBN 0-393-05182-X
 1. Children—United States—History—Pictorial works.
 2. Children—United States—Social conditions—Pictorial works. I. Thompson, Kathleen.
 II. Austin, Hilary.

HQ792.U5 A545 2003
305.23'0973—dc21 2002075321

W. W. Norton & Company, Inc., 500 Fifth Avenue, New York, N.Y. 10110
www.wwnorton.com

W. W. Norton & Company Ltd., Castle House, 75/76 Wells Street, London W1T 3QT

1 2 3 4 5 6 7 8 9 0

FOR THE CHILDREN IN OUR LIVES

Abby, Adrian, Aedan, Alexis, Anna Julia, Anna Banana, Carolina, Casey, Cassandra, Celeste, Claire, Connor, Cooper, Craig, Darian, David, Diana, Dylan, Erin, Frankie, Gabriel, Gemma, Geoffrey, Hannah, Healy, Jarrod, Jennifer, Jodie, Julia, Junior, Kristen, Laura, Libby, Lisette, Little Jennifer, Marcello, Matteus, Megan, Michelle, Mick, Mikayla, Michael, Mikie, Nathan, Nicholas, Nikki, Nina, Nora, Ousa, Paul, Phoebe, Rachel, Raffy, Rory, Sara, Shannon, Simone, Spenser, Stephen, Tad, Tino, Tonito, Tracy, Tyler, Zac, and all the others

CONTENTS

ACKNOWLEDGMENTS

We would like to thank our editor, Bob Weil, for his patience and his insight; our designer, Toni Krass, for her imagination and creativity; and our agent, Geri Thoma, for her continuing faith, as well as considerable practical support. Ralph Carlson was again our friend, advisor, and advocate. As always, Kathy Clayton and Karen Creviston of the Amanda Park Branch of the Timberland Library System were an enormous help on the text research and also graciously lent their library and its resources to us in our search for family photographs. Eunice Hundseth was our indispensable assistant in scanning and salvaging photographs. Criss Osborn and Kathleen Praxel also helped with the digitizing of photographs. Valintino Foster was a wonderful research assistant.

As usual, people at archives all over the country have been of immense help. Deserving particular mention are Nicole Wells at the New-York Historical Society, Lou Stancari at the National Museum of the American Indian, Teresa Roane at the Valentine Museum/Richmond History Center, Susan Snyder at the Bancroft Library, Coi Gehrig at the Denver Public Library, Michael Flug at the Woodson Regional Branch of the Chicago Public Library, Jon Plutte at Golden Gate National Park, Michael Bacino at Corbis Images, Cindy Kernick for the Estate of Charles "Teenie" Harris, Shelia Bumgarner and Katherine Fry at the Public Library of Charlotte-Mecklenburg County, and Ann Shumard at the National Portrait Gallery. Maria Muller, Kristen Austin, Lee C. Carter, Maria Applewhite, Dave Buchen, Miriam Davidson, Joel Millman, Troy Johnson, Catherine Scott, Sister Mary Joanne Wittenburg,

S.N.D., and Peggy Engel and Kevin Nealon of the Alicia Patterson Foundation all helped by providing great images or leads to great images.

We were astonished by the generosity of Gayle Calabrese, an eBay acquaintance, who gave us the freedom to select from her amazing collection of antique and vintage photographs. We also need to thank all the people who allowed us to riffle through their family albums and boxes of snapshots, including Ann Henry, Anthony and Sabina Nowak, Bill Grobman and Melissa Gilliam, Brenda Sampson, Carin Sampson, Dan and Jeanne Thompson, David Richmond, Deena Valdez, Diane Epstein, Elaine Brooks, Elizabeth Carlyle, Karen Creviston, Karen Falk, Kathleen Praxel, Kathy Clayton, Lavinia Prescott Ferguson and Patricia Olson-Prescott, Les and Frances Thompson, Mary Christiansen, Maurice Nobert and Craig Austin, Amy Levin, Nan Rutledge, Nancy Petrick, Phyllis Miller, Anne Tofflemire, and Sandy Zielesch.

We are very grateful to Charlie Levin, Michael Nowak, James Schulz, and the many others who took the time to look through various drafts and pieces of the book and give us their thoughts.

There are those whose help came in many forms, from material support to encouragement and inspiration. We couldn't have survived the last year, much less completed the book, without Frances and Les Thompson, Red and Nancy Austin, Darlene Clark Hine, Tracy Moncure, Earl Behr, Sara Thompson and Karen Konecky, Andra Medea, Claire Gaudiani, Janne King, and Geoffrey Austin.

FOREWORD

BY RUBY DEE AND OSSIE DAVIS

You hold in your hands a treasure, a magnificent collection of images and words that will captivate you from beginning to end. This is not a book to flip through and then relegate to the coffee table. It is a stunning work you'll want to return to again and again, to study and savor. It is a discovery, much like that of an archaeologist or an anthropologist, of history poignantly captured by photographers and artists over 400 years.

Of course what is most significant is that these are images of children, held up as if mirrors, for us to see ourselves in their eyes. This is not a contemplation of cuteness or of the preciousness of innocence. It is, rather, an unflinching look at the often haunting and intense reality of our past—raw and clear as only a child's vision and voice can be. And though there is a wealth of information to be culled from the interwoven captions and narratives, it is the pictures—native, immigrant, migrant, slave—that speak the loudest. The pictures provide both common denominator and collective backdrop for this dream—this glorious experiment we call America.

We cannot turn away from the gaze of truth; each section of the book is rich with reminders of both our pride and our shame. So many smiling portraits attest to our success, affirm that we are doing something right. Yet, many others, hungry and hollow, bear witness to the unheeded cries of our children for direction, for help, for love. They tell us in no uncertain terms that there is much, much more that we as a nation have to do. We are reminded that much of the struggle toward true democracy is written in the blood and sweat of our children—in fields and in factories—doing

11

grown folk's work. Children starving in the land of plenty. Children lynched and murdered in the land of liberty and justice for all. Children bombed into oblivion on a sacred Sunday morning. Children lining the pews of sorrow.

And yet, in these very faces we must find hope and sustenance. We must seek in these eyes the spark that gives us the right and a reason to make of children not just agents of history, but agents of change.

As we Americans, we global citizens, fly off into outer space and cyberspace, we need these images to anchor us, to warn us, to prompt us, to urge us, to remind us from whence and from whom we have come. Not long ago, it was said of children that they should be "seen and not heard." In *America's Children*, we affirm that children should be seen *and* heard, listened to, counted, remembered, and embraced.

INTRODUCTION

People who get nostalgic about childhood were obviously never children.

—Bill Watterson, *Calvin and Hobbes*

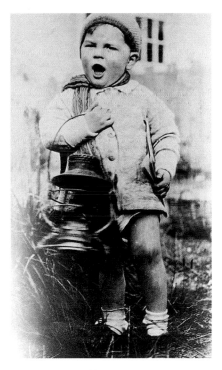

John Wesley Tofflemire, ca. 1934.

For most of us, history is a somewhat jumbled slide show, rather than a coherent story. Say "American Revolution" and against the screen of memory flashes an image labeled "Boston Tea Party" or "Washington Crossing the Delaware." The Civil War conjures a battlefield strewn with the bodies of men in blue and gray uniforms. From old textbooks and PBS specials, we have images for "The Dust Bowl," and "World War II" and "The Civil Rights Movement." They're not always clear, but they're powerful. They make us believe we know what America once was and what it has been through.

And hardly any of these images have children in them.

America's Children begins the process of adding children to our historical slide show. It is part of an endeavor to alter our visual sense of history that began with the first book we did together, *The Face of Our Past: Images of Black Women from Colonial America to the Present.* The relative absence of children from our visual history is apparent in works of history and in books on the history of photography. For example, in *American Photographs: The First Century,* published by the Smithsonian in 1997, there are just over a dozen photographs, out of about180, that include children. In most of these, the children are thoroughly incidental to the photograph. In *The Waking Dream: Photography's First Century,* published by the Metropolitan Museum in 1993, there are even fewer images that deal in any significant way with children. Even social histories tend to focus on adult men and women, with little more than a nod toward the experience of children. This underestimation of the conditions of childhood is exemplified by

13

phrases such as "men in the mines," used to caption photographs of groups that include boys as young as ten or twelve.

The images of children Americans *are* exposed to reinforce our sense of the idyllic in childhood. We have found that children have been subject to the same sort of treatment that has limited our vision of women and members of ethnic minorities. In historical volumes, photography books, and histories of American art, they are usually invisible. When present, they are pictured in an idealized or sentimentalized way.

First, there are valentines to innocence. The photographs of Charles Dodgson, Gertrude Kasebier, Ann Geddes, and others fall into this category. Even when they are not in soft focus or littered with puppies and kittens, they seem to exist on a different plane, where no reminders of the harried adult world intrude. Then there are photographs of "childhood betrayed." They reveal the horrors some children face, with the image of ideal childhood providing an implicit comparison. Jacob Riis and Lewis Hine at the turn of the century, Dorothea Lange and the other Farm Security Administration (FSA) photographers during the Depression, and Stephen Shames and Stan Grossfeld today—these photographers give us images of children in factories, eating from gutters, staring hollow-eyed at us from migrant camps or crack houses. These photographs are true and often move us to some kind of action. They have a place in our picture of childhood. But they use the same preconceptions about children that we encounter in the most sentimentalized portraits, albeit in a good cause.

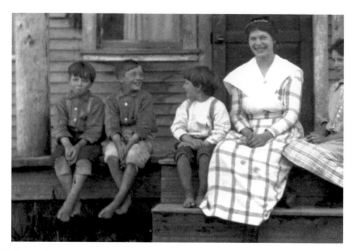

Doris Huelsdonk and some of her students in Washington state, ca. 1910.

The ideal image of childhood so many Americans carry in their minds is expressed in this excerpt from a newspaper column written in the year 2000.

> Most of us past sixty look back with nostalgia on our younger years to a time before Sesame Street when a soda cost a dime and movies a nickel; when kids wouldn't think of calling adults by their first names and profanity was unheard of; before there were retirement communities and families took care of each other; when marriage was "until death do us part" because divorce was shameful. A time when children were safe riding their bicycles and walking to school, secure in knowing they wouldn't be attacked by some hoodlum for their jacket or sports shoes. It was a time when drug abuse did not put kids on a collision course with self-destruction.

Our idea of a normal childhood in this country is compounded of scraps of sentimental paintings and bad poetry, ignorance of history, and memories that have softened with time. In the last few decades Americans have begun to strip away our

illusions about gender and race along with the paint and varnish from our renovated woodwork, but we still cherish our illusions about childhood.

Whether it's located in the suburbs of the 1950s or on the farm of the 1920s, the ideal American childhood clearly exists in the past, and we think of it as something our society needs to "get back to," to recapture for our own children and grandchildren. Perhaps because the childhood of every adult *is* in the past, this particular fairy tale is terribly easy to believe in. Those who do believe that the ideal childhood ever existed, however, can do so only by leaving *most* American children out of the picture. If we want to see children as they really are and have been, we can't leave anything out. We need, instead, to put something in, to add to the images we have of children in America.

To begin with, we need to add color to the picture. Without thinking, many people see the child in the ideal image as white. And therefore, without realizing it, they feel that most of our current problems began when "those other children" intruded. The fact is, of course, that America's children have always come in a variety of hues. There were Native American children, obviously, before any others, and Mexican children lived in large parts of the West long before their white counterparts. The first African American child was born in 1624, to parents who had arrived before the *Mayflower*. Asian American children joined the mix in the middle of the nineteenth century.

Those facts are probably not unfamiliar to you. Images of the children they represent, on the other hand, probably are. In *America's Children* you will see a watercolor of a baby, the child of Chief Herowan, painted by John White, who traveled with Sir Walter Raleigh in 1585 and 1586. You will see a painting of a Mexican baby, cradled in the arms of his beautiful and affluent young mother, from the 1700s. In a rare photograph, you will see Chinese children having dinner with their parents in Denver in 1914. There were so few women among Chinese immigrants that a family such as this one was remarkable.

The next thing we need to add to our visual history of children is class. The only children who spent their lives running carelessly in the sunshine were in a minority defined by class. The first time the U. S. Census reported child laborers was in 1870. At that time, there were 750,000 children working for pay in this country, out of a total of approximately 12 million children between the ages of 5 and 18. The number of working children reported in the census did not include those who were working on family farms, including sharecrops, or in family businesses. As the Industrial Revolution continued, the figure grew enormously. By 1910, there were more than 2 million recorded child laborers. Again, this figure does not include children who worked with their families on tenant farms, as "cottage laborers" in urban tenements, or in any situation in which an adult was paid for a family's work.

In every sense, class is an important part of the repicturing we are working toward,

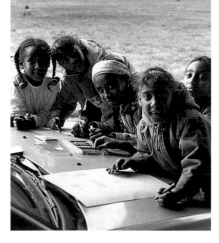

Sudanese girls in Philadelphia, 1999.

15

and it has not always fallen neatly along color lines. In this book, there are portraits of affluent African American children in the early 1800s, Mexican Americans of great wealth and breeding even earlier, and white children working in fields in the last years of the twentieth century. Photographer Arnold Genthe shows us Chinese children on the streets of San Francisco, both girls recently escaped from slavery—probably prostitution—and children in rich traditional clothing that reflects a certain wealth.

Those Chinese girls bring us to a third addition we need to make to our images of childhood. Sugar and spice and everything nice did not exist in the lives of most little girls in our history. Lewis Hine shows us a nine-year-old girl selling newspapers at night, his camera capturing a double image that shows her battling to keep her head up, and a mill girl running exultantly away from the factory after spending twelve or fourteen hours at work. Jacob Riis gives us an image of a badly beaten little girl who has been removed from her home. Of course, there was also rape and sexual harassment, to which girls of all ages were subjected at work, at home, and in their communities. On the more positive side, a family snapshot from the Montana State Archives shows two teenage girls with guns and dead rabbits flanking a youngster with a gun and a gopher, making a positive contribution to their families' subsistence.

And finally, there is simply age. Childhood is not such a clearly defined concept as we usually think it is. This could not be more vividly illustrated than by Matthew Brady's powerful photograph of an adolescent boy lying dead on a Civil War battlefield, a reminder that almost one in five of the soldiers who fought in that war was between the ages of twelve and seventeen. Or the engraving of Maria Weems, a fifteen-year-old who escaped slavery by disguising herself as a boy. Or the children in the front line in a photograph of Big Foot's Band, most of whom would die at Wounded Knee.

How we ended up with such a distorted "ideal" in the first place is a matter for conjecture. Part of the truth, of course, is that history is written by historians. There is really no such thing as the "lived history" of humanity. There is only what has been perceived at the time and written down, and only a fraction of that has survived to be interpreted by people of a different age. "We historians," says Darlene Clark Hine, "too often think of our work as the substance of history, the 'frame' in the sense of body or structure. In fact, however, what we do when we think, research, and write about the past is to create a frame in another, very different sense. We gather our insights, biases and ordering concepts, and we knock them together to form an encompassing border around one piece of the picture that has been painted by the lived experience of the past. As a result, a historian's frame is a way of choosing what will constitute the history." Historians, of course, are adults, and among their biases—along with race, gender, and class—is one that predisposes them to overlook the significance of children as agents of history.

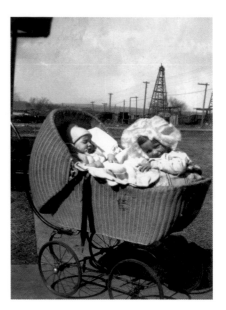

Oklahoma, 1910–1920.

We may also believe in a sentimental view of childhood because we want to so desperately. Rewarding as it often is, life as an adult is difficult. It involves disappointments, betrayals, and loss. It sometimes seems that we vacillate between boredom and disaster. But life is tolerable, and sometimes positively glorious, because of hope—an emotion that is seldom rational and never wholly justified. Children are the embodiment of hope. They represent to us the potential for happiness and symbolize the possibility of love. They are humanity as yet undisappointed. When there is no hope for a child, our hold on life as a meaningful affair is threatened. And so, we have to believe that hopelessness in children is an aberration, that the fears of children are inspired by monsters in the closet, that pure happiness exists in this world, if only for a child.

And why shouldn't we be allowed to believe this lovely fantasy? What harm does it do? To begin with, it misleads us about history—all of history. For a very long time, many participants in American history have been ignored because they were not deemed important or dynamic influences. Apart from being simply inaccurate, this view is dangerous because it underestimates the power of the mythology of history. A narrow, simplistic view of history gives us a distorted sense of the events, forces, and variety that make the world. Finding the invisible members of American history and bringing them into sharp focus helps us to understand who we are and how we got here.

Today, children are the focus of much research and theorizing. We understand that young generations in war zones, whether they are in Afghanistan, Northern Ireland, or the Mideast, have been brought up in a culture of war and that to expect them to move easily into a peaceful society might be asking too much. After the attacks of September 11, 2001, the media spent a great deal of time exploring how children might be affected by the events. Parents and caretakers were advised how to reassure children, help them feel safe, and help them understand. It has become accepted that children are affected by their environment and by historical events in very particular and important ways.

Our view of history changes if we see it with this modern understanding of childhood. If each child's experience of history becomes an adult's making of history, then each era's childhood becomes a way to interpret the history that follows. To understand the Puritans, whom we so often see as founders of our country, we ought to know that they believed any measure at all was defensible for breaking the will of a child. Even physical violence was not only defensible but laudable, because breaking a child's will was necessary in order to save his or her soul. There were some Puritan fathers who killed their children in the process and felt they had done their duty. And Puritan children, among others, became the great revolutionary force that fought for freedom from the British.

To understand the full extent of the horror of slavery, we need to know that one out of two enslaved children never reached adulthood. That is, half of the children born

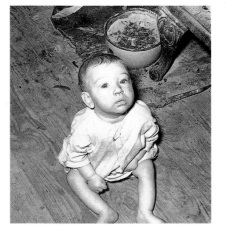

Jefferson, Texas, March 1939.
RUSSELL LEE

to enslaved mothers died before they reached eighteen. Slavery killed them, and that institution was accepted by the vast majority of the American public as an economic necessity. And what about the children who survived? How did they shape the second half of the nineteenth century? And what about the white children who grew up next to them? How did their experience make our history? These are questions that will never be answered in adult-focused histories, and their answers could illuminate our understanding of the past and present in crucial ways.

The "settling" of the West takes on a different look when we think of the children. There were thousands of children among the Native Americans who were slaughtered, captured, and relocated. American soldiers killed those children just as surely as Hitler's men killed Jewish children in the concentration camps. As for the children who rode in the covered wagons, thousands of them died as well, from illness and starvation and all the other hardships of a journey they did not choose for themselves. And the children who survived—those who were physically and emotionally resilient—how did their knowledge of hardship and death, as well as freedom and expanding possibilities, take us into the twentieth century? Another question that needs answering.

Laura with Jennifer's brother, Chicago 2001. CAROLINA VELASQUEZ

Most people know that the Industrial Revolution changed American society forever, but we may think primarily in terms of people moving to town, leaving their farm jobs to weave cloth and make cars. Think instead about the boy born in a slum who began work just as early as children on farms but, instead of plowing and planting next to his father, went into a coal mine to work a sixteen-hour day. Think about a girl who, instead of canning and hoeing the kitchen garden alongside her mother, worked in a sweatshop where she had no protection from the almost inevitable sexual harassment.

In other words, children can change our view of history. With any luck, history can also change our view of children, perhaps even our uncritical acceptance of what childhood is. We have chosen to include in this book people who were under eighteen, whether they were seen as children in their own time or not, largely because we want to illuminate our own age, to put into relief our views and attitudes about children, and our modern parameters of childhood itself.

America's Children attempts to present the reality of childhood in the United States over four centuries. It is not an exposé but an exploration. We look at children playing, working, and participating in the life of the community. We see them in relation to their families and to other adults. The words are their own. The images show them against the dramatic backdrop of historical events and movements as well as in the intimacy of their homes—in other words, as participants in the American story, with all its invention, diversity, tragedy, and joy.

HOLDING STILL (1)

Family snapshot, Christopher Christiansen, 1993, ten minutes old.

Family snapshot, Evva Taft, January 5, 1900, six months old. HENRY ARTHUR TAFT

Studio photograph, ca. 1900.

Formal portrait with a flag, ca. 1890s.

*Family snapshot (real photo postcard).
On the back of the card is written: "Dear
Grandma and Auntie, hear comes a
picture from little Coollige Brown and
he is a mighty Bad little Boy. I can sit
alone I am awfully Lazy though I like to
stay out doors, Coollige Brown."*

Studio photograph, possibly Oklahoma, ca. 1890.

Identity photograph, Chun Jan Yut, 1893. Part of his INS case file related to the enforcement of the Chinese Exclusion Acts.

Family snapshot, Benjamin Grobman, 2000.

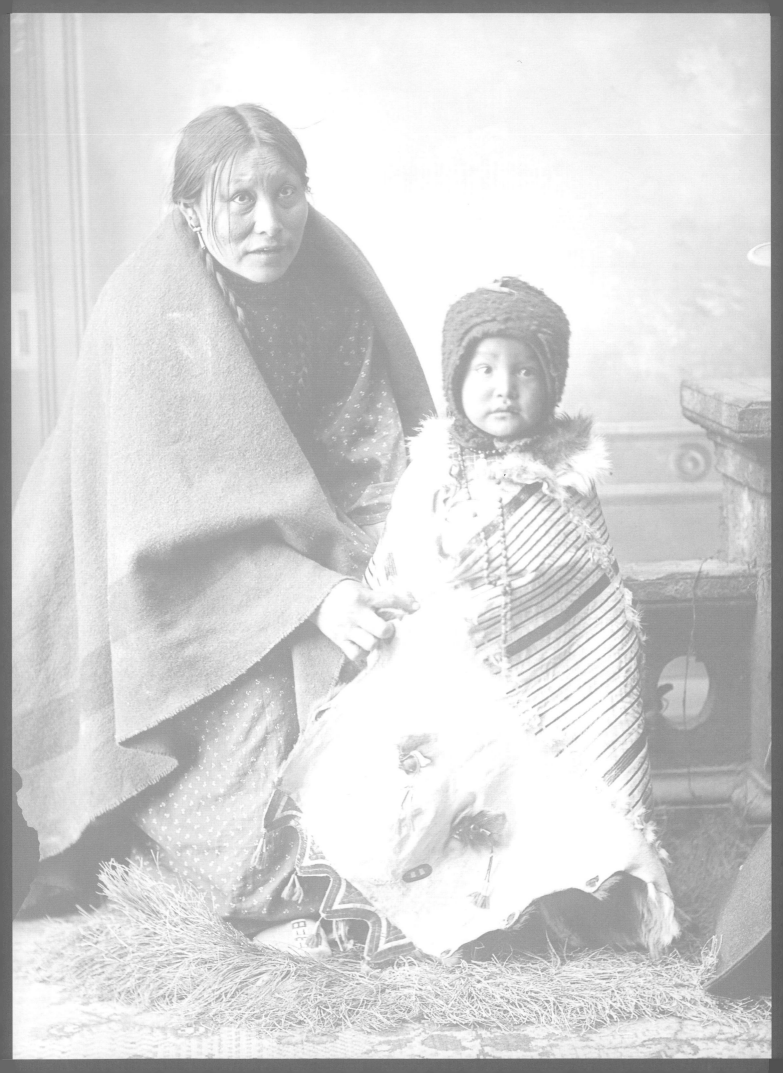

PART ONE

CHILDREN IN FAMILY LIFE

THE FAMILY IS THE NATURAL HABITAT OF children, and our sense of family is itself an environment mined with preconceptions. Most of us would like to think that family life provides sustenance, safety, love, and loyalty. When the family provides, instead, anything from benign neglect to the crippling or destruction of the child, we believe that something has gone terribly wrong. What may be difficult to accept is that the latter so often comes in the form of the "traditional" American family, and the former may come in a package we barely recognize.

Even before the European incursion, American family life was varied, as different tribes had different family structures. One child in the 1400s might have viewed several women in the tribal community as her mothers, while in another part of the country, the biological mother/child bond took precedence. For about a century and a half after European Americans began to settle on the eastern seaboard, their basic family unit consisted of the people who inhabited a house or farm. This included servants and apprentices and, frequently, enslaved people. The entire family, including children of all ages, was involved in the work of the house or farm. Indeed, work was the basic purpose of the family. Apprentices and indentured servants, of course, were separated from their biological parents, at the age of nine or even earlier, to live with this different "household family."

At the beginning of the nineteenth century, the American family was evolving. Fewer families included servants and slaves. As individual families managed to survive for a number of generations, they accumulated generational layers. Children could and did relate to grandparents and cousins almost as closely as to parents and siblings. Enslaved children were often part of a biological family with their parents and siblings, but that could be a fragile unit. When it was torn apart by sale or death, a child was almost always adopted into another group of slaves, one that functioned as a highly adaptive form of the extended family, whether related biologically or not.

Then, within a matter of decades, the Industrial Revolution fundamentally transformed the family in the United States. Children who found work in factories often had a more tenuous relationship to their families than did those who worked on farms, directly under the guidance of their parents. Some children became independent by the age of ten or twelve, supporting themselves and directing their own lives. Also, when people moved to the city to find work in industry, they moved away from other generations of their families, making for a much smaller family unit.

During the twentieth century, more and more children experienced family as what came to be called a nuclear unit, with the extended family as a sort of halo around it. Seldom sharing living quarters, the extended family was known through celebrations and ceremonies. For most children, "visiting Grandma" became a special occasion.

Still other people began to take on importance in family life when divorce began to be more common. Historically, there have been blended families for as long as there have been families. In Europe and the Americas, most were the result of remarriage after the death of a spouse. Today, when one in two marriages ends in divorce, and most divorced people remarry, many children experience life in a blended family. This is only one of the ways that the "modern family"—in the form of the two-parent nuclear family—is being challenged. Another way is financially. At least some approximation of the extended family is considerably more practical, and culturally more comfortable, for those who do not belong solidly to the American middle class. And, as always, immigrants often bring their extended families with them and keep them together for survival. Ultimately, though, as any child knows, the form of the family hardly matters, compared to what happens within its bounds.

In this section, we rely on the often extraordinary photographs taken by family members and on a number of unusual portraits. In the former category are the early twentieth-century photographs of Henry Arthur Taft, a highly gifted amateur, and the late twentieth-century photographs of Jan Gleiter, another remarkable amateur. In the latter category are Denver studio photographer David Frances Barry's glimpse of a touching family dynamic when he catches a Dakota family off guard and the Washington state photograph taken on the steps of a brothel, probably to advertise to sailors in the port town of Aberdeen. More revealing than conventional family portraits, they show us children in genuine relation to their familial context.

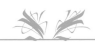

FEBRUARY 22 I HAVE SPUN 30 KNOTS of linen and mended a pair of stockings for Lucinda, read a part of the Pilgrim's Progress, copied part of my text journal. Played some, laugh'd enough, & I tell aunt it is all human nature, if not human reason.

Anna Green Winslow, thirteen years old,
in her diary written in Boston in 1772

The baby wriggling in her mother's arms in 1585 or '86 is the child of Chief Herowan, of the town of Pomeiock, in what is now North Carolina. JOHN WHITE

Timucua children are pictured here swimming to an island for a picnic with their family, ca. 1562.

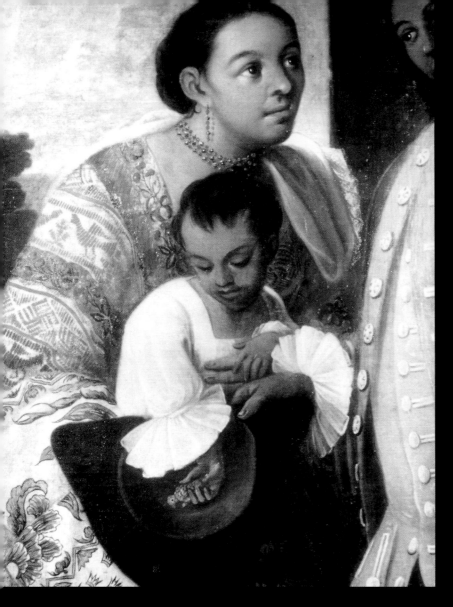

This child is part of a "caste" painting, an 18th century genre in which Spanish artists depicted the changing face of their colonies by showing the various mixes of African, Spanish, and Indian peoples. The first soldier-settlers in the borderlands married Native American women, but the Spanish government strongly promoted the immigration of Iberian women in order to create an upper class of largely Spanish descent. The result was considerable diversity in family life, with class lines often following race. MIGUEL CABRERA

From the Pennsylvania Journal and Weekly Advertiser, July 25, 1765. Although the group in the woodcut seems to represent a family, African children were usually kidnapped and separated from their families when they were brought to the Americas in the 17th and 18th centuries.

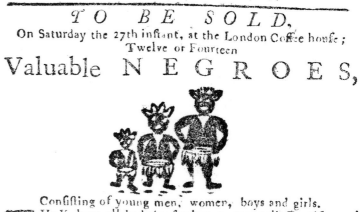

TO BE SOLD,

On Saturday the 27th inftant, at the London Coffee houfe; Twelve or Fourteen

Valuable NEGROES,

Confifting of young men, women, boys and girls. THEY have all had the fmall pox, can talk Englifh, and are feafoned to the country. The fale to begin at twelve o'clock.

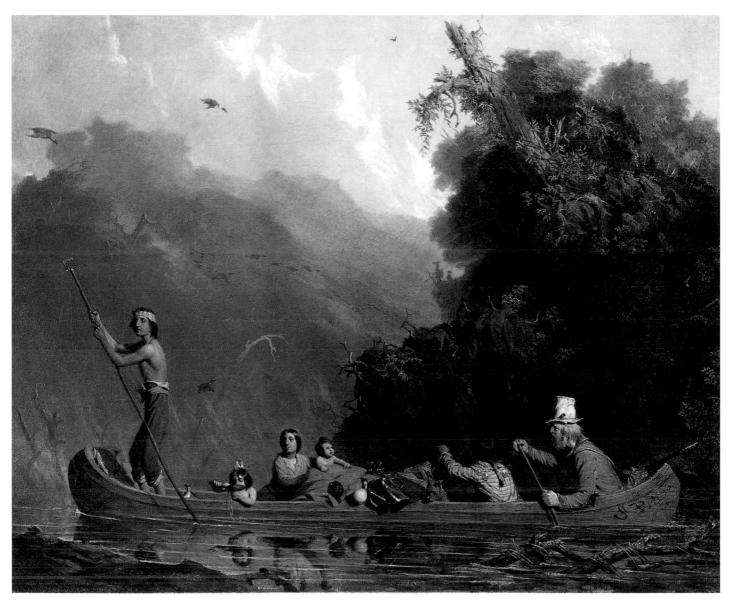

Many American children in the early years of colonization had European fathers and native mothers. European explorers, trappers, and merchants, who always preceded women, often married and had children with Native American women, as depicted in this early 19th-century painting, The Voyageurs, *by Charles Deas.*

Joshua Johnson, the earliest known African American painter, created this portrait of the well-to-do McCormick family, ca. 1800. Until the 19th century, fathers had complete legal control over all other family members.

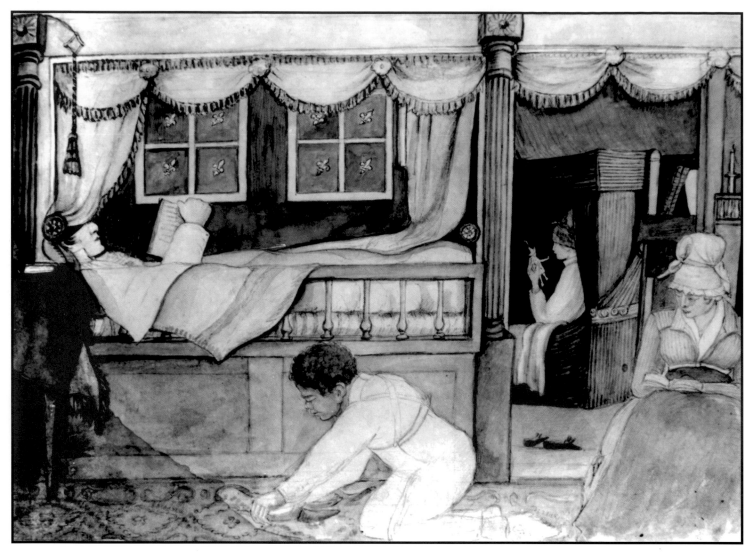

The de Neuville Cabin on the "Euridice" *depicts a family relaxing while their young servant works. In the 17th, 18th, and into the 19th centuries, children were often put into service at the age of nine, sometimes even seven. Their new employers, loving or cruel, became, in effect, their families, responsible for their upbringing until they reached adulthood. It is unknown whether the boy in this drawing was enslaved, indentured, or simply employed.*
BARONESS HYDE DE NEUVILLE

WHEN I WAS NINE YEARS OF AGE, MYSELF AND MY BROTHER were hired out from home; my brother was placed with a pump-maker, and I was placed with a stonemason. We were both in a town some six miles from home. As the men with whom we lived were not slaveholders, we enjoyed some relief from the peculiar evils of slavery. Each of us lived in a family where there was no other Negro. . . . I remained with the stonemason until I was eleven years of age: at this time I was taken home. This was another serious period in my childhood; I was separated from my older brother, to whom I was much attached; he continued at his place, and not only learned the trade to great perfection, but finally became the property of the man with whom he lived, so that our separation was permanent, as we never lived nearer after, than six miles.

James W. C. Pennington, speaking of his experience in the early 1800s

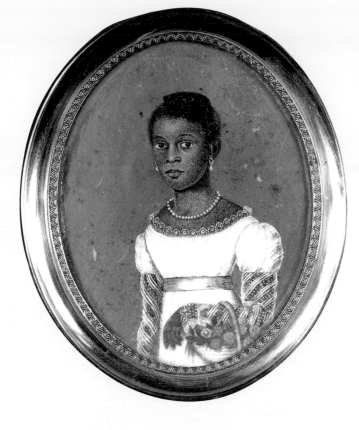

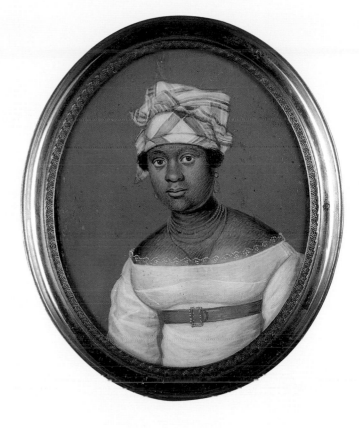

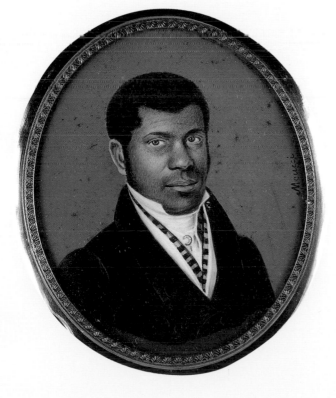

Pierre Toussaint, his wife, and their niece and adopted daughter, ten-year-old Euphemia, had these portraits painted in about 1825. Euphemia died four years later. Toussaint and his sister Rosalie (Euphemia's mother) were slaves in Haiti and were brought to New York by their owner, Jean Berard, during the Haitian Revolution of 1791. After Berard died, Toussaint became a hairdresser and supported the entire family, including his new owner, Berard's widow, until she remarried. Adoption, both legal and virtual, has been extremely common in the African American community throughout American history.
ANTHONY MEUCCI

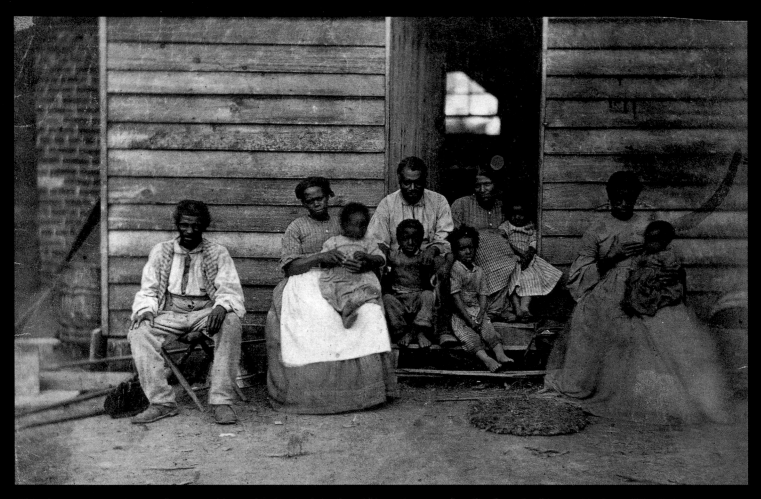

This photograph, found in an album owned by Larkin G. Mead, is of an African American slave family or families posed in front of the Gaines house, either in Washington, D.C., or Hampton, Virginia, in 1861 or 1862. Following the Civil War, African American parents often spent years searching for their children who had been sold away from them. GEORGE HARPER HOUGHTON

SUNDAY, JULY 5TH, 1863

Today will be remembered by us because we took a pleasant little drive to see one of the neighbors this evening, and got some blackberries. The negroes have all been gone to the Yankees some two months. Little Nellie grows more and more interesting every day. He can say anything he wants to. I think our people did right to invade the enemy's country, as that is the only way to bring them to their right senses. I wonder where my dear Brothers are tonight? I suppose when we see Brother George again he will be a man. Poor little Wallace has been very sick, and has now gone to bed. We took him with us this evening. Little Nellie is running about the room calling "Granma" and telling her about the "moon" and "Titers."

Katie Darling Wallace, eleven years old, Glencoe plantation, Virginia

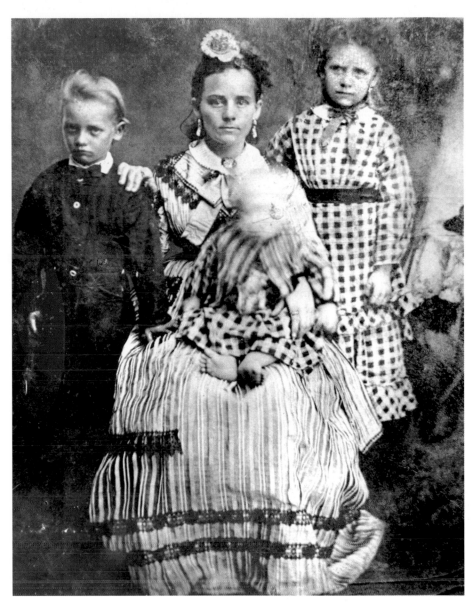

The Simms family included (left to right): Lawrence Alexander, mother Alice Victoria Hill, and Kate Exalna. The baby who couldn't keep still for the slow tintype process was William F. They were photographed in Lafayette County, Florida, in the 1850s.

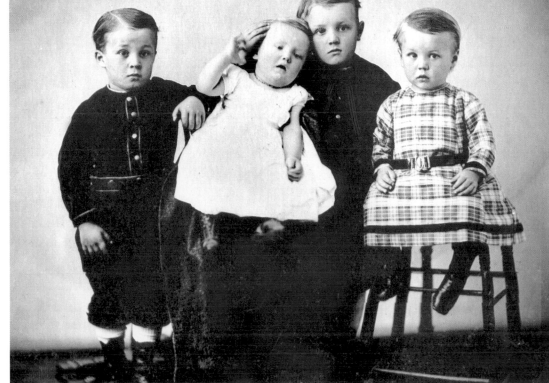

Siblings successfully hold themselves—or each other—still in order to be captured by the camera in this photograph taken in about 1860. Siblings provided the only sense of family for the hundreds of thousands of orphaned and abandoned children whose numbers were swollen by the Civil War.

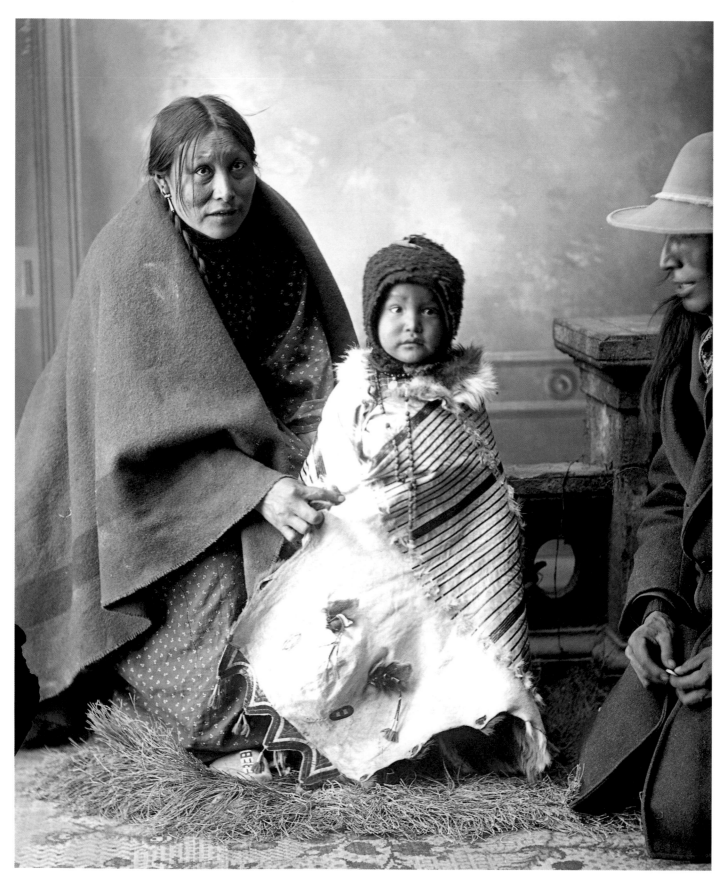

A Dakota family is caught preparing for a posed studio photograph in Denver in the 1880s. DAVID FRANCES BARRY

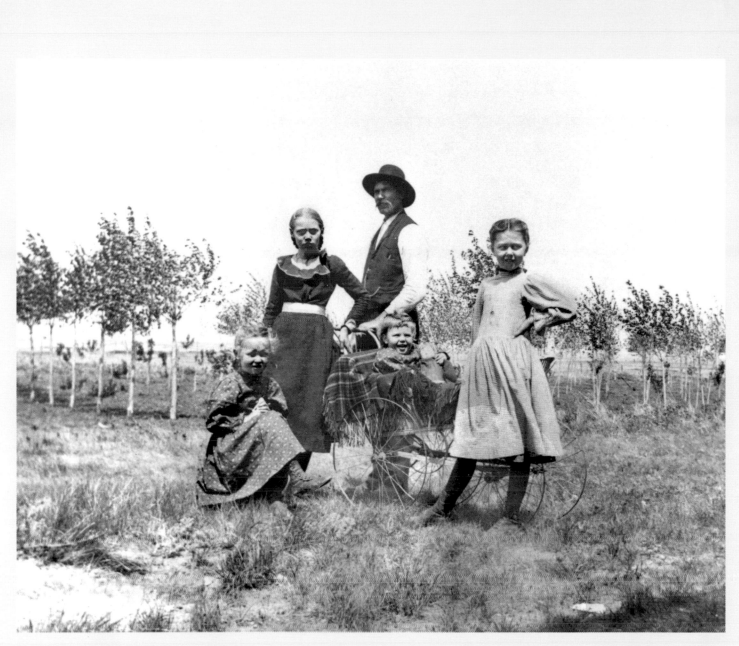

Evelyn, Amelea, and Ingeborg Gjevre (baby Christine is in the carriage) pose with their father, Anton, on the plains of North Dakota at the turn of the century. The girls' mother, Marie Flom Gjevre, is not pictured. FRED HULSTRAND

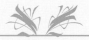

ALWAYS, WHEN MY MOTHER STARTED FOR THE RIVER, I STOPPED my play to run along with her. She was only of medium height. Often she was sad and silent, at which times her full arched lips were compressed into hard and bitter lines, and shadows fell under her black eyes. Then I clung to her hand and begged to know what made the tears fall.

"Hush; my little daughter must never talk about my tears"; and smiling through them, she patted my head and said, "Now let me see how fast you can run to-day." Whereupon I tore away at my highest possible speed, with my long black hair blowing in the breeze.

Zitkala-Sa (Gertrude Simmons Bonnin), speaking of her childhood in the 1880s on the Pine Ridge Reservation in South Dakota

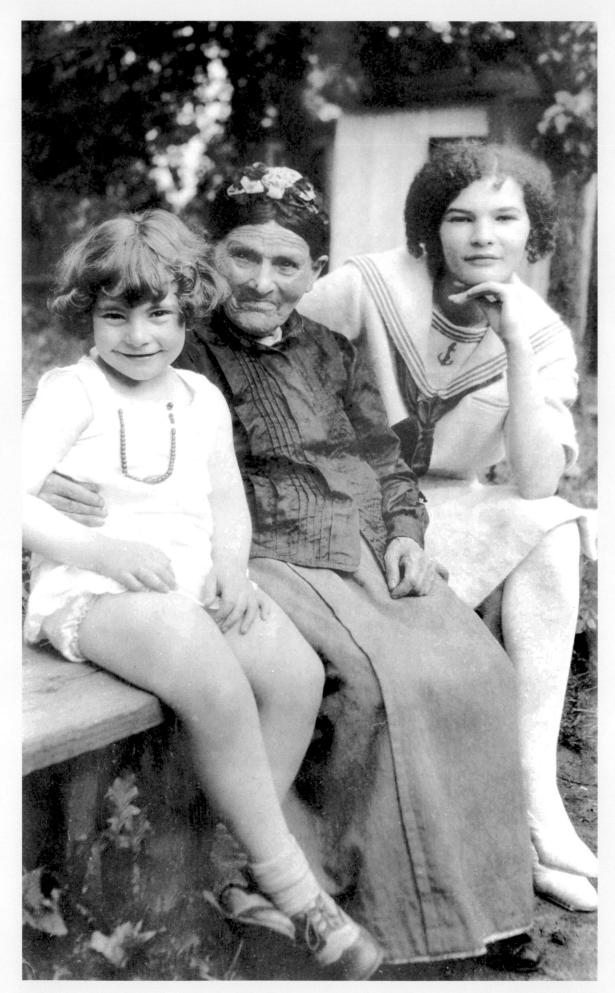

Grandmother and granddaughters in the Grobman family, who immigrated from Russia in the early 20th century, pose for a family photograph. In immigrant families, children often assimilated much more quickly than parents and grandparents.

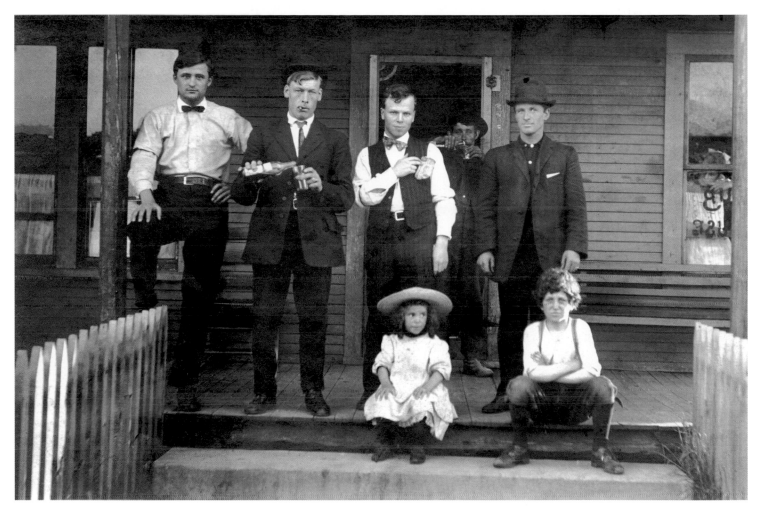

Two children choose to join an oddly posed group portrait outside a brothel in Washington state around the turn of the century. It is likely that this photograph was a kind of advertisement for the entertainments offered, including those of the woman peeking through the window at the right of the photograph. It is not known what relationship the children may have had to any of the adults.

This Chinese family was photographed by William W. Cecil in the kitchen of their Denver home in November 1914. The photograph is titled "Family at Dinner," bringing to mind the cheerful chaos of many family meals. At the time, only about 5 percent of Chinese immigrants were female, and many of those were child prostitutes. A Chinese family, therefore, was remarkable.

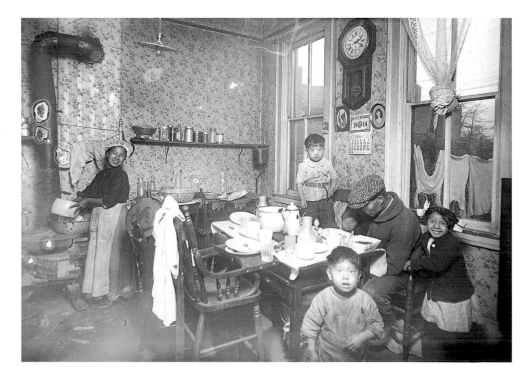

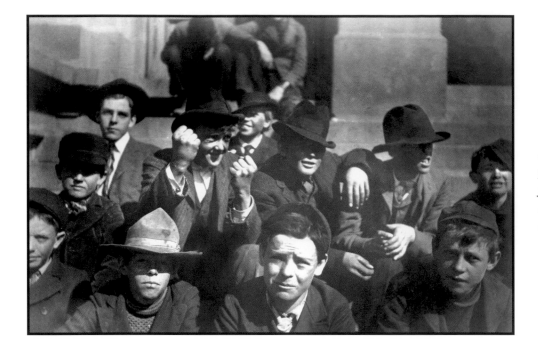

This 1910 photograph of the "River Front Gang" is part of a scrapbook of pictures of juvenile delinquents and the juvenile courts of Denver, Colorado. For bad or good, gangs have provided a sense of family to many children over the years.

I'D WAKE UP IN THE NIGHT-time, and he would be in bed with me. I'd holler to her, and she'd come and get me and tell him to go back to bed. She'd tell me to lock the door, but it didn't do any good. One time he drilled a hole in it so he could watch me undress, and another time I caught him watching me through the window. They had a daughter, too, and she got married at sixteen. I think it was to get away from him.

Marguerite Johnson, speaking of her experience as a twelve-year-old placed on a Nebraska farm in 1911

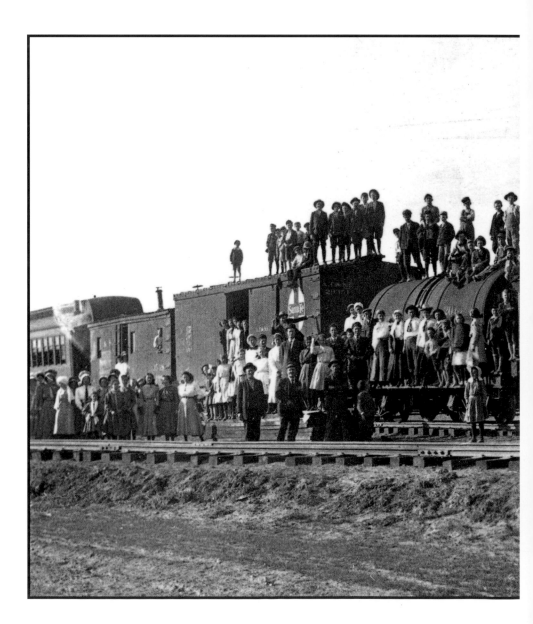

ON THE FOURTH OF AUGUST TWENTY-ONE OF US HAD
homes procured for us at N———, Ind. A lawyer from T———, who
chanced to be engaged in court matters, was at N——— at the time. He
desired to take a boy home with him, and I was the one assigned to him. He
owns a farm of two hundred acres lying close to town. Care was taken that
I should be occupied there and not in town. I was always treated as one of
the family. In sickness I was ever cared for by prompt attention. In winter
I was sent to the Public School. . . . I shall ever acknowledge with gratitude
that the Children's Aid Society has been the instrument of my elevation.

John Brady

During the second half of the 19th century, a quarter of a million children traveled the "orphan trains." In 1849, in New York City alone, more than 3,000 children lived on the streets, sleeping in alleys and doorways. That constituted 1 percent of the total population of the city. Thousands more were incarcerated in prisons and asylums for the crime of homelessness. The Children's Aid Society attempted to solve this problem by sending children on trains to be adopted in the West. This one was photographed in Kansas in 1900.

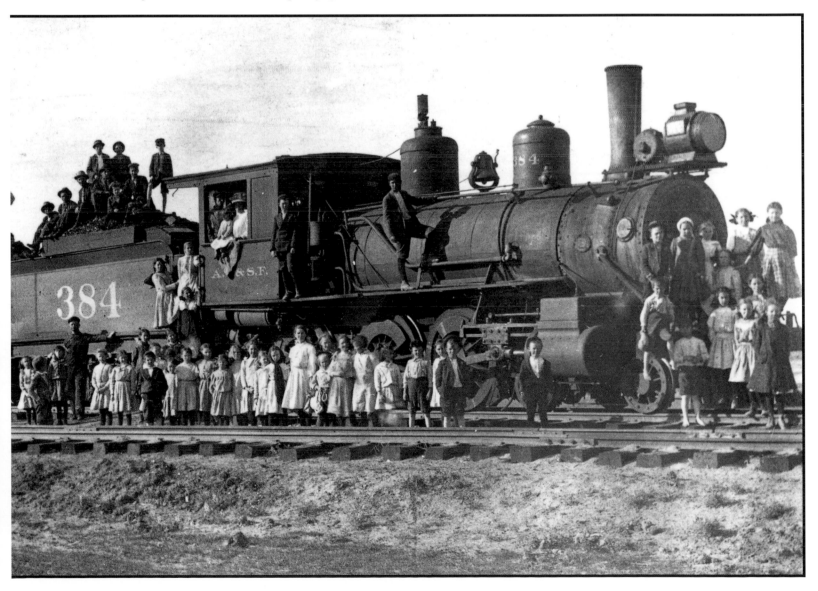

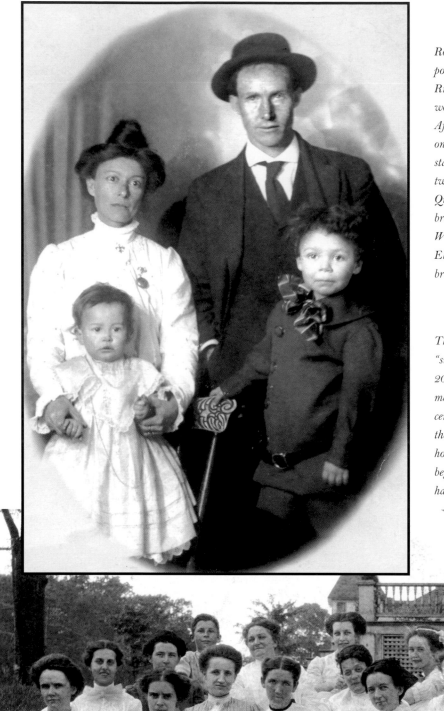

Rosario Quinones, the mother in this 1909 portrait, married John Milbourn in Puerto Rico at the turn of the century, when he was working for the United States government. After he was killed in a government operation, one of John's brothers took her to Washington state to visit the Milbourn family. While there, two of her children drowned crossing the Quinault River. Rosario married John's brother, Frank, and lived the rest of her life in Washington. The children pictured here are Elizabeth Julie Milbourn and her half-brother, Jack.

These children and their female relatives, "summering" in upstate New York in the early 20th century, are joined by two male family members for a group portrait. During the 19th century, men were increasingly separated from the family by jobs that took them away from home during the day. Women and children began to form the kind of domestic unit that has since been idealized.

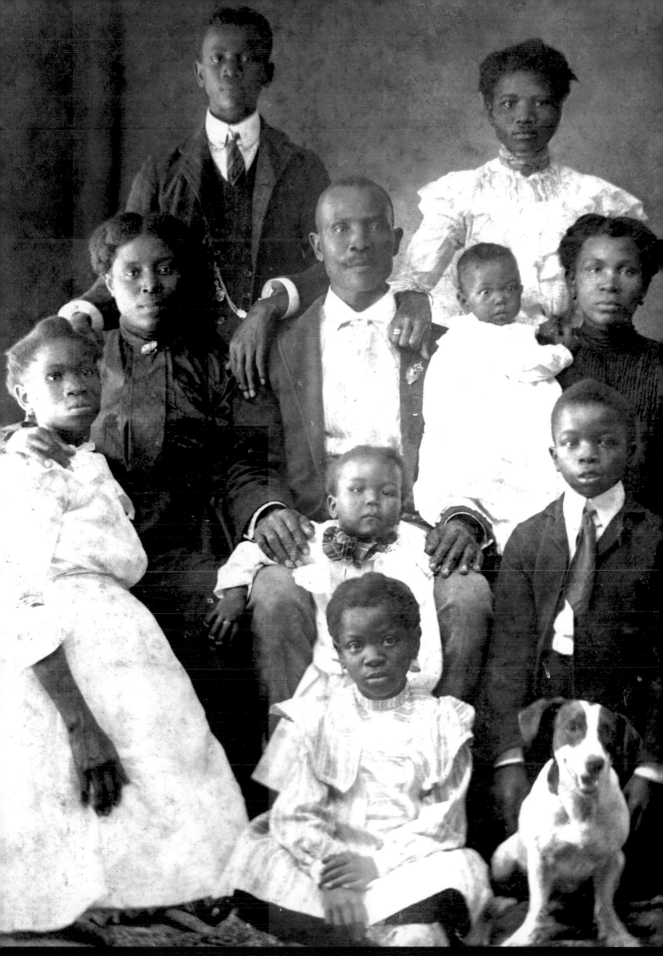

This family lived in Key West, Florida, at the turn of the century. The father had immigrated to the United States from the Bahamas.

This photograph of Evva Taft is part of a series that her father, Henry Arthur Taft, took of her as she explored (and ate) the toys on her highchair tray on February 15, 1900.

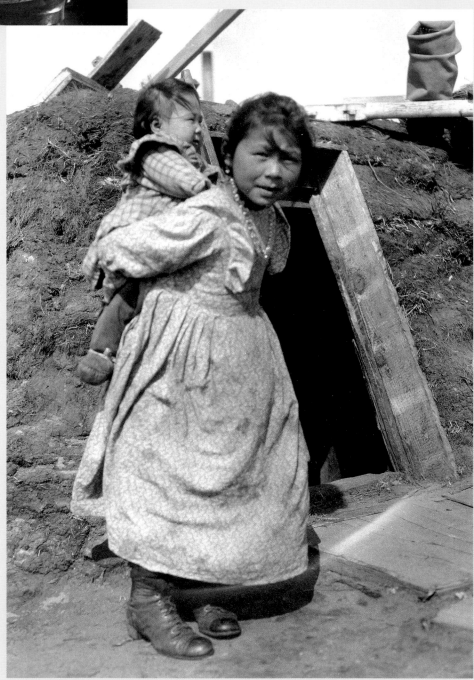

A girl takes care of her small sibling in the fishing village of Egegik, Alaska, in 1917.
JOHN N. COBB

I HAVE NO RECOLLECTION OF EVER HAVING been kissed by any one—have never been kissed by mamma. I have never been taken on my mamma's lap and caressed or petted. I never dared to speak to anybody, because if I did I would get whipped. I have never had, to my recollection, any more clothing than I have at present.

Mary Ellen Wilson, eight years old, testifying in a New York court, April 1874

Jacob Riis, working for the Children's Aid Society in 1898, took this portrait of an abused child who had been removed from her home. The late 19th century marked the beginning of widespread public awareness of child abuse. Records from earlier periods show that beating children was not uncommon and was often considered to be in the child's best interest.

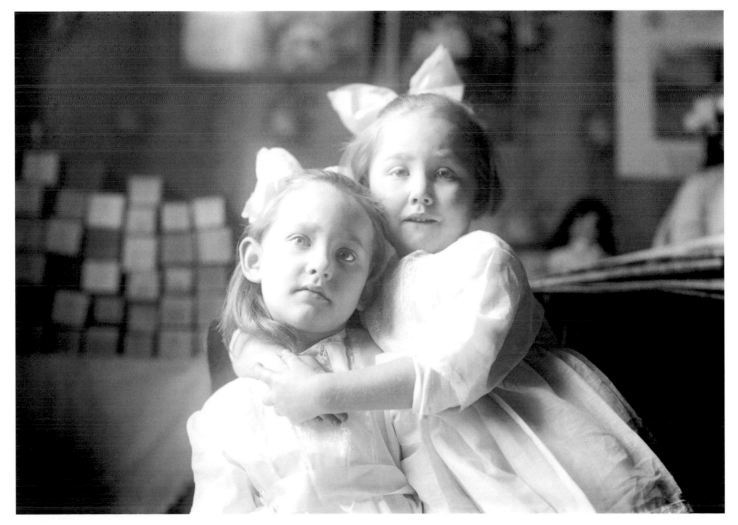

Violet and Geraldine Thomas's father was in jail for abandonment and their mother's whereabouts was unknown when this photograph was taken in 1919. They were taken in by their father's half-brother and his wife. ALBERT R. STONE

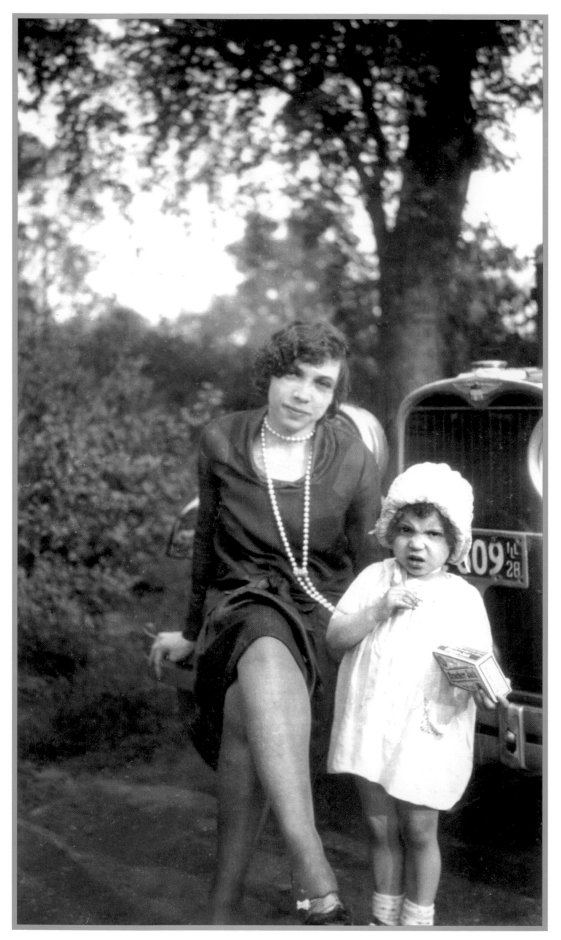

Lavinia Prescott and her mother, Eunice Lavinia Lyons Prescott, in the 1920s.

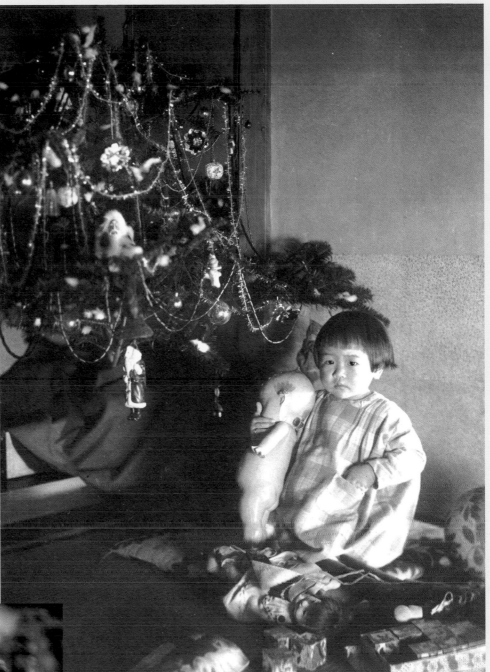

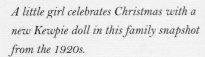
A little girl celebrates Christmas with a new Kewpie doll in this family snapshot from the 1920s.

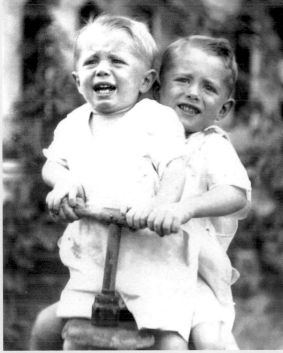

In a scene reminiscent of siblings all over the world, Les Thompson pushes his little brother Dan into the handle bars of their scooter in Oklahoma City in 1925.

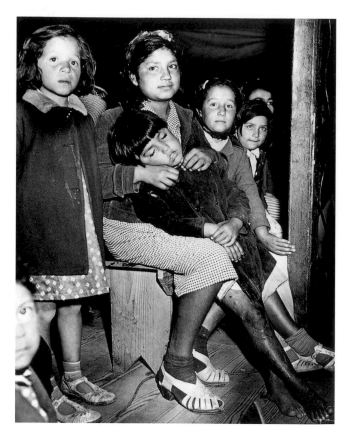

Sisters are among the audience at an event at the El Rio Farm Security Administration camp for Mexican migrant workers in California in 1940.
ROBERT HEMMIG

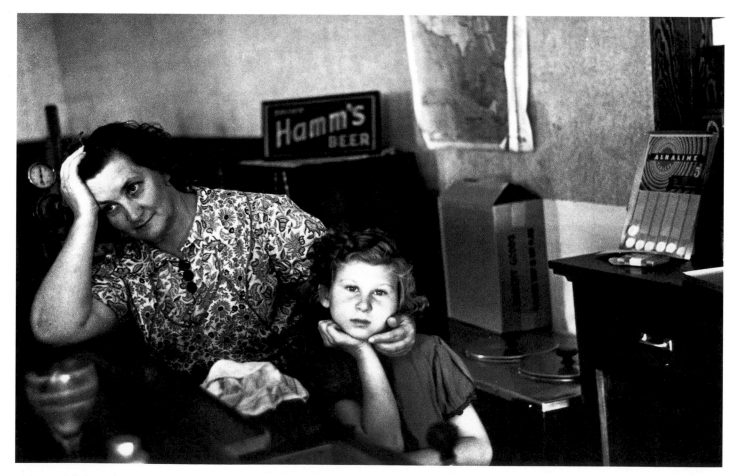

A young girl sits with her mother in the saloon-restaurant her mother owns in Gemmel, Minnesota, in August 1937. RUSSELL LEE

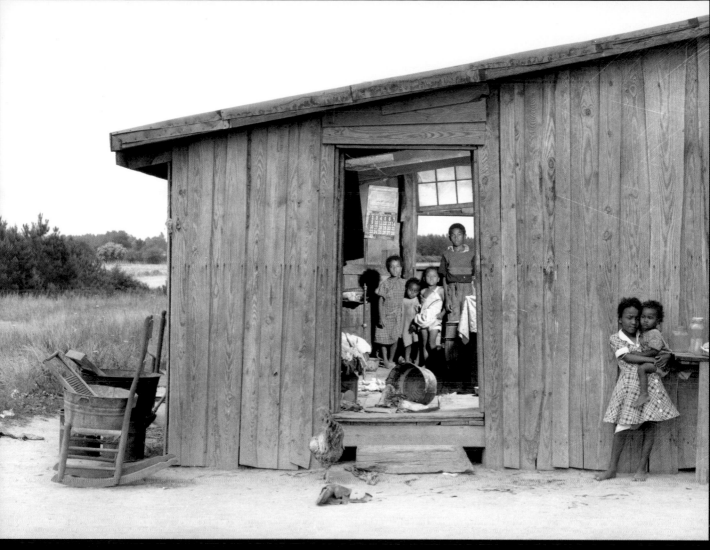

Ten people lived in this shack in Caroline County, Virginia, in June 1941. At the height of the Depression, 28 percent of the American people were entirely without income, and millions of children such as these suffered constant hunger. JACK DELANO

I DIDN'T WANT TO MAKE ANY NOISE BECAUSE I WAS scared that if my parents heard me, they'd know I was there and they might send me away, where if I was real quiet maybe they would forget about me and I wouldn't have to go. But eventually, mom and dad shipped us kids to live with relatives. . . . I cried the night I left. I told my parents that if they kept me, I'd eat only one meal a day so they could save money. I was so angry with my dad, even though it wasn't his fault. He tried so hard, but the Depression was too much. It broke his spirit. It broke my child's heart, I can tell you that.

Alma Meyer

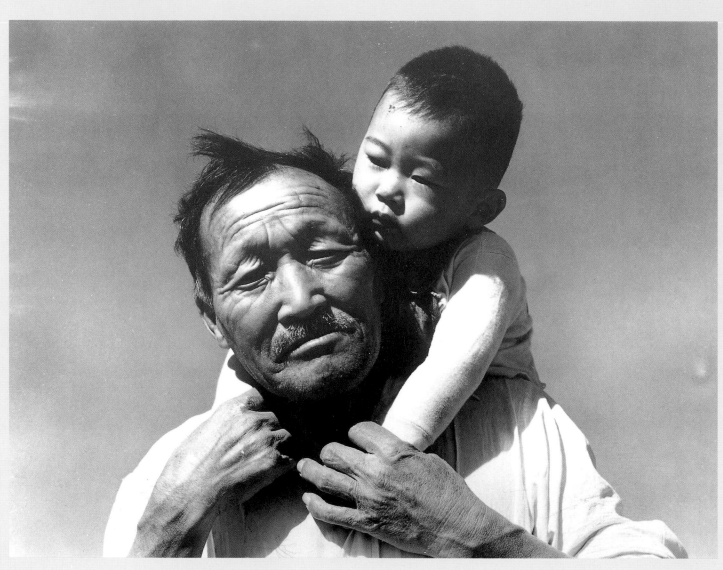

A small boy rides on his grandfather's shoulders at the Manzanar Relocation Camp during World War II. In addition to families, the United States government removed Japanese orphans from orphanages and sent them to the relocation camps. Many of those orphans were sent to Manzanar.

DOROTHEA LANGE

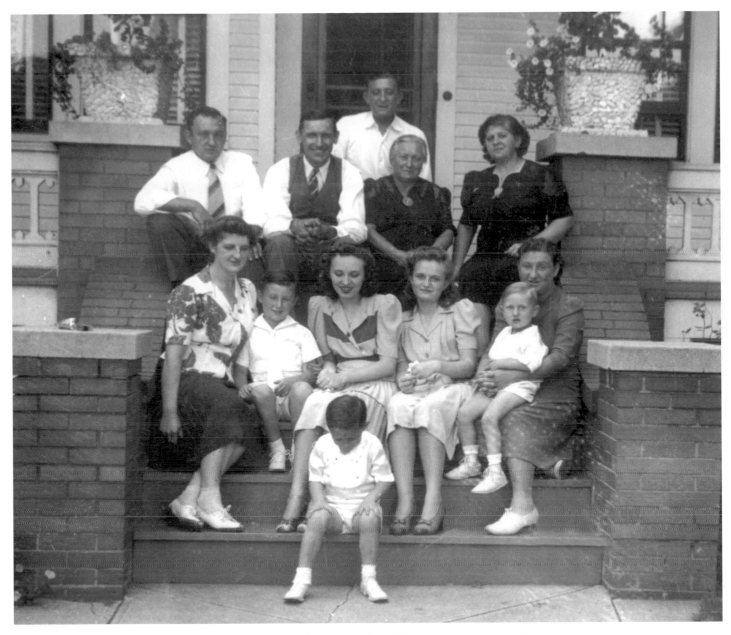

The Nowak family poses for a snapshot in the 1940s. Son Anthony is not pictured because he was serving in the army overseas.

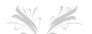

IF I HAD WINGS LIKE AN ANGEL I WOULD TAKE SOME bombs and fli over to germany and japen and bom them, then you could come home sooner. I want you most if all.

Letter from Betsy Berman, age seven, to her father in the Army, September 20, 1944

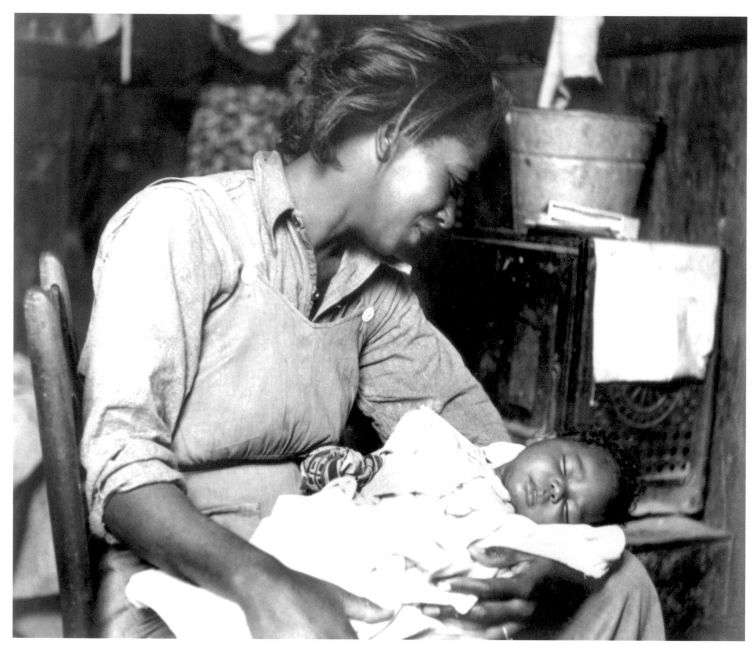

In November 1940, Dorothea Lange captured a migrant cotton picker holding her baby in their home near Buckeye, Maricopa County, Arizona.

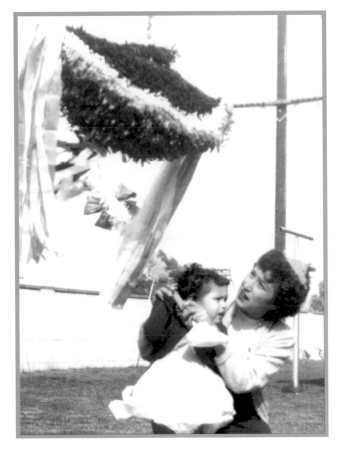

A little girl gets help breaking a piñata at a birthday party in the 1950s.

SOMETIMES I WONDER IF IT WAS EVEN hard for my mother to give me away. Sure, everybody tells you it was because it was best for you and they were just thinking about you. But I wonder. That's what they say, but maybe there was something else besides that, because I wasn't exactly an angel, either, when I was in Korea. I think all adopted children wonder why.

Soon Hee, child adopted by American parents

Maria Gouvistapoulou meets the couple adopting her, in the 1950s.

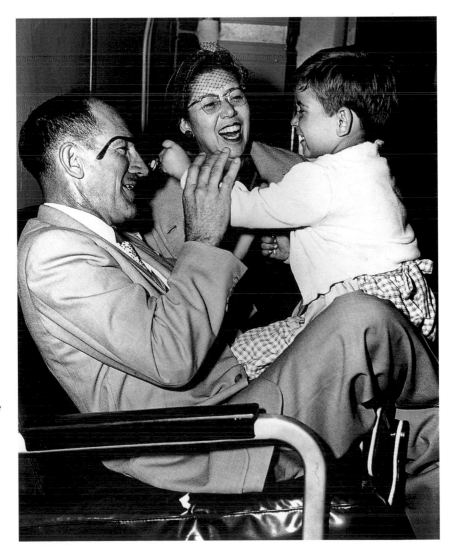

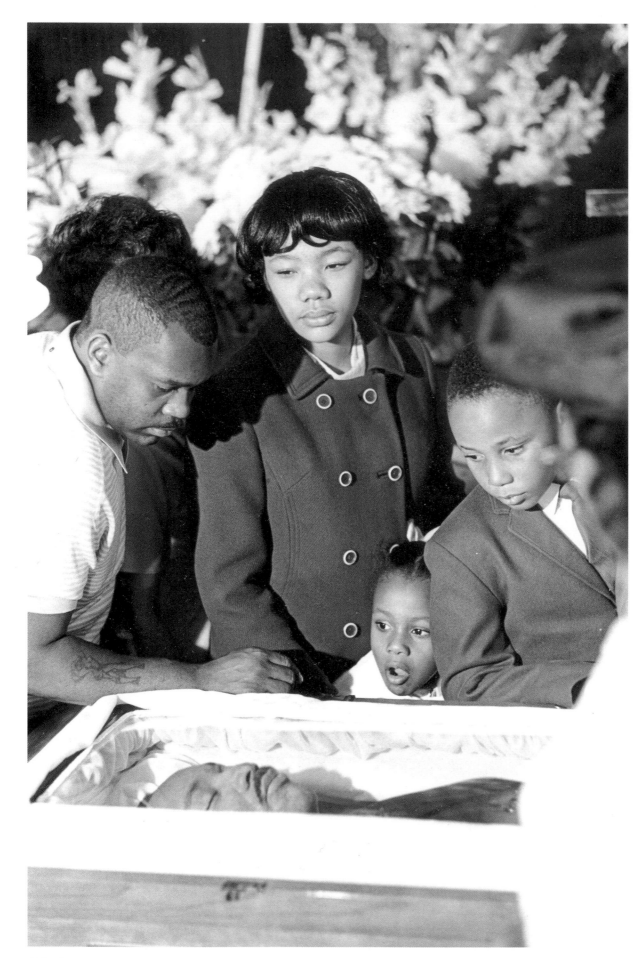

Yolanda, Bernice, and Martin Luther King III pass by their father's casket during his funeral in 1968.
BENEDICT J. FERNANDEZ

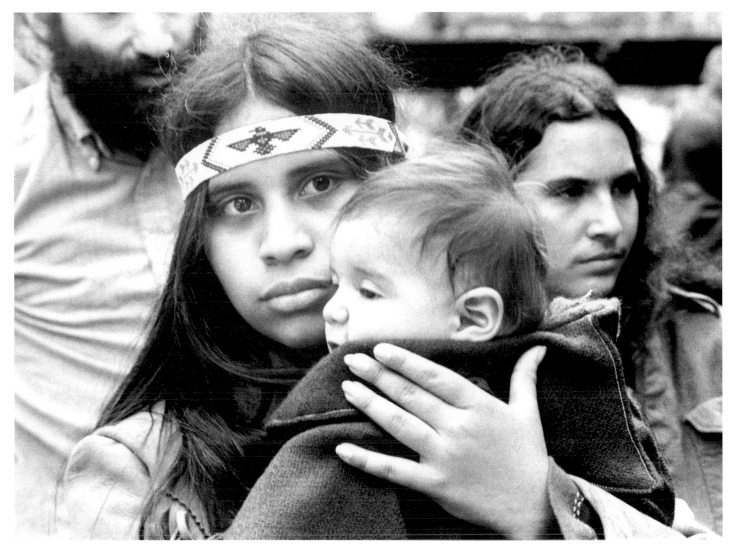

An American Indian mother and her baby attend a civil rights protest at the United Nations on May 4, 1975. BETTYE LANE

I AM NOT A BASTARD, THE PRODUCT OF RAPE, THE CHILD of some white devil. I am a Movement Child. My parents tell me I can do anything I put my mind to, that I can be anything I want. They buy me Erector sets and building blocks, Tinkertoys and books, more and more books. Berenstain Bears, Dr. Seuss, Hans Christian Andersen. We are middle class. My mother puts a colorful patterned scarf on her head and throws parties for me in our backyard, under the carport, and beside the creek. She invites all of my friends over and watches over us as we roast hot dogs. She makes Kool-Aid and laughs when one of us kids does something cute or funny.

I am not tragic.

Rebecca Walker, remembering her childhood in the 1960s

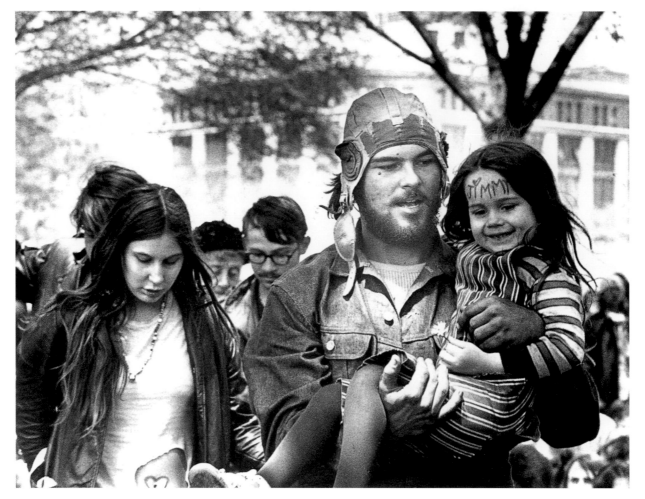

A counter-culture family attends an antiwar protest in Washington, D.C., on May 1, 1971. BETTYE LANE

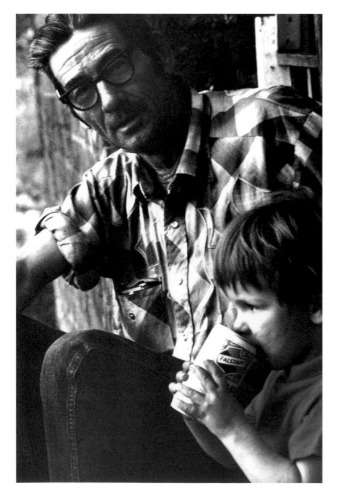

This 1973 photograph taken in Kansas City, Missouri, was captioned by photographer Kenneth Paik: "Ernest Watkins of Mulky Square . . . likes his beer and likes teaching his three-year-old son to like it."

A little girl gets help with her socks from her mother at the Twelfth Street beach on Chicago's South Side in August of 1973. JOHN H. WHITE

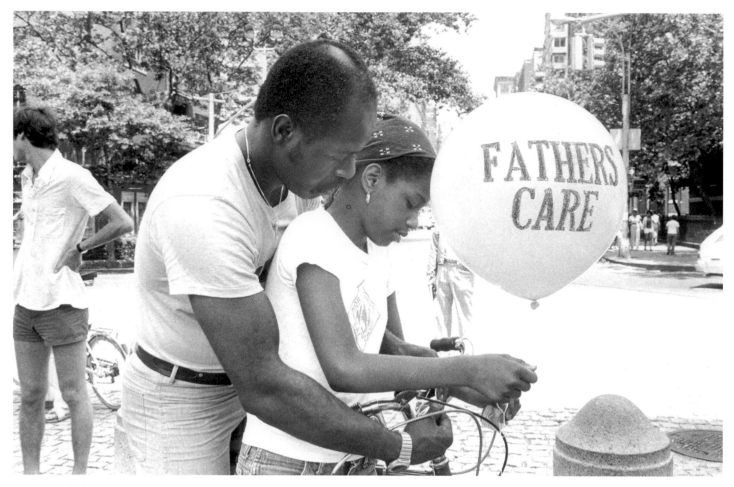

A father helps his daughter tie a balloon to her bike on June 20, 1976. They were participating in a women's rights rally in New York City and were also protesting for more visitation rights for fathers. BETTYE LANE

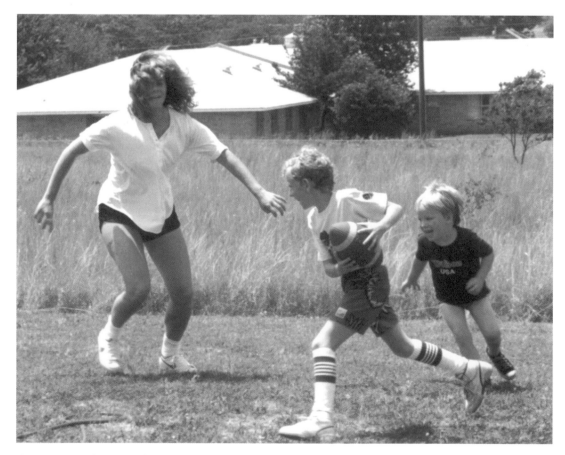

Cousins Zac and Cooper Thompson play a game of football with their Aunt Sara in the 1980s. JAN GLEITER

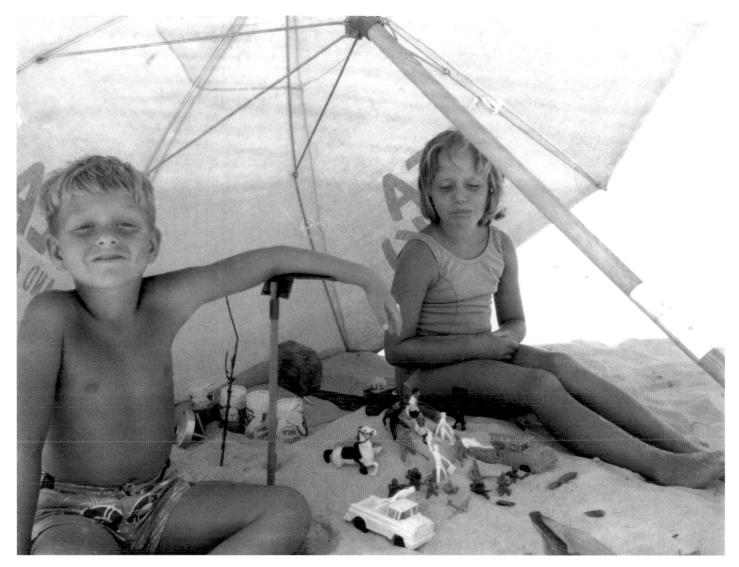

A brother and sister sit under a beach umbrella with their toys in the 1960s.

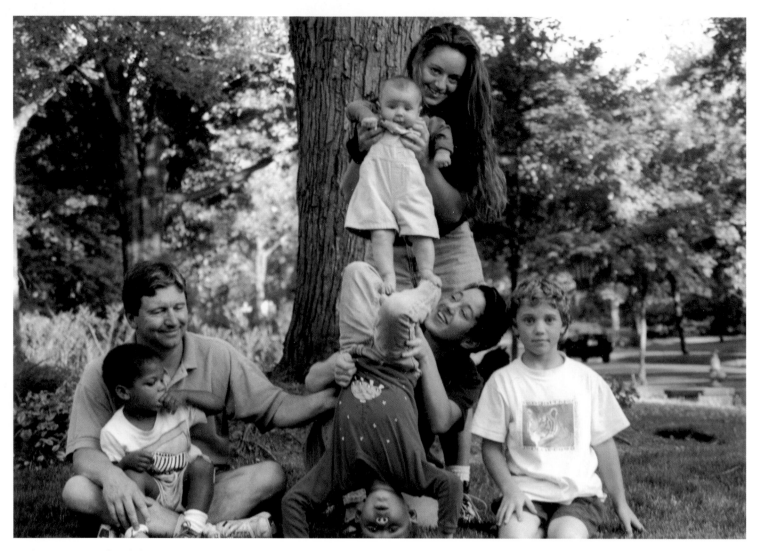

Father Maurice Nobert holds his son Gabriel in his lap while his daughter Melissa holds her niece Mikayla. Below them, Melissa's sister, Laura, helps her brother Adrian with a headstand while their brother Connor looks calmly at the photographer. CRAIG AUSTIN

Cindy and Tanya with their troop; newborn twins Paul and Olivia, and teenagers Anna, Rose and Claire.
LEE C. CARTER

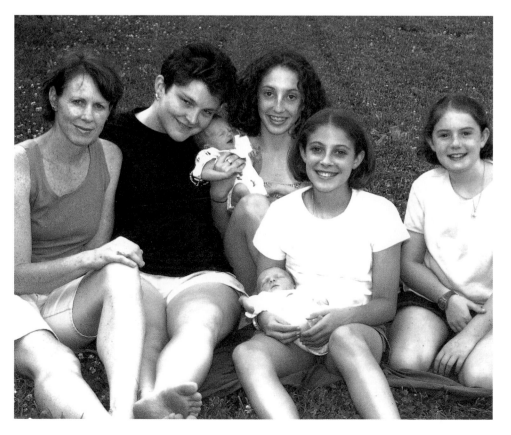

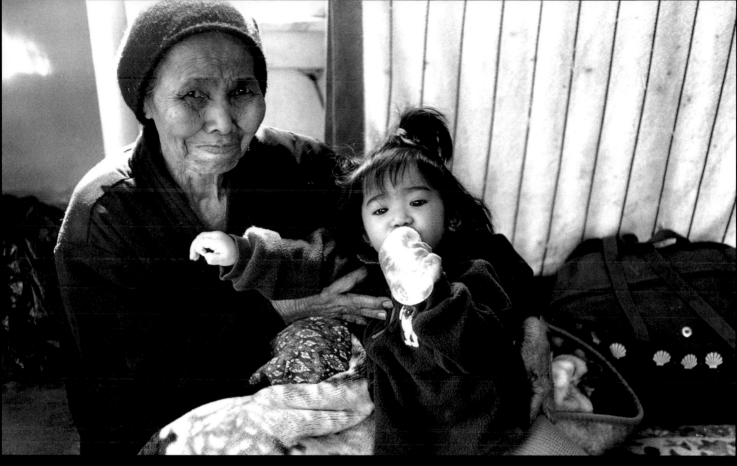

Mardi sits with her great-grandmother, Nork Norm, in the family's Chicago home. Nork Norm escaped from Cambodia in the 1980s. Mardi was born in the United States. KAY BERKSON

I LIKE LIVING IN CHICAGO—KIND OF. BUT I DON'T LIKE the way the family is treated. Life would be better if my dad could find work. It's hard to find work. If I were big, I would take my family and buy a big house. That's my dream—to buy a car and have a garden about five miles long and grow mint and garlic.

Lonhak Orch, fourteen years old, from an interview by Jill Rohde for the Changing Worlds *exhibit, 1999*

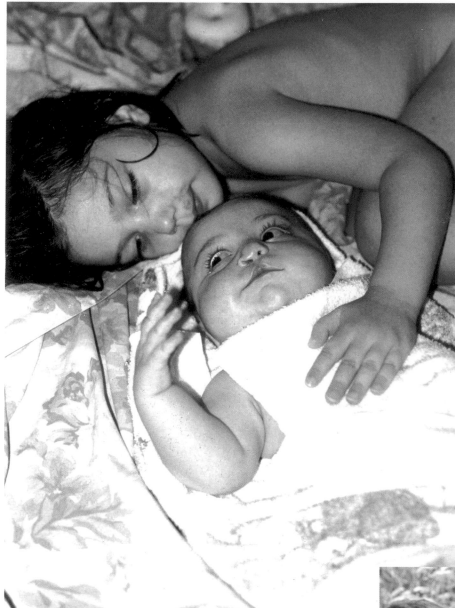

Sisters Madeline Frazer and Louisa Ceylon Neel. Louisa died just after her first birthday as the result of congenital birth defects.
CHARLOTTE NEEL

Joel Rutledge shows his sister Brook a frog.
LYNN SHERARD–STUHR

Bill, Melissa, and their son Benjamin Grobman in Chicago in 1999.

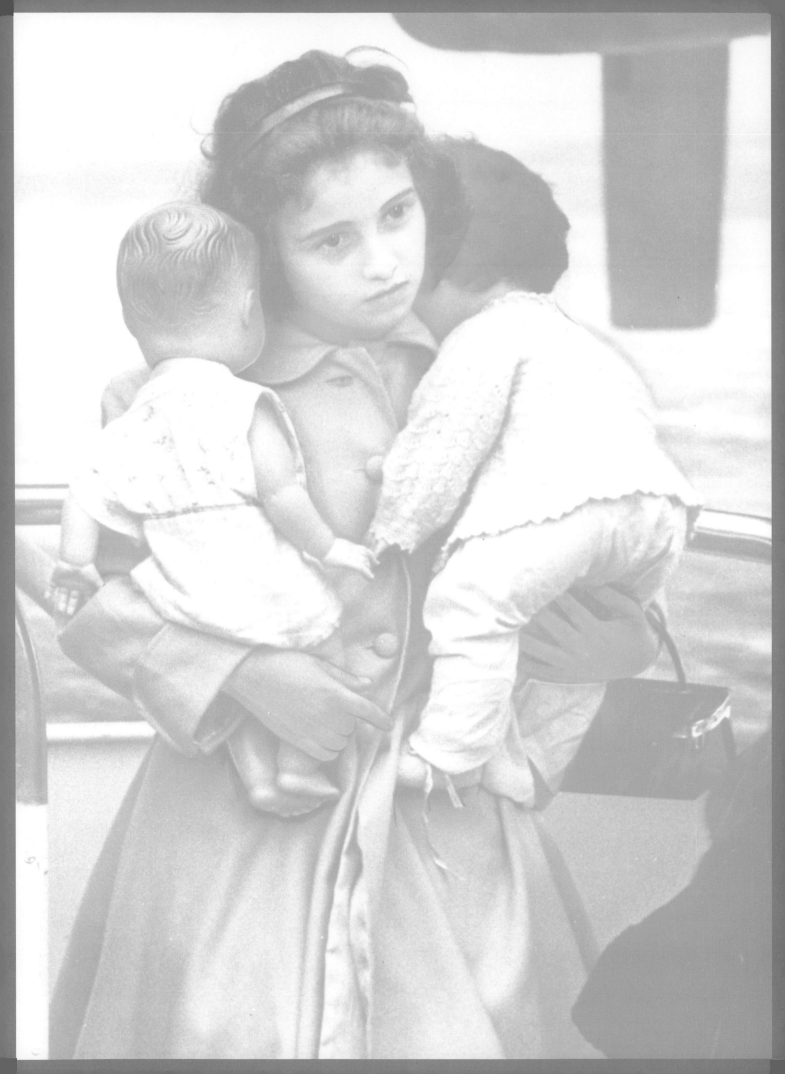

Part Two

Children and Their Families on the Move

EVERY SINGLE AMERICAN IS ULTIMATELY descended from someone who moved here from somewhere else. Since Asians crossed the Bering Strait and moved south to populate both American continents, the history of America has been one of movement. That movement powerfully shaped the lives of children, the most vulnerable to hardship in a traveling or newly transplanted community. The experience profoundly affected their sense of themselves, their view of the world, and the future of their community.

When the British established their first settlement in Jamestown, there were young boys among the company, street urchins indentured to work for the upper-class colonists. At Plymouth, children came with their parents. Thousands more children came alone from Great Britain and Ireland, voluntarily and involuntarily, to serve indentures. Enslaved children were transported from Africa and the Caribbean, without the comfort and protection of their families. Orphans were sent from Mexico to California in the late 1700s to be apprenticed into existing households. The importation of unwilling labor continued into the middle of the 1800s as Chinese girls were sold into prostitution in the American West.

The largest number of children entered this country between 1880 and 1915, the most famous and active period of immigration in our history until the last twenty years of the twentieth century. The cities of the East, particularly New York, filled with languages from across the globe. Germans, Swedes, and other immigrants, along with native-born Americans, also moved west to take advantage of cheap land. The trip was more dangerous than most of us can imagine, especially for children, and it was not unusual for a family to lose several children to illness or starvation along the way, a high price to pay for a parent's dreams of a better life. More extraordinary, perhaps, was the number who survived the hardship and horrors of the journey. Of course, as settlers traveled ever further West, thousands of tribal children and their parents were hounded from their homes and killed or sent to prison camps and reservations, often far from their homelands.

Immigration slowed considerably from 1915 through 1965, largely because of quotas, but migration within the United States did not. The Great Migration brought thousands of African American children from southern farms to the northern cities to escape Jim Crow. The Great Depression displaced children all over the country, particularly from the Dust Bowl. In the 1950s and 1960s, children migrated from the city to the suburbs, changing the American experience of childhood forever.

The Immigration and Naturalization Act of 1965, as well as other laws, did away with the quotas of the 1920s, and, as a result, the United States changed significantly. America's children now truly come from all over the globe, including South America, Southeast and South Asia, Africa and the Mideast.

Americans are not nomadic, but they often seem to be the next thing to it. Today, there are about a million children of migrant farm workers who seldom stay in a school long enough to learn. An unprecedented number of all American children move frequently, as corporations routinely reassign their parents. Others travel from one town to another as their families try to escape poverty and homelessness. Except in small, rural areas, few children graduate from high school with their kindergarten classmates or think of one house as home. Movement has become part of a child's experience in America.

We located the visual record of the perpetual movement of American children in all of the expected places, as well as some unusual ones. The engravers for illustrated newspapers such as *Harper's Weekly*, *Frank Leslie's Illustrated Newspaper* and the *London Illustrated News* were, in a sense, pre-photographic "visual documentarians." They gave us essential visual records of American life, as have the journalists that followed. Commercial photographers such as Robert Runyon could be equally important. Taking photographs to sell as souvenir postcards, Runyon (who later opened an immensely successful portrait studio) was one of the only photographers to record the Mexican Revolution (1910–1920) on both sides of the Texas border; his work includes pictures of Mexican children and their families who fled the war. Farm Security Administration photographers such as Dorothea Lange and John Vachon were assigned to create propaganda to support the efforts of various New Deal programs but transcended this mission to create an unparalleled portrayal of life during the Great Depression, transforming documentary photography in America.

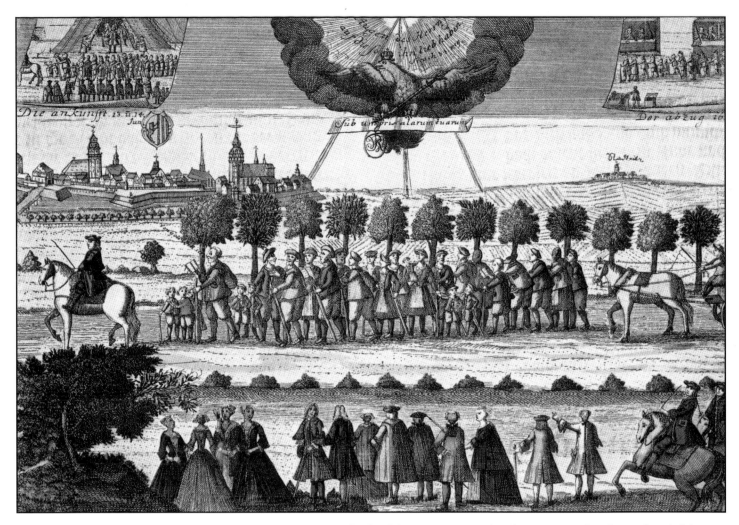

Children were among the earliest European immigrants to America. This detail from a 1732 engraving shows a group of Lutherans from Salzburg as they set out for Georgia.

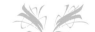

THIS DAY, MY TWO CHILDREN, SAMUEL AND MARY, BEGAN TO BE sick of the small pox, which was brought into the ship by one Mr. Brown who was sick with the small pox at Gravesend. By Tuesday, towards night, my daughter grew sicker. She died by five o'clock that night, and was the first of our ship to be buried in the great Atlantic Sea. By the following Saturday we were comforted with the hope that my son Samuel would get well.

The Rev. Francis Higginson, describing events on a ship
from England, just before it reached America, 1629

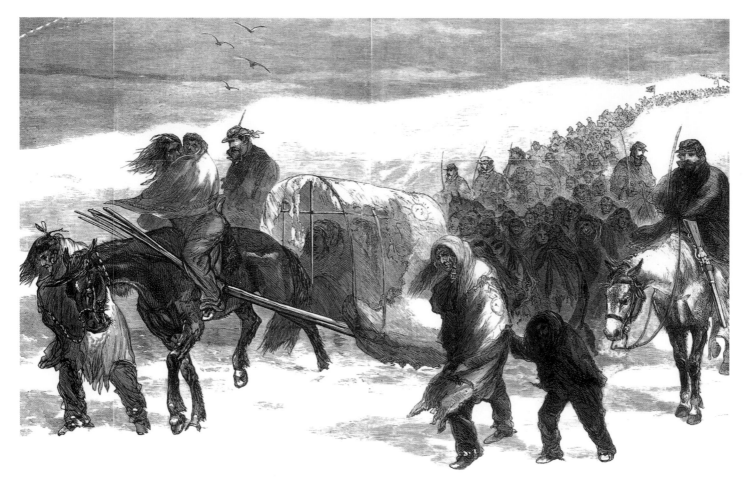

Pictured here are the more than fifty Cheyenne prisoners, mostly women and children, who were captured by General George Custer after the Battle of Washita in 1868 and the destruction of Black Kettle's village. Custer then ordered the slaughter of the Indian pony and mule herd, estimated at more than 800 animals. The lodges of Black Kettle's people, with all their winter supply of food and clothing, were burned. The people were forced to move on.
THEODORE R. DAVIS

This engraving from the Illustrated London News shows children aboard a slave ship that was captured on June 20, 1857, fifty years after the importation of slaves into the United States was supposedly abolished. Over three hundred years, about twenty million African people, including hundreds of thousands of children, were brought, unwilling and afraid, to America.

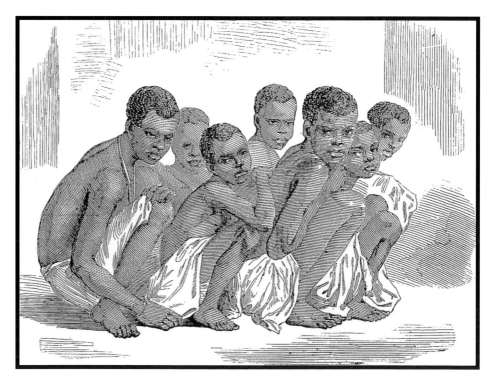

A family of settlers heads west in this photograph taken in the 1880s. During the thousands of 19th-century treks across the continent, children and their mothers were often casualties of a father's desire for "a better life" in the West. Children frequently died of illness or starvation on the trail.

WE HAD A DIFFICULT TIME TO FIND A WAY DOWN THE mountains. At one time I was left alone for nearly half a day, and as I was afraid of Indians I sat all the while with my baby on my lap on the back of my horse. . . . It seemed to me while I was there alone that the moaning of the winds through the pines was the loneliest sound I had ever heard.

We were then out of provisions, having killed and eaten all our cattle. I walked barefeeted until my feet were blistered and lived on roasted acorns for two days. . . . My husband came very near dying with cramps, and it was suggested to leave him, but I said I would never do that, and we ate a horse and remained over till the next day, when he was able to be moved.

Nancy Kelsey, seventeen years old, on her way across the country in 1841

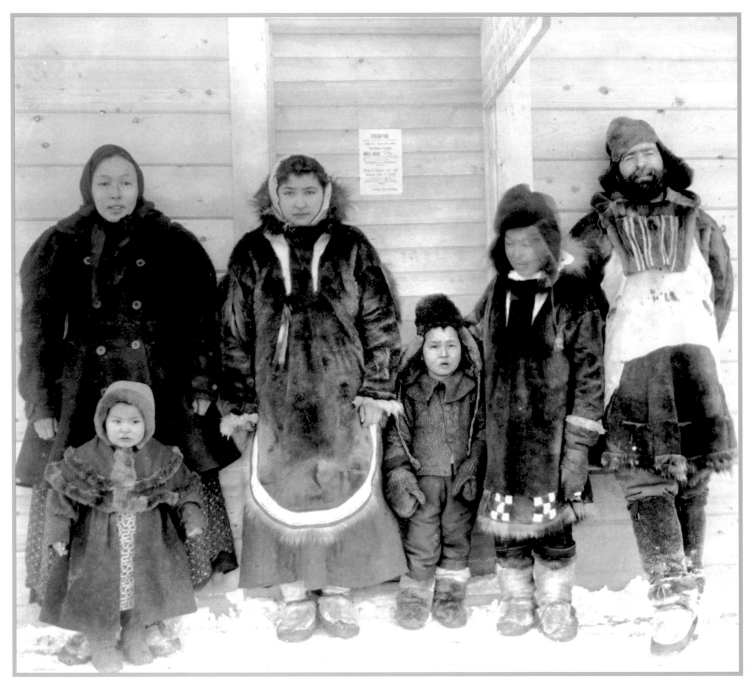

This photograph was originally captioned "Pioneering family in the Klondike, Alaska, ca. 1898." ERIC A. HEGG

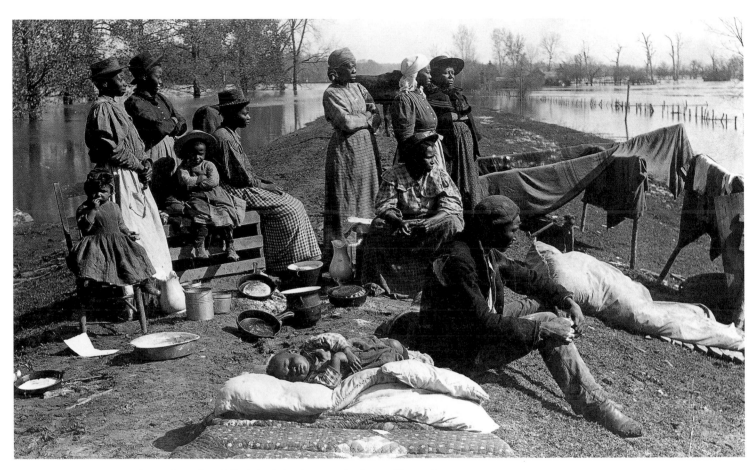

Emigrants to the West wait on a levee for a Mississippi riverboat to take them to Kansas in 1897.

This boy had his formal portrait taken in Leavenworth, Kansas, an important black town during this period. In the 1880s, black Americans suffering under Jim Crow in the South began an exodus to the West in search of freedom. Often, the safety and education of their children was an important motivation for black parents.

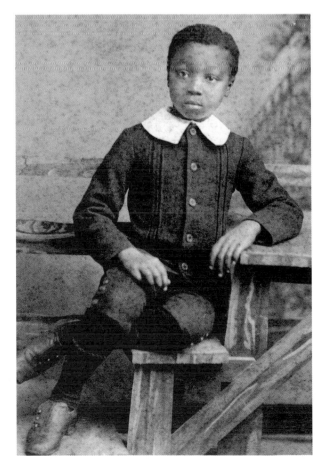

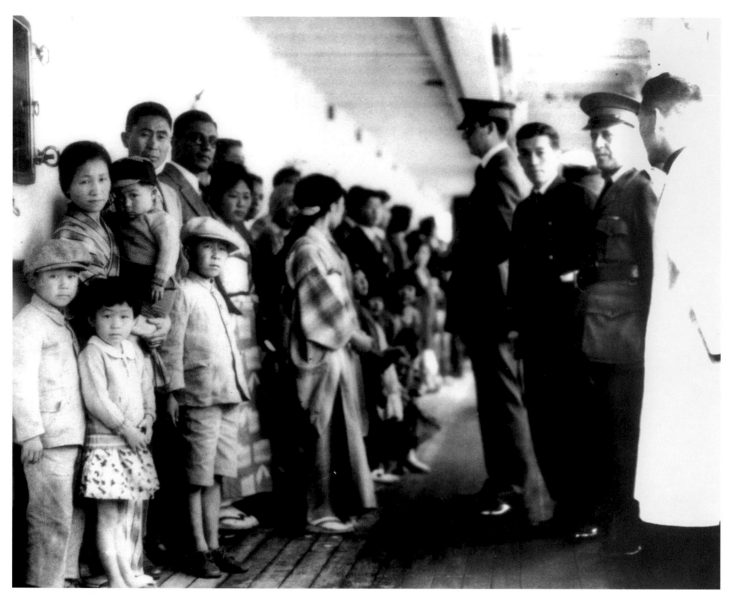

Japanese families await examination by American officials on the ship Shinyo Masa, *near the Angel Island immigration center in San Francisco Bay. The examination of immigrants by American doctors was often a traumatic experience for children from a different culture.*

These girls were photographed at Ellis Island in 1911. Between 1860 and 1920, about 29 million people came into the country, including several million children who would have to learn a new language and new customs.

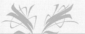

"MY JOURNEY TO ELLIS ISLAND"

By Helen A. Russell (Age 15)

During a recent trip to New York, I visited Ellis Island. We started out on a cold, bright afternoon, from the Battery, on a ferryboat which brought immigrants from the island. The ride took about ten minutes. Leaving the boat, we went up a broad walk which led to a large brick building. On entering this, we were given passes, and told to go where we chose. We went to a gallery overlooking a large room containing foreigners of all nationalities. . . .

One family which I saw consisted of the father, mother, and six children, the eldest of whom was not over ten. She carried her three-year-old sister, and the boys carried the luggage. But the most interesting to me were the twin babies, who were not more than two months old. They lay at opposite ends of a large basket which was carried by the father and mother, by means of handles at either end. There were many other interesting families, some of whom seemed too nice and respectable to have come in the steerage, but none were as interesting as this family of eight.

Later we went to the other end of the gallery to see what was going on in that part of the room. Coming up some stairs were a large number of men who carried in their hands slips of paper. At the top of the stairs sat an official who stamped these papers before the men passed on to a medical examination. The first examiner looked for swellings, and if any were found, it was indicated by a chalk marking on the immigrant's coat. I saw one man with "Hand" written on him, meaning that his hand was defective.

Next, the immigrants passed a doctor who examined their eyes, quickly lifting up the lids, then passing them on if all was satisfactory. Some poor fellows, however, had to wait with those who had been marked, for a closer examination, but the others went on. Soon after this, we left the building, taking the boat for the Barge Office, with a load of immigrants, some of whom we had seen before, waiting at the desks.

St. Nicholas *magazine, August 1907*

Children made up the bulk of refugees from the Mexican Revolution who crossed the Rio Grande River from Matamoros, Mexico, to Brownsville, Texas, in June 1913. The people in this picture have fled to the Charity House for aid. ROBERT RUNYON

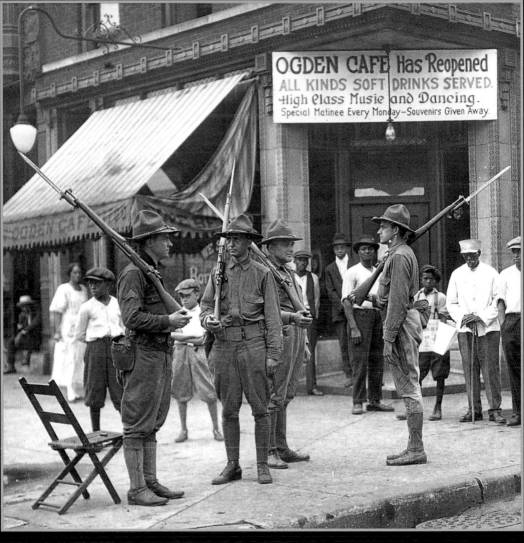

These children in Chicago have just been through days of riots against African Americans who were perceived as taking "white jobs." The Great Migration of African Americans from the rural South to Northern industrial cities sparked rioting in cities across the Midwest in the early 20th century but also led to a cultural renaissance in Harlem, Chicago's South Side, and other black enclaves.

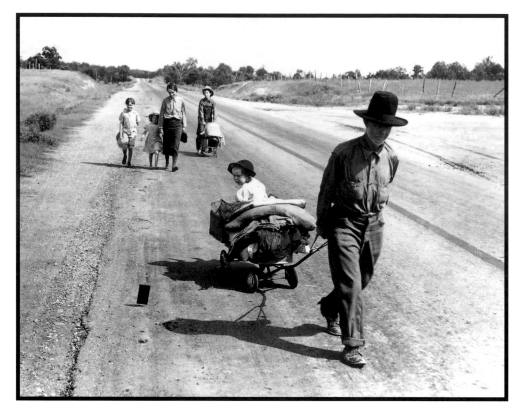

In this photograph a family from Idabel, Oklahoma, is walking to Krebs, Oklahoma. Grace Abbott, chief of the Children's Bureau of the Department of Labor, described the situation for children in the Dust Bowl in 1932: "Some families are managing to exist on a smaller per capita than $2 a month, but at the cost of greatly lowered vital capacity and resistance to disease." Facing starvation, many families left their homes to try to find work. DOROTHEA LANGE

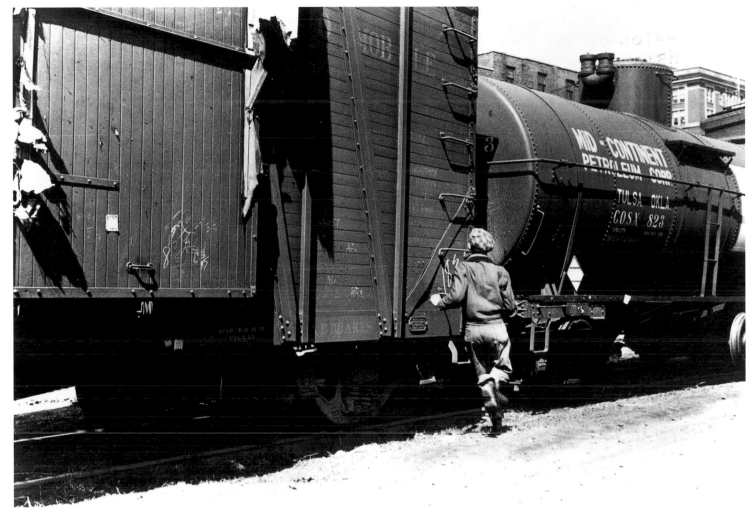

This boy is running to hop a freight train in Dubuque, Iowa, in April 1940. During the Depression thousands of children left home—often describing themselves as "one more mouth to feed"—and tried to make it on their own. Far from the romantic adventure that is sometimes depicted, life in the freight cars and hobo camps was violent and dangerous. JOHN VACHON

Friends Leslie Denton and Donna Johs pose outside a home in Levittown, one of the first modern subdivisions ever built. The 1950s saw a major migration that again changed the face of the United States—the move to the suburbs.

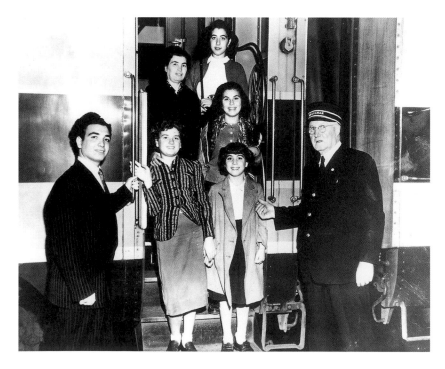

The Ackos family, born in Greece, arrives in St. Paul, Minnesota, in about 1948. After World War II, thousands of Holocaust survivors moved to the United States. Many children came alone and were adopted into American Jewish families.

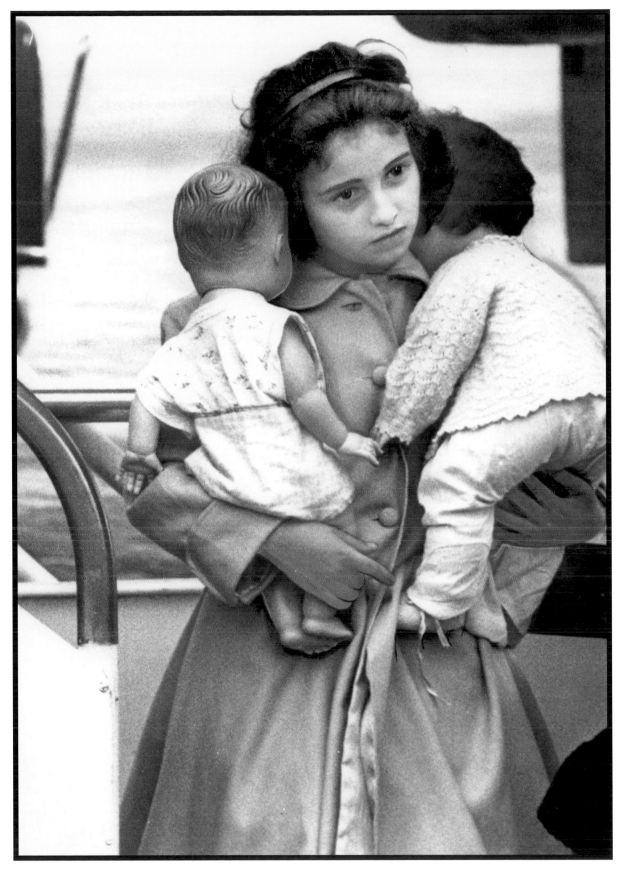

A young Cuban refugee enters the United States with her dolls in 1961, two years after the Cuban Revolution. About 500,000 Cubans immigrated to the United States between 1959 and 2001.

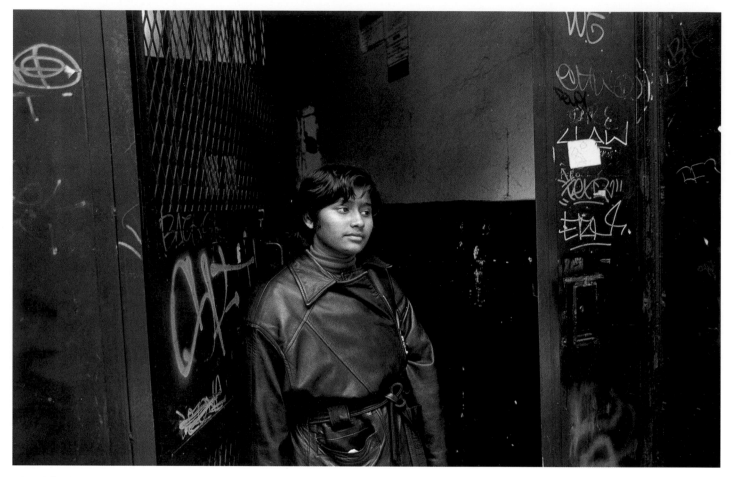

Khandakar Mita, age 11, immigrated to New York City from Bangladesh. Children from non-European countries poured into the United States in the last decades of the 20th century. In the 1980s alone, almost 3,000,000 Asian/Pacific Americans entered the United States, and about 500,000 illegal Chinese immigrants came here between 1984 and 1994. YALE STROM

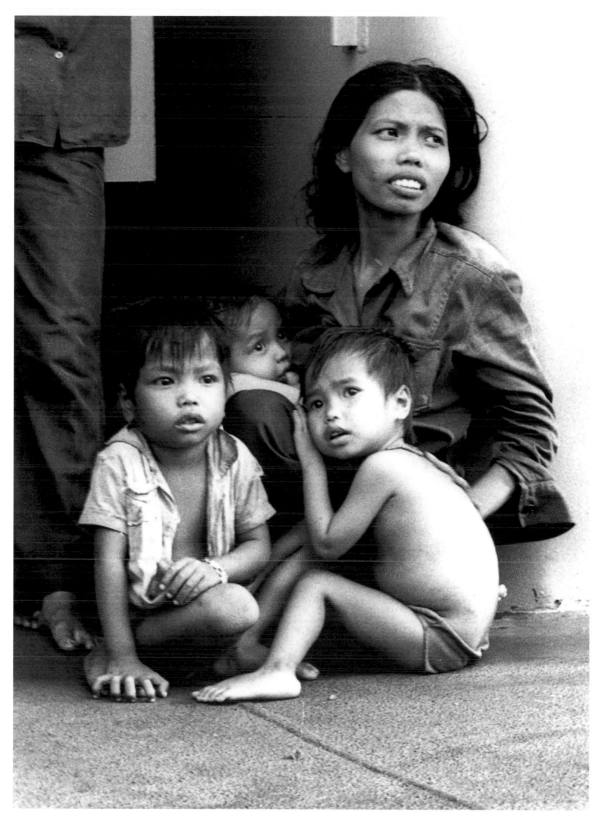

These children were photographed aboard the replenishment oiler USS Wabash *after they had been picked up from a wooden boat in the South China Sea on August 5, 1979. After the Vietnam War more than 200,000 Vietnamese, Cambodian, and Laotian immigrants settled in the United States, often after months or years in makeshift refugee camps.*
FELIMON BARBANTE

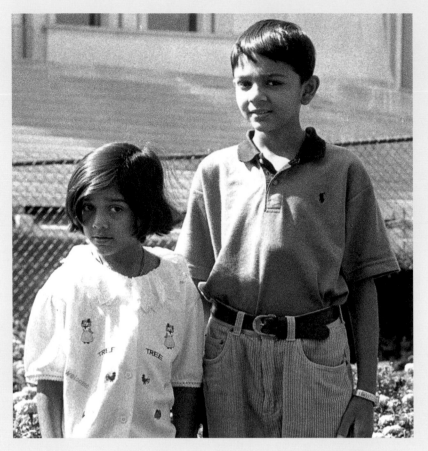

Hira and Haris Aziz stand in front of the Baha'i Temple in Wilmette, Illinois. The Baha'i Church has helped a number of refugees flee their country, Pakistan.
EUNICE HUNDSETH

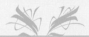

THEN TROUBLE STARTED. I WAS ABOUT TEN THEN. SOLDIERS COULD come and shoot you and take what they wanted. They pushed you, messed up stuff, and took money. They were young. They trashed stuff. We couldn't sleep. It was so noisy and guns were all over. They had grenades. My big sister's husband died there. We had to stop going to school. We went shopping once and never went back. It was very dangerous. . . . Then we had to leave fast. We couldn't bring anything—just the clothes we were wearing. I was scared. We went on foot. My mom stayed to watch the house with my sister. . . . We were so worried about her. My mom thought she would never see us again, and we thought we would never see her. . . . We were dreaming of coming to America, and our dreams came true. When we went to school, nobody was from Somalia. Everyone stared, but they were nice. I was in bilingual and it took me two years to learn English. There were a lot of kids who were talking to me, but I just shook my head because I couldn't understand. Then I made friends with some Puerto Rican girls. . . . We never heard from my mom, not for a long time. I didn't know if she was ok, if she was alive . . . she came last November.

Mulki Hassan, age fifteen, from an interview by Jill Rohde for the Changing Worlds *exhibit, 1999.*

Thousands of South American children, particularly Mexicans, immigrate to the United States both legally and illegally every year. For those who enter illegally, the experience is often harrowing and dangerous. This father and son have been found by border guards. JEFFRY SCOTT

HOLDING STILL (2)

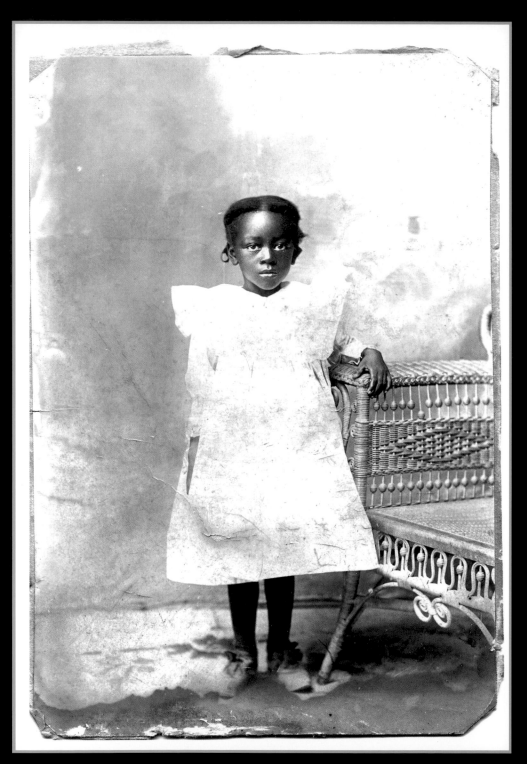

Studio portrait, Minnie Choice, age 4, ca. 1880.

Family snapshot, ca. 1900.

Tintype, 1850s or 1860s.

Family snapshot, ca. 1900.

Family snapshot, "on the farm, 1914."

Family snapshot, Texas, 1920s.
(The gun appears to be real.)

Professional photograph, Markia Gandy
Jarmin, 1980s. LYDIA ANN DOUGLAS

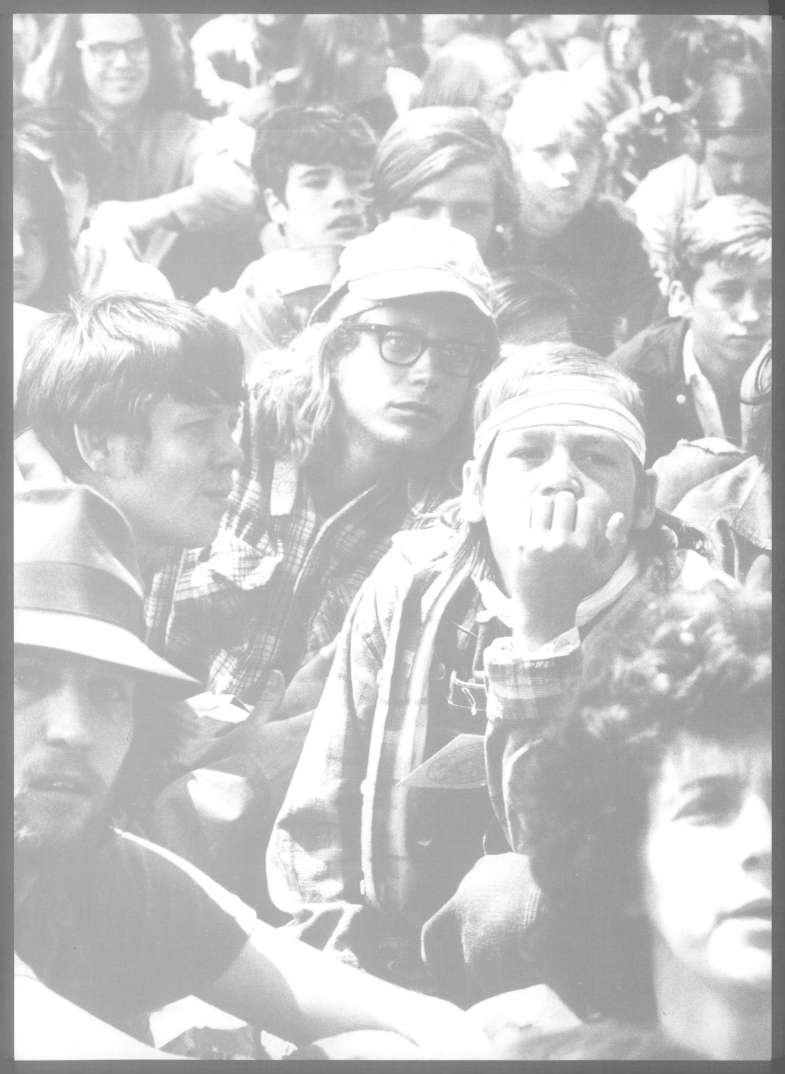

PART THREE

CHILDREN AND THEIR COMMUNITY

A CHILD'S COMMUNITY IS THE TOWN, THE neighborhood, the street, or the playground. It is the church, the temple, or the mosque. It is the "window-raising grandmas," the teachers, and the coaches. The community is also other children, a separate world with its own rules of behavior, secret pacts, support, and cruelty. Some of the most important lessons of life are learned in this community of children.

Today, children have a clearly defined position in American communities. They are the responsibility of the adult members of the community—to shelter, to care for, to educate. Adults do not always fulfill this responsibility, but most would say that it exists. Surprisingly, this is a relatively new concept. It's true that, to a large extent, children held that same position in early tribal societies, although the span of childhood was shorter. In the European colonies, however, the majority of children were workers. Their role was to do what their adult employers ordered them to do, and their peers were other workers, adults as well as children. All workers were under the virtually complete control of the head of the business, farm, or household, and all tried to escape that control in the same ways, from running away to getting drunk together. For enslaved children, the community was especially important, offering their best hope for survival and an important sense of place and belonging.

As European Americans spread across North America, families were required by homestead laws to farm individually and at far remove from each other. Some American Indian tribes forced onto reservations were made to define the boundaries of their land in much the same way, as individual lots to be farmed by a single family. The human need for a community beyond the immediate family survived these difficulties, however. People in the rural West traveled huge distances in order to participate with each other in community life. Children of what we would con-

sider tender years mounted horses and traveled alone to go to school, to visit friends, to go to church youth groups.

Urban communities have faced different struggles. Gathering places for immigrants from all over the world, American cities have developed innumerable subcities within them, often replicating, as closely as possible, the villages left behind. Because of legal, economic, and voluntary segregation, "the neighborhood" has often provided the first community a child knows. These communities are defined by race, language, religion, or income bracket. Unfortunately, they can also be defined by prejudice and hatred.

What has saved many children, and perhaps as a result America as a whole, is the fact that most don't live in and aren't influenced by a single community. As children move farther out into the world they become members of an increasing number of different communities, such as school, scouts, church, and work. They then learn to operate among those communities. Sometimes this means children raise barriers, but often it means they cross them.

Among the painters, engravers, and photographers who recorded children in all of America's diverse communities, perhaps the small-town newspaper photographer is the most overlooked. Albert R. Stone took photographs of newsworthy events for the *Rochester Herald* in the 1910s and 1920s. His images of children participating in everyday activities combine immediacy and elegance. He was a master of the "well made photograph." Of a completely different genre is the "big-city" crime photographer Weegee (Arthur Fellig). An influence on later art photographers such as Diane Arbus, Weegee photographed the darker side of life and was not afraid to show that children were both participants in and witnesses to that aspect of the human condition.

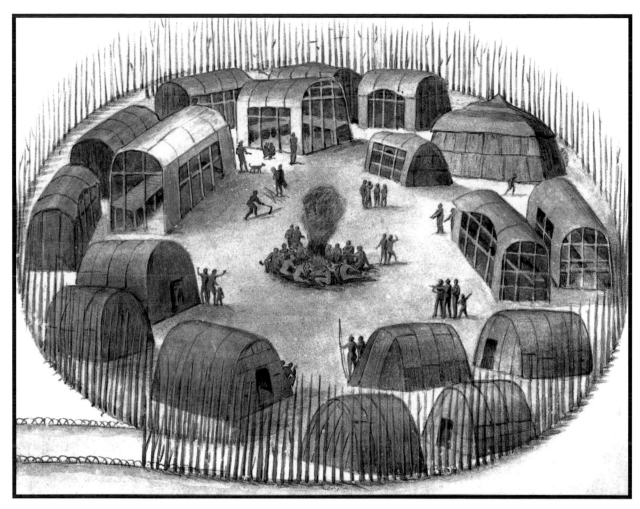

The town of Pomeiock, the home of a group of Algonquians, was located near Mattamuskeet Lake in what is now North Carolina. Children could run in and out of each other's houses in the daytime, when the grass-mat walls were rolled up to let in light and air. A child who lived in Pomeiock can be seen on page 27. John White, who traveled with Sir Walter Raleigh, made this watercolor in 1590.

A Hopi boy watches his elders preparing for a corncob ceremony. Although this image is from 1899, the ceremony had been performed in much the same way for centuries. SUMNER W. MATTESON

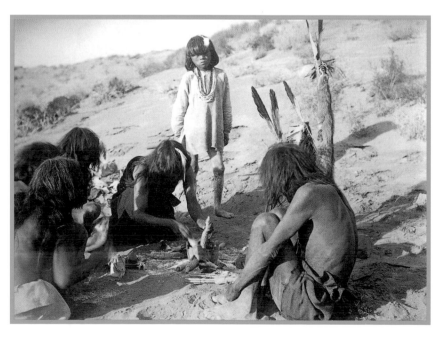

THE ADAMS ARRIVED WITH SIX TOWNSPEOPLE AT SUN-
rise. We set the stringers and put the kingposts in place. We have made a fine
bridge. Father put a brush atop the posts and we all sang and drank. Sarah
brought a cake. One man fell into the brook but he was not hurt.

Noah Blake, fifteen years old, in a diary written in 1805

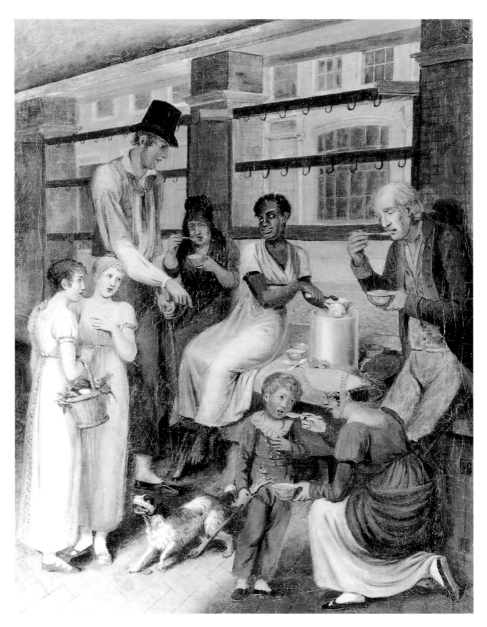

Pepper-Pot: A scene in the Philadelphia market *is the title of this painting of street life in
Philadelphia in 1811 by the artist John Lewis Krimmel. The two refined girls at the left were
probably not allowed to partake of the treat being served.*

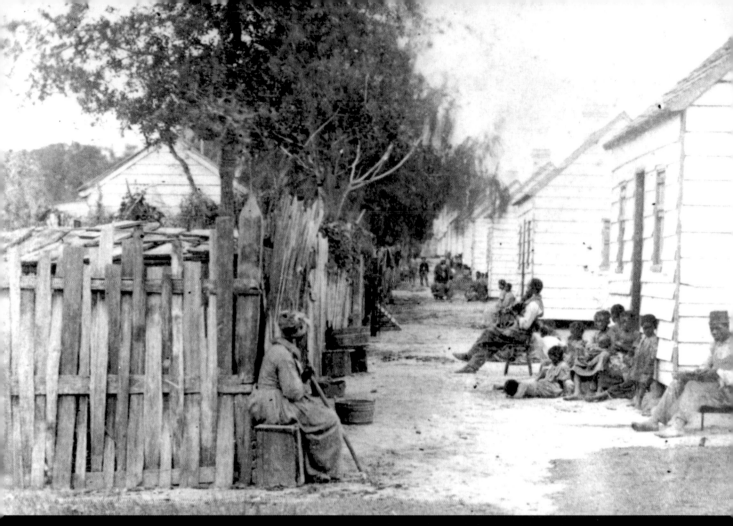

The inhabitants of the slave quarters at the Perseverance Plantation in Goose Creek Parish, South Carolina, were photographed, probably by a Union soldier, between 1860 and 1863. Enslaved children were usually allowed to play and do small domestic chores around the house and slave quarters until the age of five or six, at which time they were put to work.

In this engraving published in Frank Leslie's Illustrated Newspaper on July 8, 1867, boys drink in a gambling den on Baxter Street, in New York City. In the middle of the 19th century and beyond, children in poor and working-class families still lived fundamentally the life of adults.

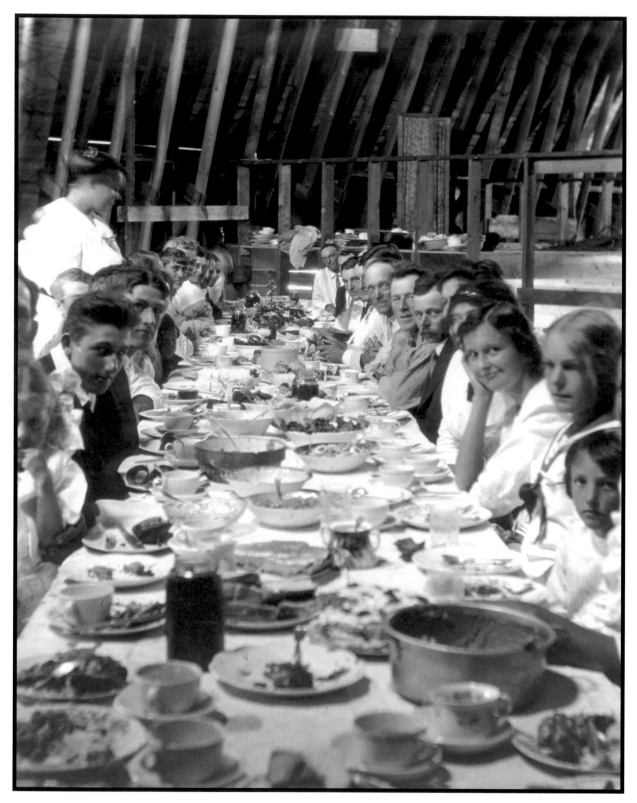

Settlers' children worked hard and looked forward to any form of social event. This barnwarming was held at Joe Pazandak's farm in Fullerton, North Dakota, in the 1910s. Some of the families in attendance were the Johnsons, the Newmans, the Bartas, and the Kelshes.

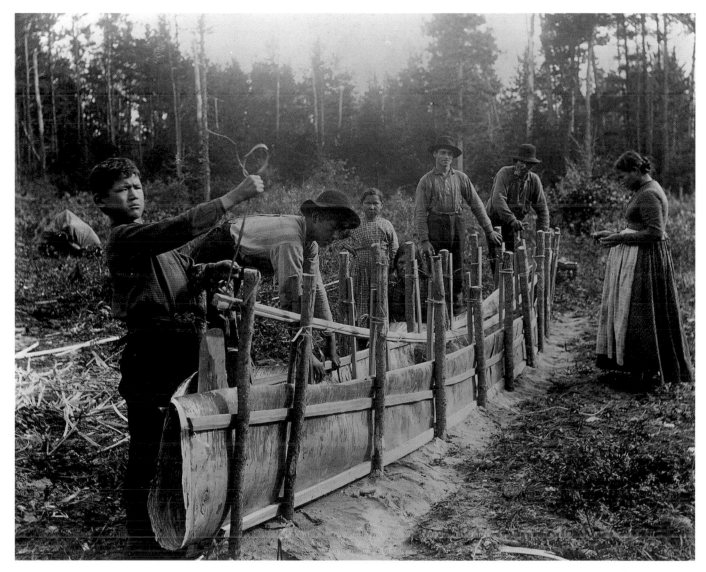

Children in the West participated in the work of the community, as well as that of their family. This Chippewa group is building a birchbark canoe in 1895. TRUMAN W. INGERSOLL

WE WENT TO CHURCH A LOT. THEY HAD DIFFERENT MEETINGS at various churches. We went to the Seventh Day Adventist—my friend and I— and the Methodist. We visited all the churches. I had a friend who lived across the street, a daughter of the pastor of the Evangelical Church. We just wanted to check it out and hear the programs. It was someplace to go. . . . There wasn't much else.

Daughter of Katharina Schmidt, late 19th century

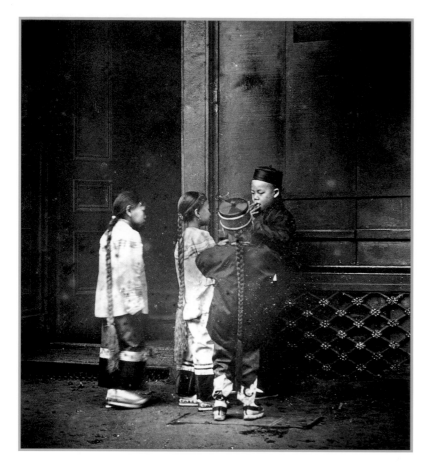

Watched by curious friends, a boy tries out "his first cigar" in Chinatown, San Francisco, sometime between 1896 and 1906. ARNOLD GENTHE

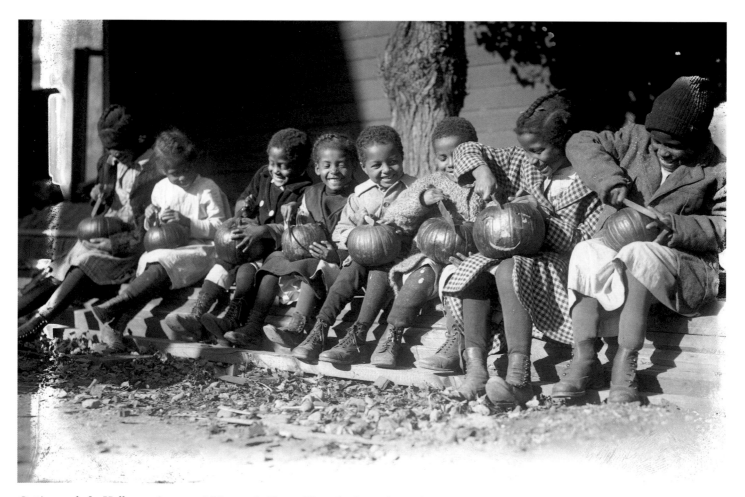

Getting ready for Halloween in 1918, children at the Dorsey Home for Dependent Colored Children carve pumpkins. Victor Jackson (fifth from the left) grew up to become the Recreation Supervisor for the city of Rochester. ALBERT R. STONE

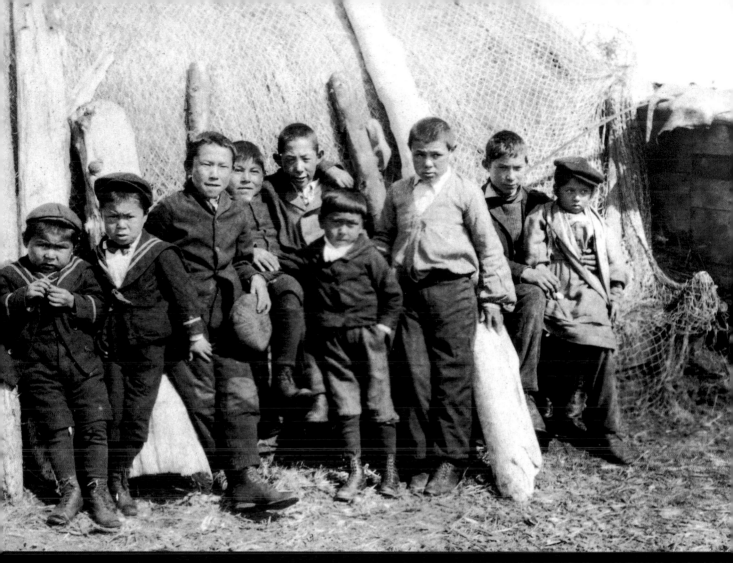

These children in Karluk, Alaska, in 1906 are both Russian and Eskimo. They are leaning against a barabara, a type of sod house found in the area.

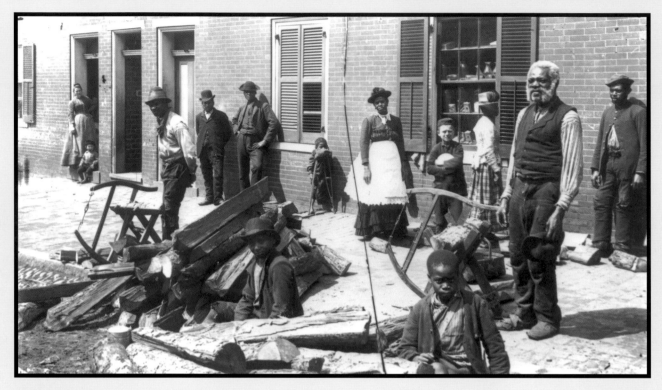

Children are seen as part of a working community in this street scene in Richmond, Virginia, in the 1890s.

HUESTIS OR GEORGE COOK

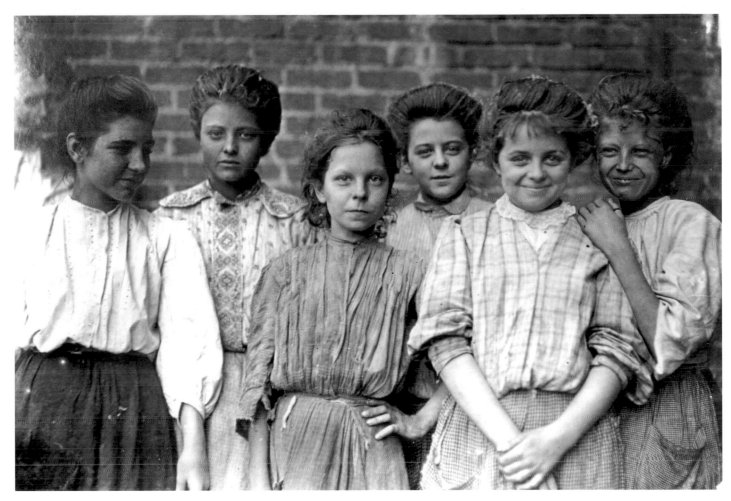

Friends made at work provide a community for children as well as adults. These mill girls from Georgia were photographed by Lewis Hine ca. 1910.

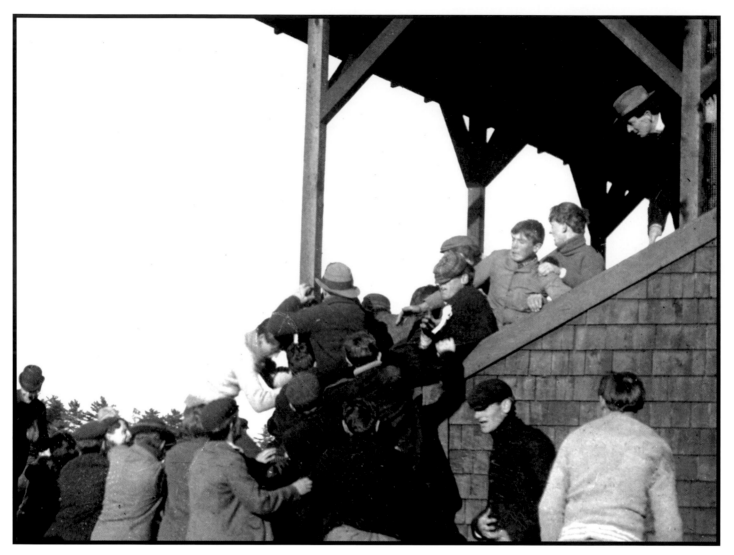

Teenage boys are caught up in a fight, probably at a sporting event.

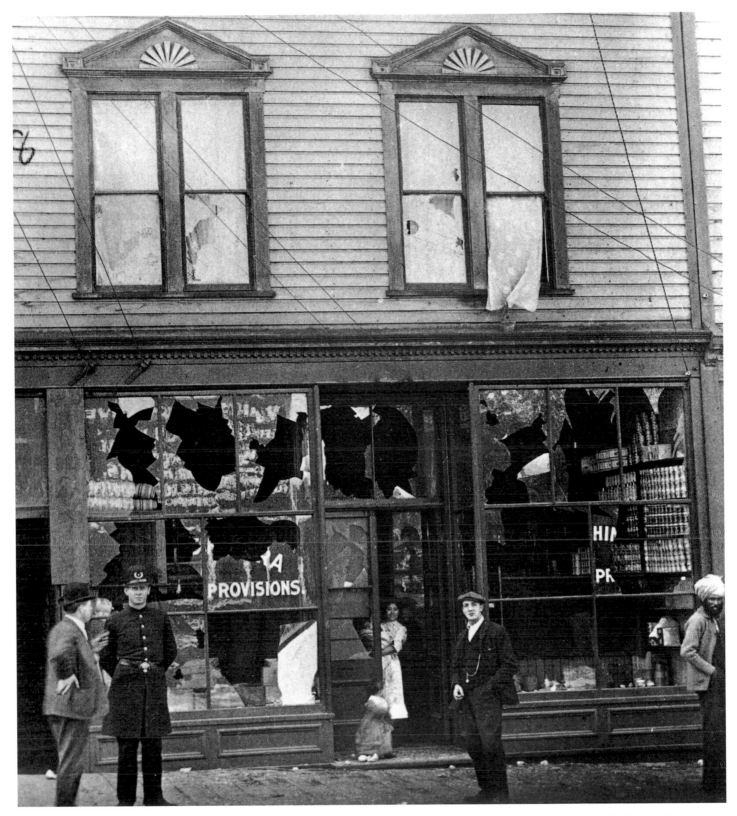

Throughout this country, minorities have always suffered discrimination within communities. The girl in the doorway views the damage done to a store during an anti-Chinese riot in Seattle, Washington, near the beginning of the 20th century.

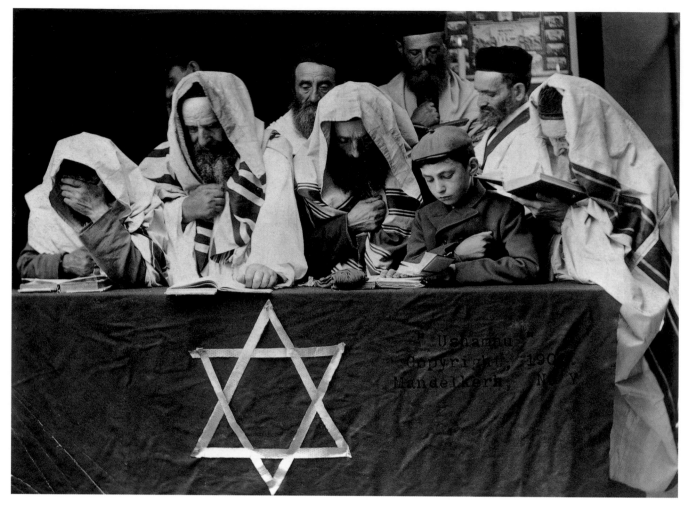

Entitled "Ushamnu," this photograph was taken in New York City in 1901. MANDELKERN

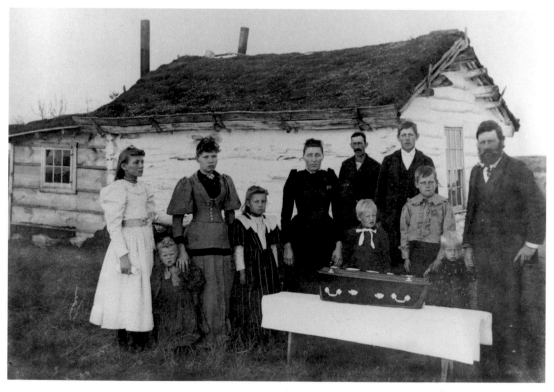

A child's funeral, probably in North Dakota, ca. 1900. FRED HULSTRAND

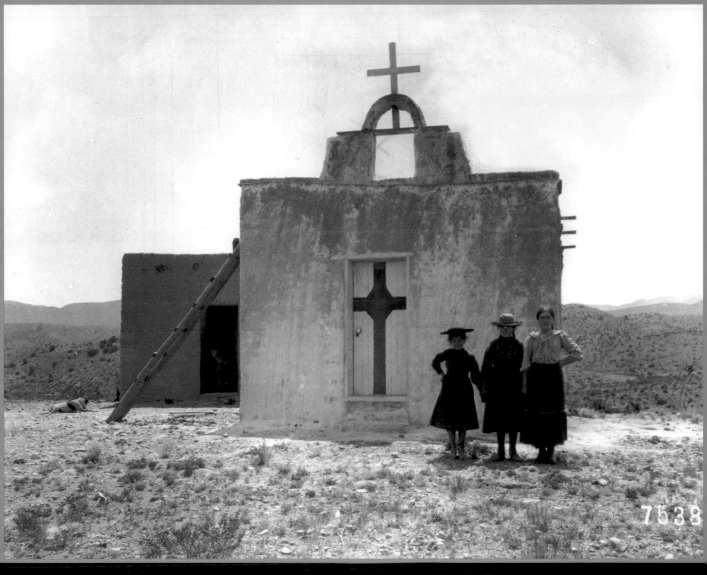

Children in their Sunday clothes pose in front of an adobe church in the Alamo National Forest, New Mexico Territory (now Lincoln National Forest), on May 13, 1908. A. M. NEAL

WHEN MY LITTLE BROTHER WAS SEVEN MONTHS, WE CAME down with scarlet fever. I remember taking sick, crawling into bed, turning my face to the wall, and wanting to be left alone. Two of my sisters also took sick, and my little brother, who died. My memory records the part of the funeral when a man who I thought had a very ugly face picked up the small casket in which the baby brother lay, and I wondered that my parents permitted that man to carry the baby away.

Ellen Dute, remembering her childhood at the turn of the century in Union Township, Grand Forks County, North Dakota

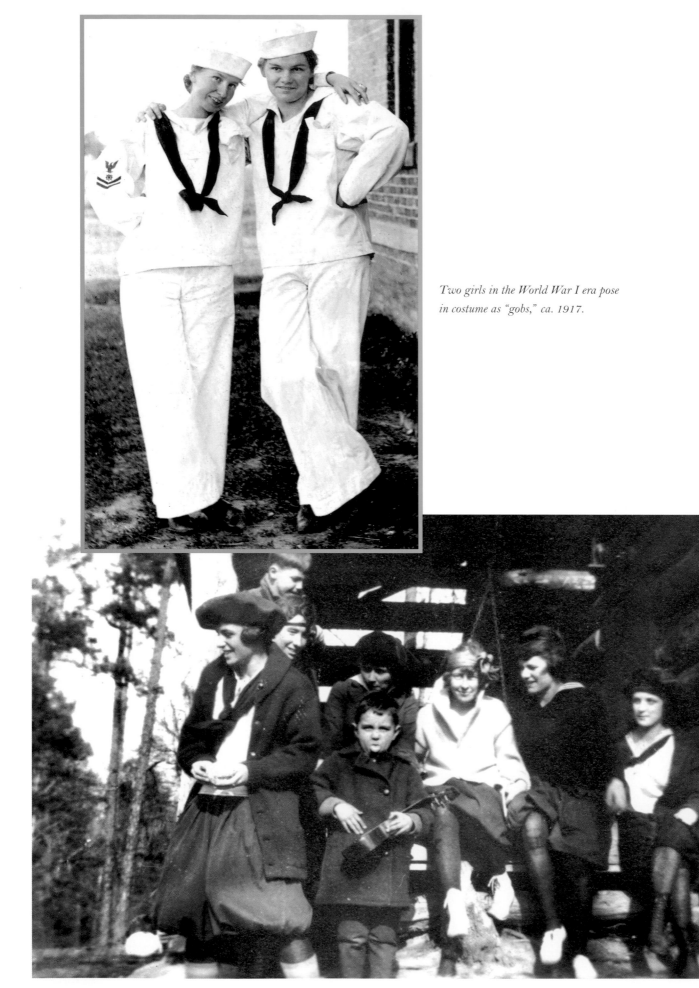

Two girls in the World War I era pose in costume as "gobs," ca. 1917.

A crowd of young friends and/or cousins hang out, ca. 1915.

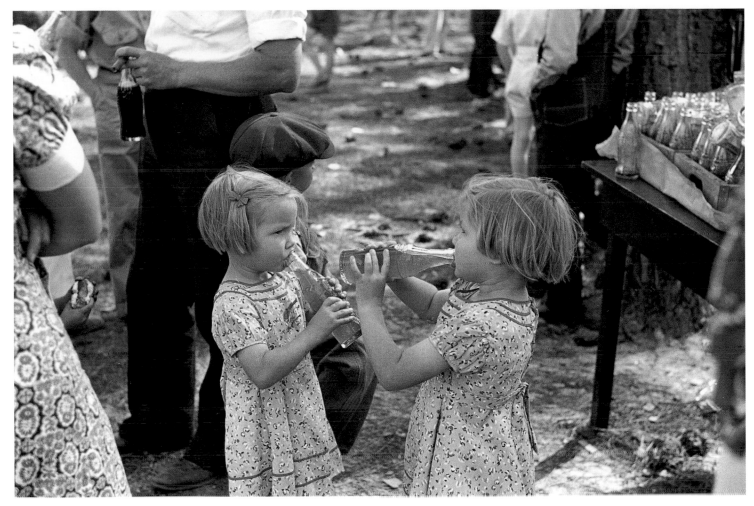

Two girls drink orange pop at a picnic at Irwinville Farms, Georgia, on May Day, 1939. MARION POST WOLCOTT

WE LIVED IN THE DAYS WHEN THEY SAID colored and white. . . . We just went to the colored fountain and didn't think anything about it. We knew that the colored children [had a place]. I'm saying colored because that's what we said: colored children. We knew that the colored children could not [drink] at a fountain [other than designated colored]. We knew they couldn't sit at a lunch counter and we didn't go there. OK?

Gladys Austin recalling Laurel, Mississippi, in the 1930s

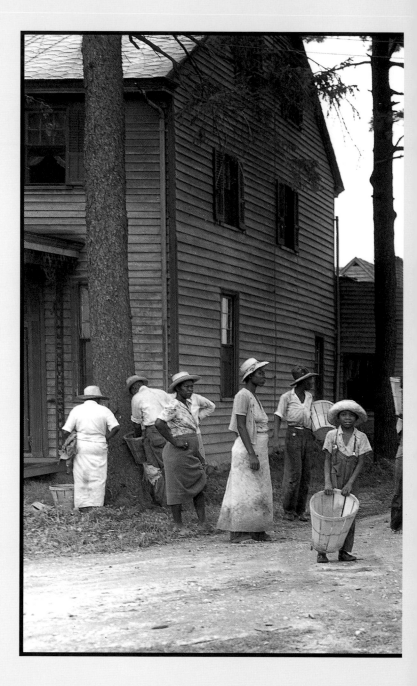

Children are part of a group of migrant farm workers at Seabrook Farms in Bridgeton, New Jersey, gathering at the end of the day in July 1942.
JOHN COLLIER

Patsy Patricks poses in her first communion dress in 1944.

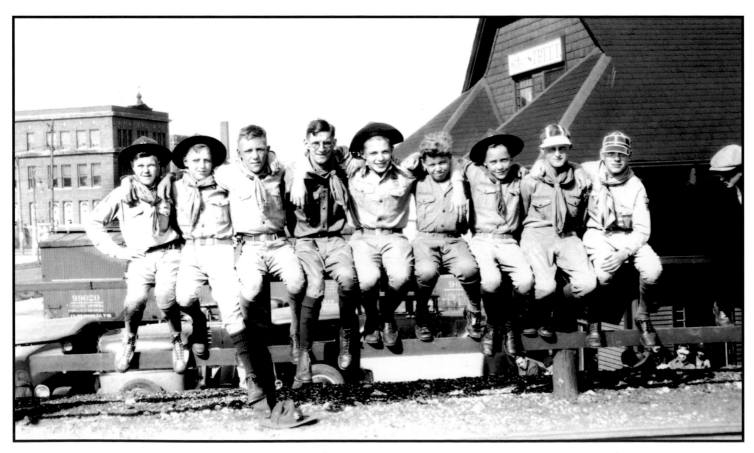

A group of Boy Scouts poses in the 1930s. The scouting movement came to the United States in 1910 and became an important part of community life for many children.

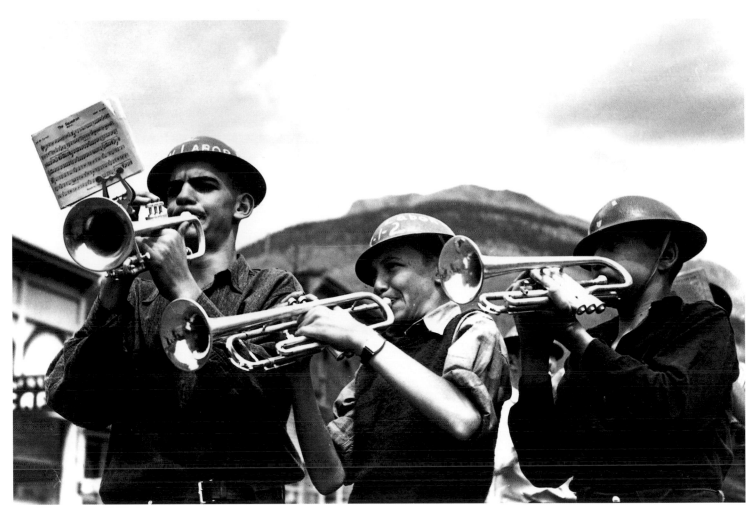

Members of a high school band play during the miners' Labor Day celebration in Silverton, Colorado, in 1940. RUSSELL LEE

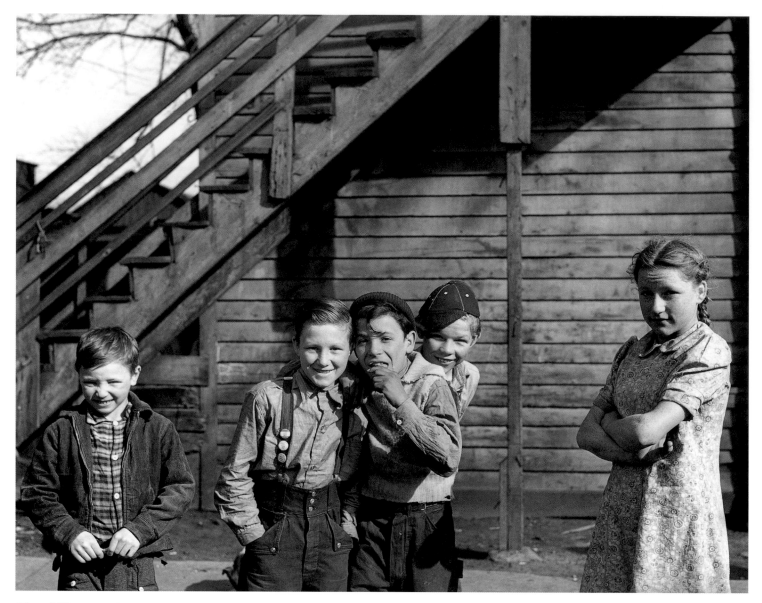

These children in Dubuque, Iowa, were photographed by John Vachon in April 1940.

AND MY MOTHER GOT ILL. SHE DIED OF CANCER WHEN I WAS 13, so we moved in with my grandmother because my father was on the road. . . . The sister of my mother had also moved in with my grandmother. They had a large house and at one time 17 of them living in that house. And generally it was a ball. . . . My grandmother also took in girls that didn't have any homes and now would be like foster children, but she didn't raise them all that long. She just took care of them until they could find another place.

Inez Williamson, speaking of her life in the 1930s

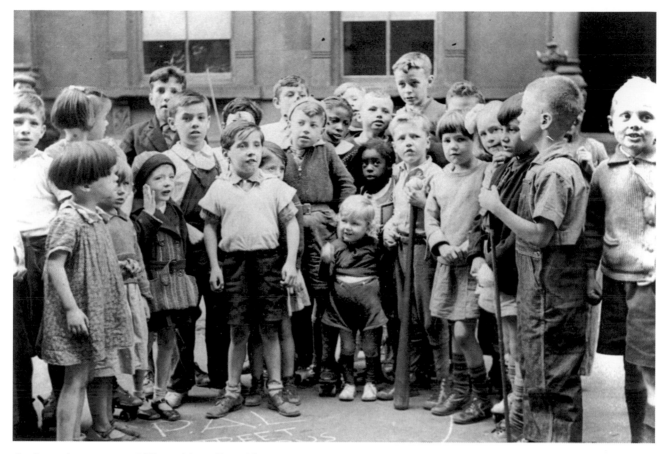

On September 22, 1937, children of the Police Athletic League chorus in New York City were photographed by the Juvenile Aid Bureau.

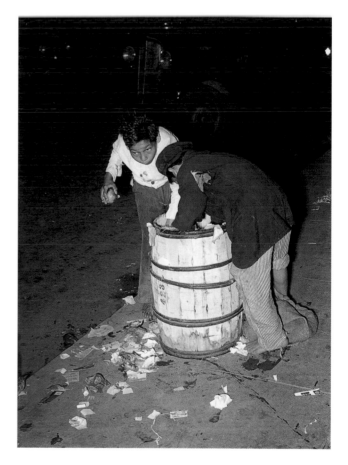

Young Mexican boys scavenge in the trash at the San Antonio market in March 1939.
RUSSELL LEE

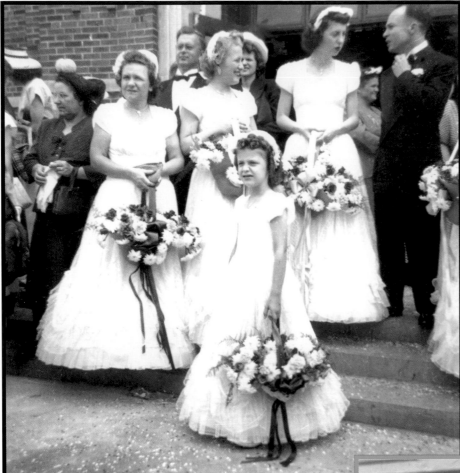

Patricia Fret was a flower girl at this family wedding in Detroit in 1948.

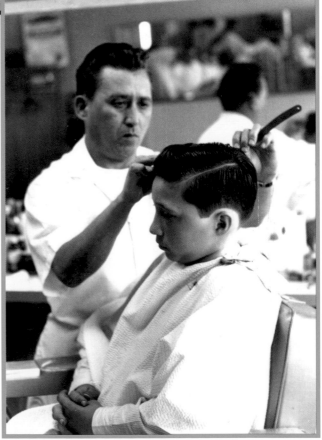

A boy gets his hair cut in a barber shop in Chicago, ca.1950.

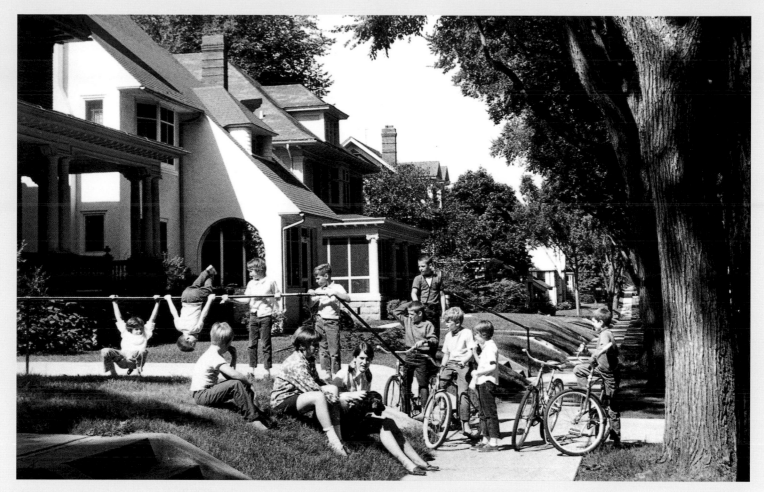

Kids hang out on their lawns on Goodrich Street in St. Paul, Minnesota, in 1969.

OUR GRANDFATHERS AND GREAT-GRANDFATHERS STILL celebrated the *cinco de mayo* and *diez y seis de septiembre* and *bodas* or weddings and *quinzeaneras*, so we grew up with all that flavor. We also celebrated the Fourth of July, Independence Day for the United States. I enjoyed celebrating the Fourth of July. It made me feel, just like when you hear the National Anthem, the hair from the back of your neck raises up. You know it's just kind of strong. I felt real proud of being American.

Juan Vallenzuela, describing his experiences in the 1950s

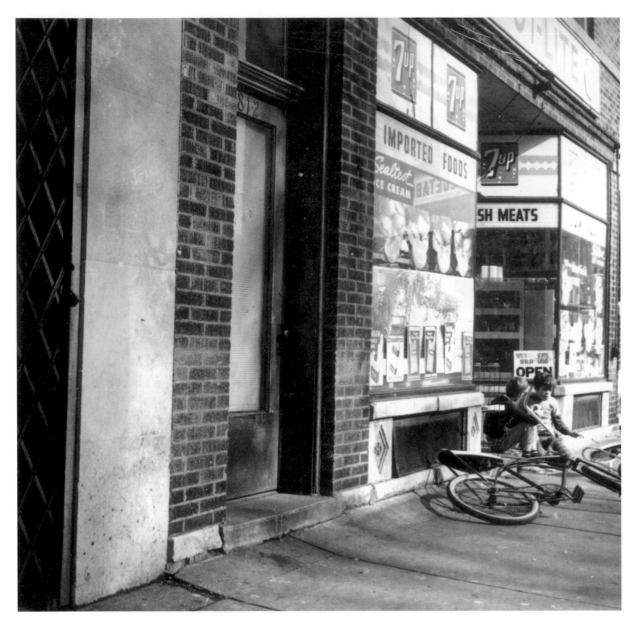

Two boys visit in the doorway of a small grocery store on the South Side of Chicago in the 1960s. ANDRA MEDEA

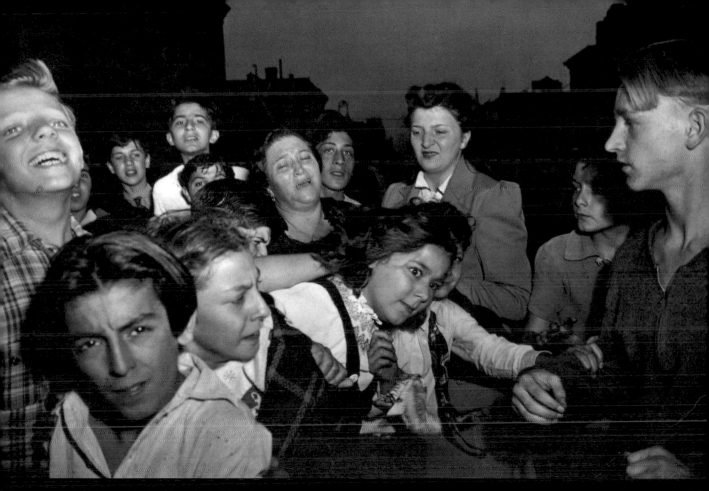

Children in Brooklyn watch a gambler murdered in the street in 1941. —WEEGEE

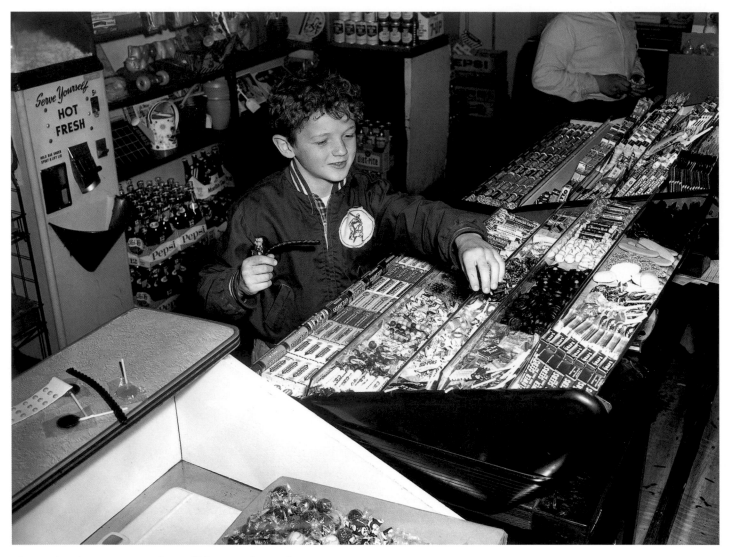

A young boy chooses penny candy at a Chicago candy store in 1965.

ON THURSDAY, AUGUST 14TH, 1969, MY ARGENTINEAN GIRLFRIEND, Patty, and her two brothers, Claudio and Sergio, and I piled into Sergio's old Chevy in Fair Lawn, New Jersey, with some food, camping equipment, and mind-altering substances, and drove north up through Bergen County in New Jersey on Route 17. We were headed for the Woodstock festival in Bethel, New York, which, judging from the lineup of performers on the bill, promised to be the best rock concert we had ever seen.... I was a 17 year old high school student studying classical guitar at the time, but was still a rock and folk fan anyway. For the past two years I had been getting into the hippie scene by growing my hair and speaking the hipster patois, participating in antiwar demonstrations, and reading the literature of the counterculture. And like most everyone else in the new "revolution," I was also smoking pot and dropping LSD. Not only was the music going to be good, but my friends and I were going to scrape the stratosphere this time.

Glenn Weiser

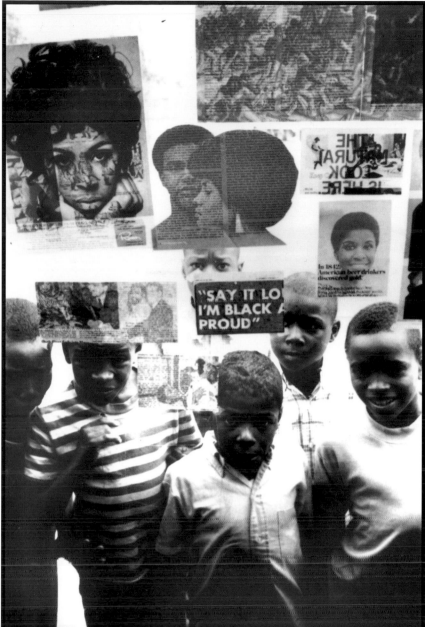

Boys look through the window of a
VISTA office in Washington, D.C., in
the 1960s.

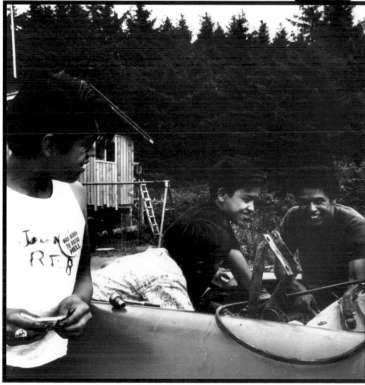

Boys fix a car on the Quillayute
Reservation in the 1960s.

A young girl looks out of the doorway of her tent home in a Vietnamese refugee camp in California in the 1970s. CARROLL
PARROTT BLUE

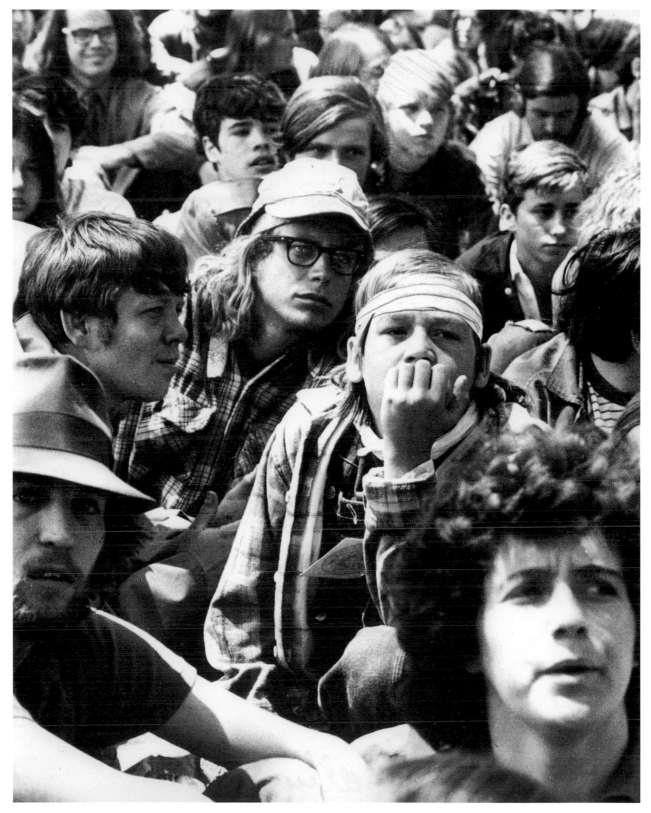

Children attend an anti-Vietnam War/May Day rally in Washington, D.C., in 1971. BETTYE LANE

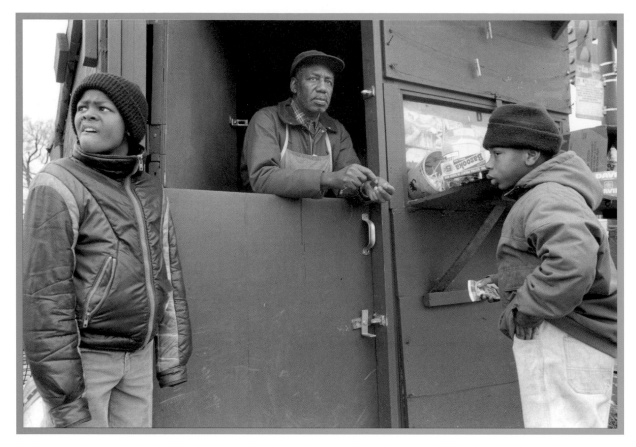

In the 1990s, boys on the South Side of Chicago visit the local newsstand/candy store as children have for the past sixty years.
© JIM NEWBERRY

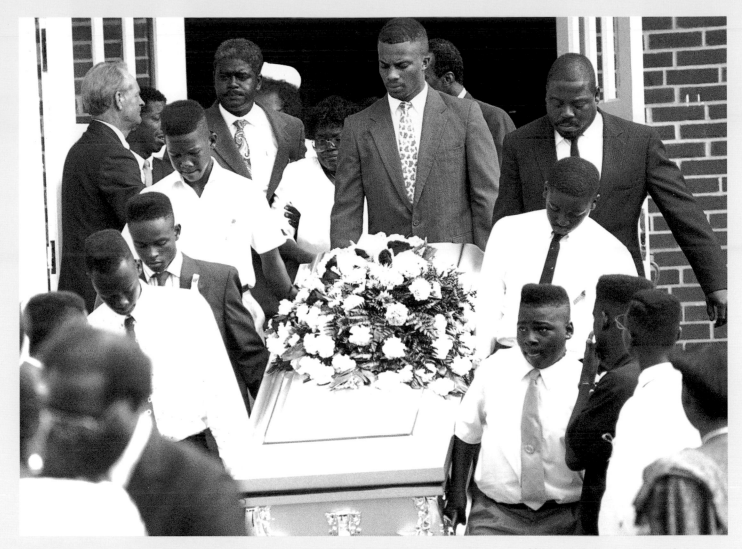

These boys are carrying the coffin of a friend. On August 24, 1990, following a football game, fifteen-year-old Marcus Grier, Jr., was caught in crossfire, shot, and killed.

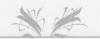

TODAY GUNSHOTS ECHO IN MY HEAD. THEY ARE THE SAME GUNSHOTS THAT killed an innocent human being right across from my house last night. They are the same gunshots that have scarred me, I think, forever.

Late last night, I was in bed when I heard a man screaming for a police officer. I told myself, I didn't hear that. Later I told myself I didn't hear the four gunshots that followed his cry for help. I lay there in bed and it was like I was frozen. I didn't want to move an inch. I then heard hysterical crying. I ran to the window when I couldn't keep myself back any longer. What I saw outside were cops arriving. I ran into my parent's [*sic*] and woke them up. By that time, tears were pouring unstoppably from my eyes. I couldn't stop shaking. My parents looked through the window and got dressed. They rushed outside and I followed them. It turned out that I knew the person who got shot. He worked at the store at the corner. He was also so nice to me, he was always smiling. He didn't know much English, but we still managed a friendship.

I can't believe this happened. Things like this happen everyday [*sic*] in N.Y., but not in my neighborhood, not to people I know.

Latoya Hunter, January 9, 1991, The Diary of Latoya Hunter: My First Year in Junior High

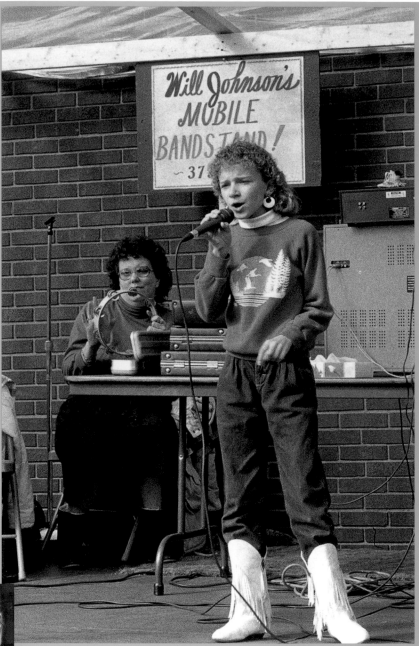

A young girl sings at Will Johnson's mobile jamboree. MICHAEL TAYLOR

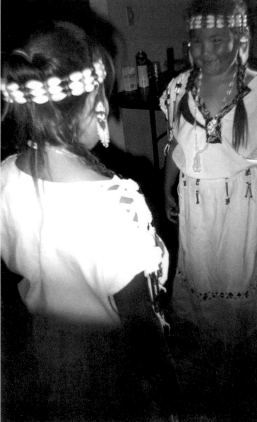

Charlene checks out her new powwow dance dress, made by her grandmother Deena Valdez, in the mirror.

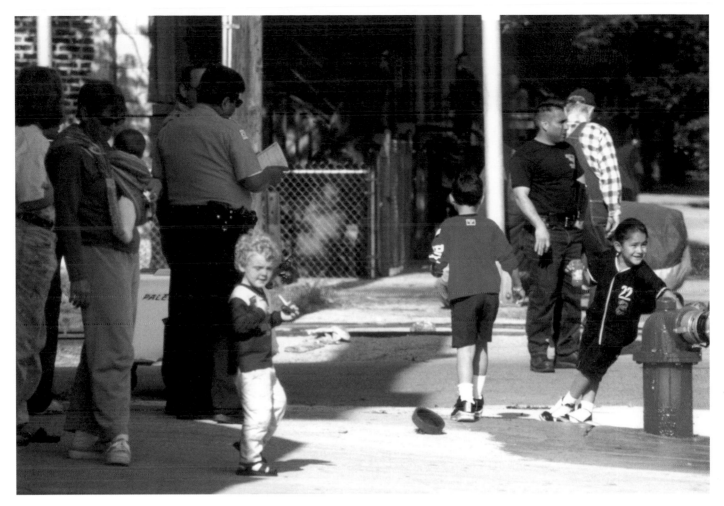

The community comes out to watch a fire in the Pilsen neighborhood of Chicago. © JIM NEWBERRY

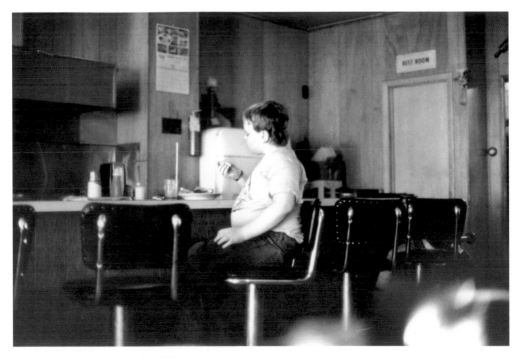

A boy eats a hot dog in the local diner. MICHAEL TAYLOR

A PERFECT WORLD IS WHEN NO DRUG NEEDLES ARE ON THE ground. And no paper on the ground, just clear grass and houses. . . . And they [children] would be fed nice. They would be respected. A big world with no guns, no drugs and everybody getting along. Like if you walk out at night, nobody will try to stick you up with a gun. . . . No one would rob you.

Sam, nine years old, New Haven, Connecticut, 1993

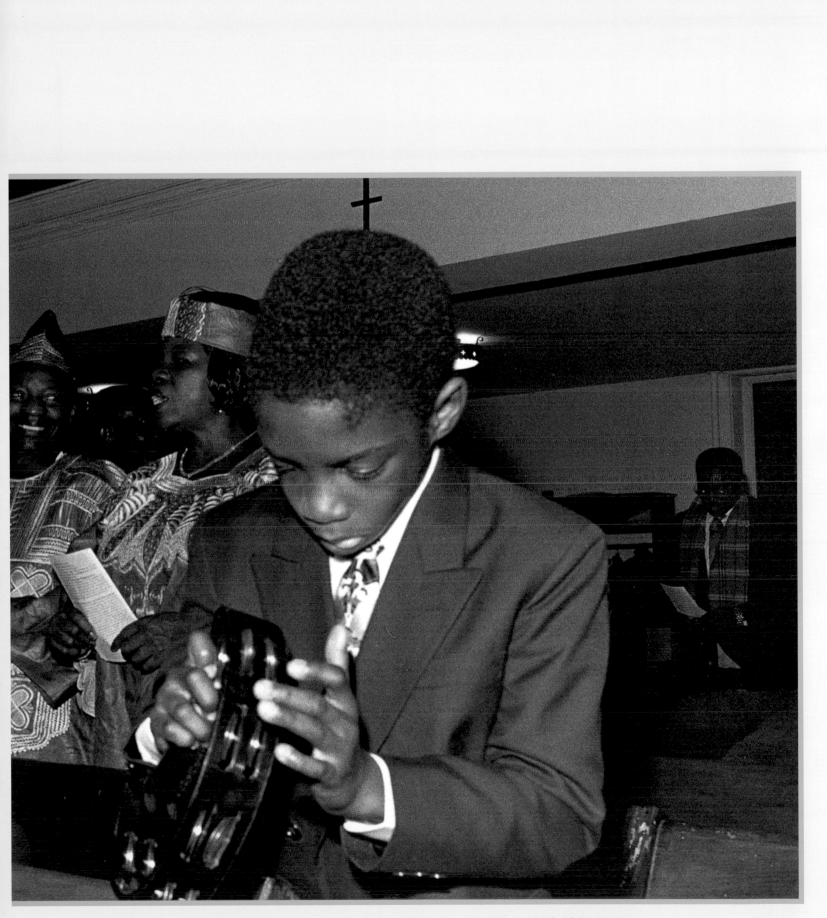

A young boy who recently immigrated from Ghana plays the tambourine in a Ghanaian church in Philadelphia in 1999.

HOLDING STILL (3)

Tintype, ca. 1860.

Studio portrait, ca. 1890, bound feet.
I. WEST TABER

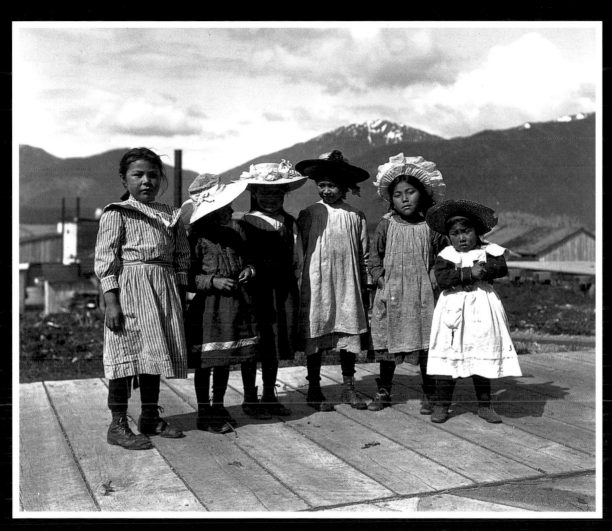

Documentary photograph, Tsimshian girls, Alaska, 1904. JOHN N. COBB

Family snapshot, 1920s.

Documentary photograph, Kituk, an Eskimo boy, Alaska.

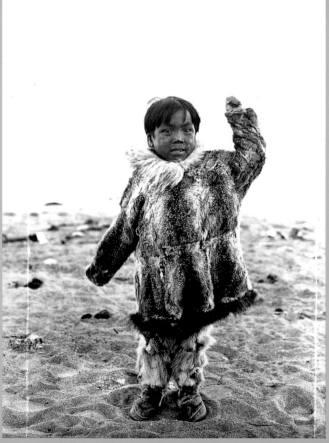

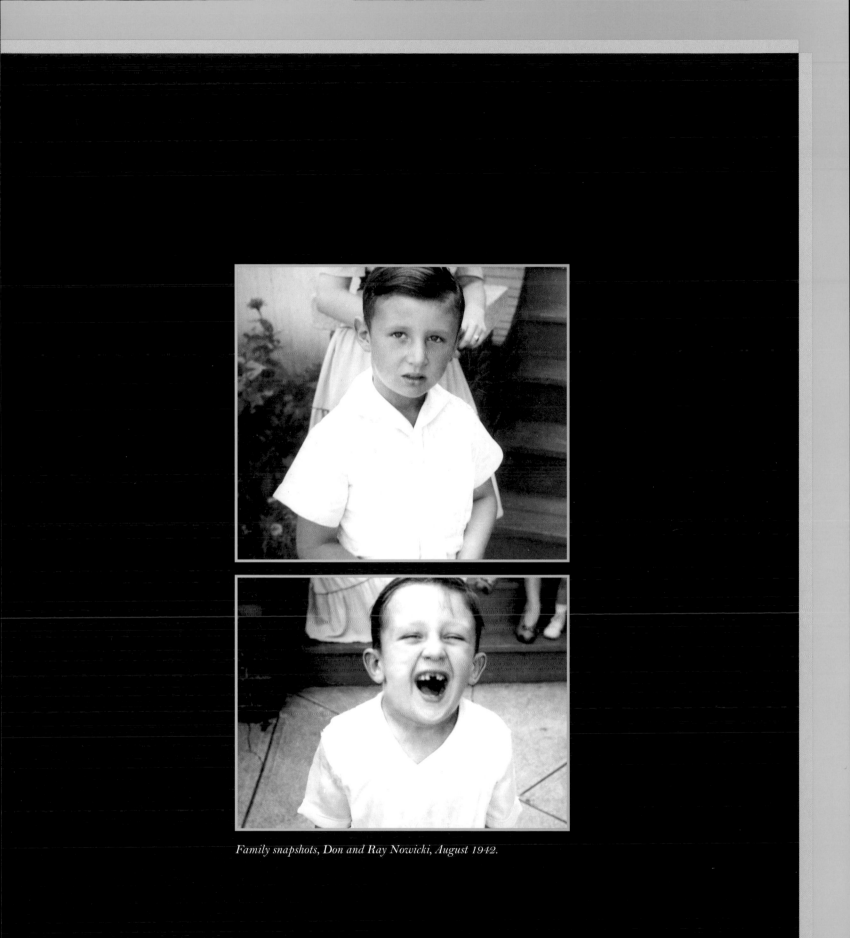

Family snapshots, Don and Ray Nowicki, August 1942.

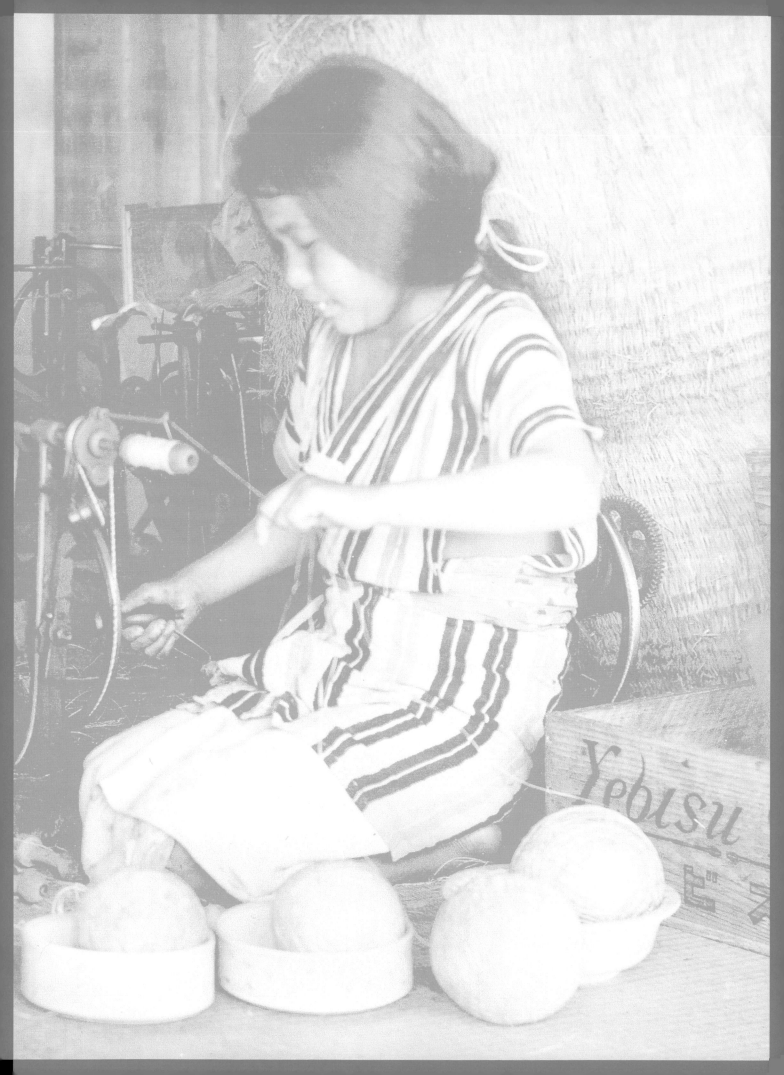

PART FOUR

CHILDREN AT WORK

WORK HAS PLAYED A COMPLEX ROLE IN the lives of American children, and generalizations about its value, as well as its destructiveness, are difficult to make. Tribal societies incorporated children into hunting, fishing, and domestic work at an early age. From what we know, this seems to have been done in a humane way that helped to define the child's future role. To a degree, this was also true of early European American farm families. However, a great many children in this country did not belong to families. They were brought here solely as workers—either indentured servants or slaves. Also, the industrial age changed the nature of children's work. No longer under the watchful eyes of parents, children worked under conditions that were by no means humane.

At the beginning of the 1800s, one-third of the workforce in factories in the United States consisted of children. During the antebellum period, some states began to pass laws that were aimed at regulating child labor. In 1842, for example, Massachusetts passed a law limiting the work day for children under the age of twelve to ten hours. But the laws didn't have enforcement provisions and were, of course, irrelevant to enslaved children, who began working as soon as they could walk, without any limitations on their labor.

By 1900, the U. S. Census showed that almost one-fifth of all children in this country between the ages of ten and sixteen were officially wage earners. That figure did not include sharecroppers' children, nor African American and immigrant girls who worked as domestics, nor children working on family farms. Indeed, the list of workers it did not include is much longer than the list of those it did.

In the early twentieth century, the National Child Labor Committee began working for laws protecting children. Its members effectively publicized the problem, using Lewis Hine's powerful photographs, but practical changes were small. Congress passed two child labor laws, which the Supreme Court struck down. In 1924, Congress passed an amendment to the Constitution. It was never ratified. The only time in the history of this country—until after the Depression—that child labor figures failed to mirror general employment figures was during the brief period when the National Recovery Act imposed codes on participating industries. In other words, except for that brief three-year period, children had always worked, and their rate of employment had *never declined*, except when the rate of employment of adults did.

Nonetheless, America began to think of itself as a country where "children shouldn't have to work." In 1938, the Fair Labor Standards Act limited child labor, although it did not solve the problem. Today, an estimated 5.5 million children between the ages of twelve and seventeen are legally employed. Almost another million, many as young as six and eight years old, work as migrant and seasonal farm workers. Hundreds of thousands of others are employed unlawfully, working in sweatshops in large metropolitan garment districts and on street corners or door-to-door selling candy. The National Institute for Occupational Safety and Health estimates that 100,000 adolescents are injured in the workplace every year, and more than 100 are killed on the job.

Through their work experience, American children have learned responsibility and, sometimes, significant skills. They have enjoyed a sense of independence and personal control and have contributed to both family and community. They have also been crippled, and destroyed. The question facing contemporary America seems to be not whether children should work but how.

In any depiction of American children at work, photographers Jacob Riis and Lewis Hine stand out. They were among the first social reformers to use photographs to shock and to motivate change. The photographers of the Farm Security Administration continued this tradition into the Great Depression and brought the hard lives of child workers to the attention of a new generation of Americans. Perhaps even more interesting, particularly when placed alongside the work of the social activists, are the images in which children working are simply part of the record of life, with no moral comment attached. Eric A. Hegg was a commercial photographer who traveled to Alaska to record the Klondike Gold Rush and to sell his photographs in souvenir albums. The children he photographed working in the gold mines, both above and below ground, were simply participants in his story.

THE BOYS FISH TILL THEY ARE
fifteen years of age, then hunt. When they
have given a proof of their manhood by
getting together a large lot of skins, they
may marry. This is usually at the age of
seventeen or eighteen. The girls stay with
their mothers, and help to hoe the ground,
plant corn, and carry burdens. They marry
when they are about thirteen or fourteen
years of age.

Gabriel Thomas, 1698

*In virtually all tribes, Native American boys learned to hunt
and fish early and then spent a part of their time working to
provide food for the group.*

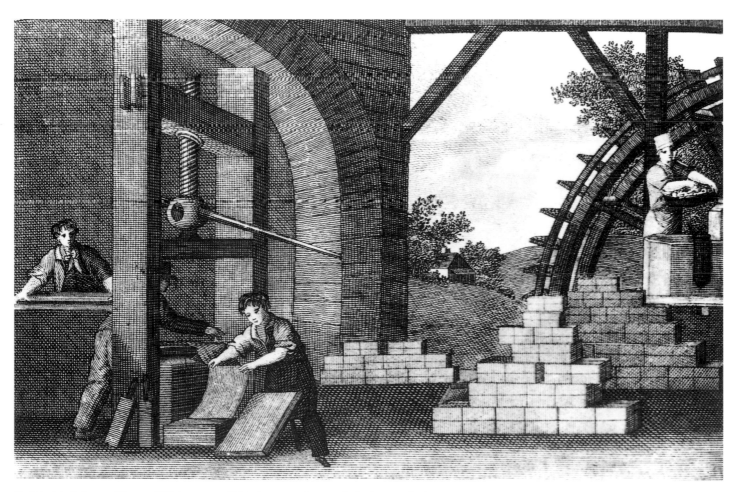

In this detail from a Thomas Gilpin papermill label, a young boy works laying out sheets, ca. 1810.

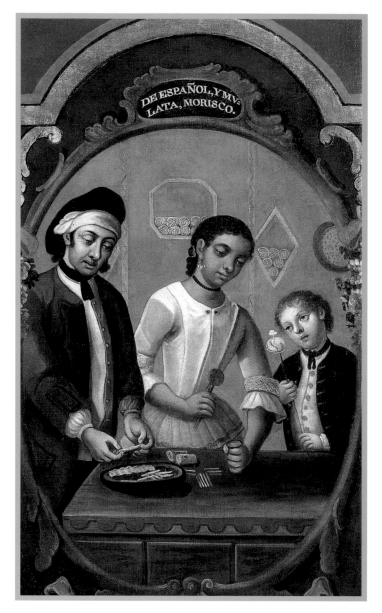

The boy in this caste painting, ca. 1765, is helping his Spanish father and mulatta mother make cigarettes for a tobacco shop. The father rolls the cigarette, the mother pounds the tobacco into it, and the boy seals the bundle.

Enslaved children usually went into the fields, but some went to work in the many skilled professions needed to run a large plantation. For this woodcut, from the American Anti-Slavery Almanac for 1840, *the ironic caption reads: "Poor things, 'they can't take care of themselves.'" The fact that a child is among the skilled enslaved laborers is unremarkable and not commented upon.*

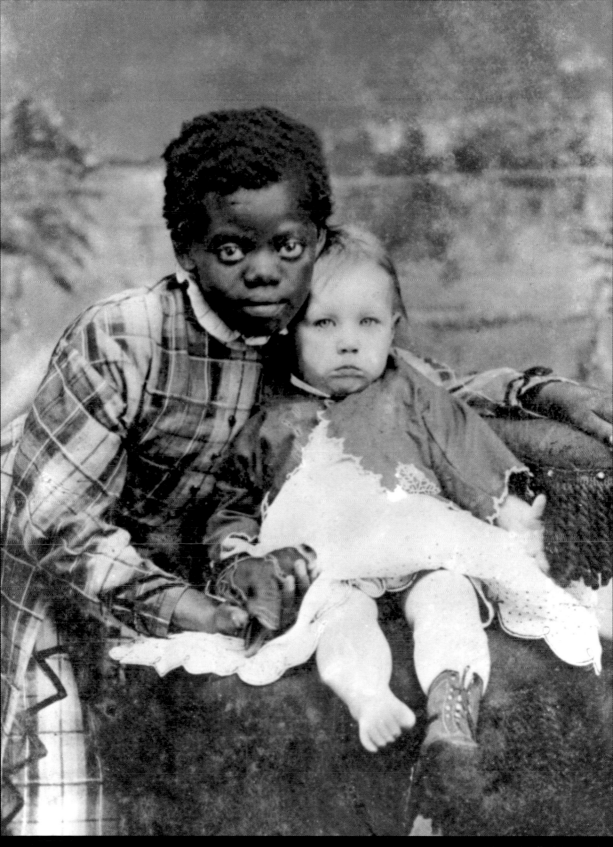

This 1868 photograph is entitled "Magby Peterson and his Nanny." This little girl may have considered herself fortunate to be chosen to work as a nanny rather than as a field worker. However, house servants were usually isolated from their families and community. She may never have lived with her parents again after being given this job.

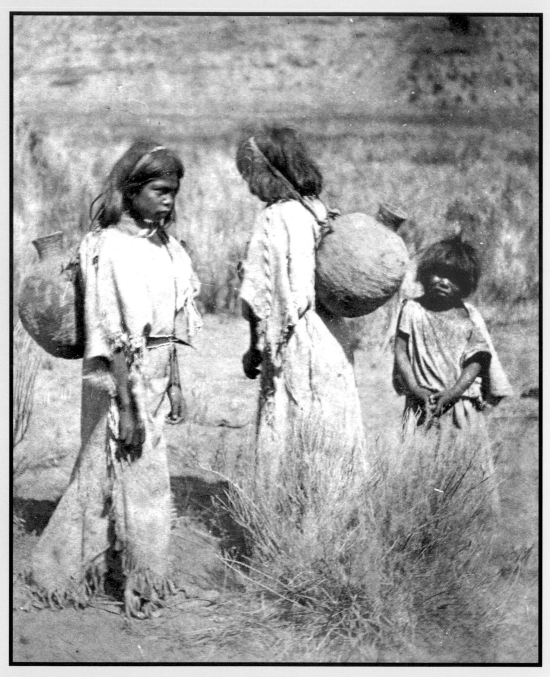

As their ancestors had for centuries before them, two Ute girls haul water in this photograph, ca.1873, by John K. Hillers, who traveled with the Powell Survey.

IT WAS MY DUTY TO SUPPLY MY GUN WITH POWDER. . . . A WOOLEN screen, saturated with water, was placed before the entrance to the magazine, with a hole in it, through which cartridges were passed to the boys. We received them there and covering them with our jackets to prevent sparks from prematurely exploding them, hurried to our respective guns. These precautions are taken to prevent the powder taking fire before it reached the gun.

Samuel Leech, powder monkey in the early 1800s. It should not be necessary to explain what would happen to a boy if sparks were to ignite the powder as he was carrying it.

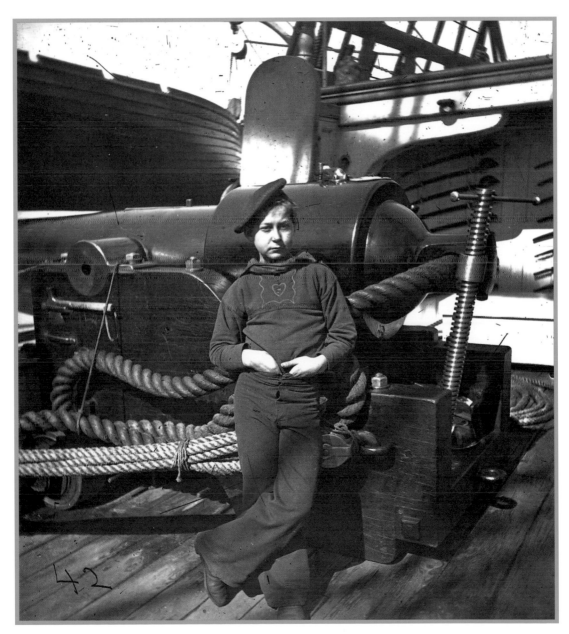

A powder monkey stands by a 100-pound Parrott rifled gun on the USS New Hampshire *during the Civil War.*

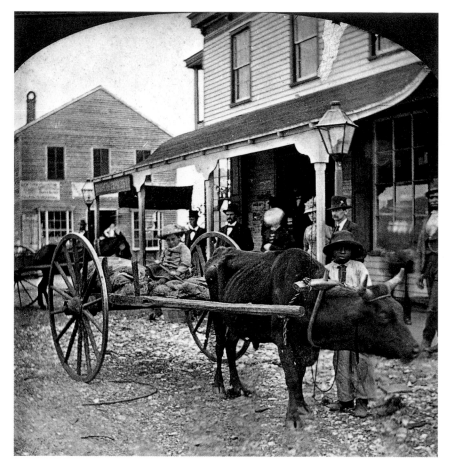

A young boy, possibly in Palatka, Florida, has charge of driving an ox-cart in this photograph taken in the 1870s.

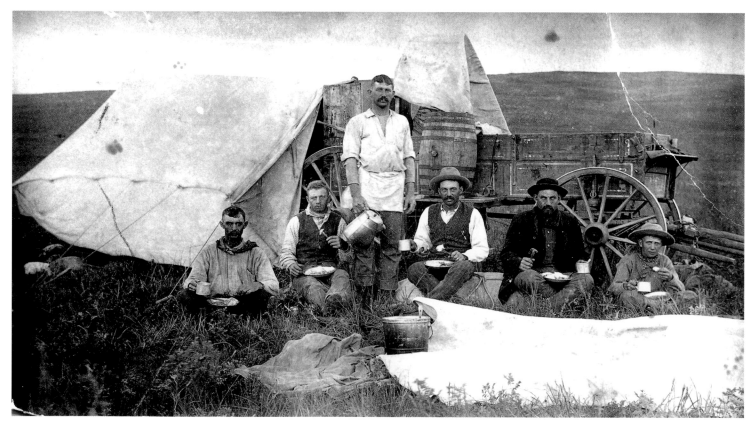

Cow punchers, including the boy on the right, take time out for a meal while working on the Birdwood Ranch in Nebraska sometime between 1870 and 1890.

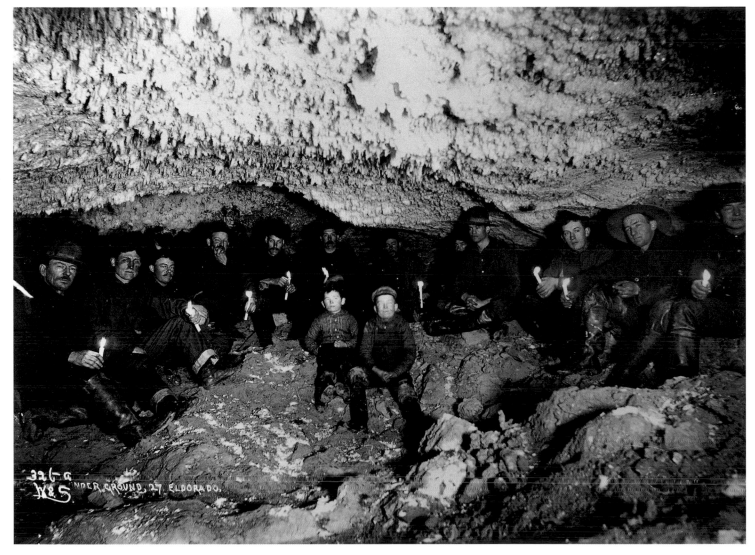

These boys are members of a group of Klondikers mining the underground streambed of Eldorado Creek in 1898. Mining was common work for young children, who were sometimes used to enter shafts where only their small bodies could fit. ERIC A. HEGG

This Mexican water seller was photographed in Bisbee, Arizona, ca.1892.

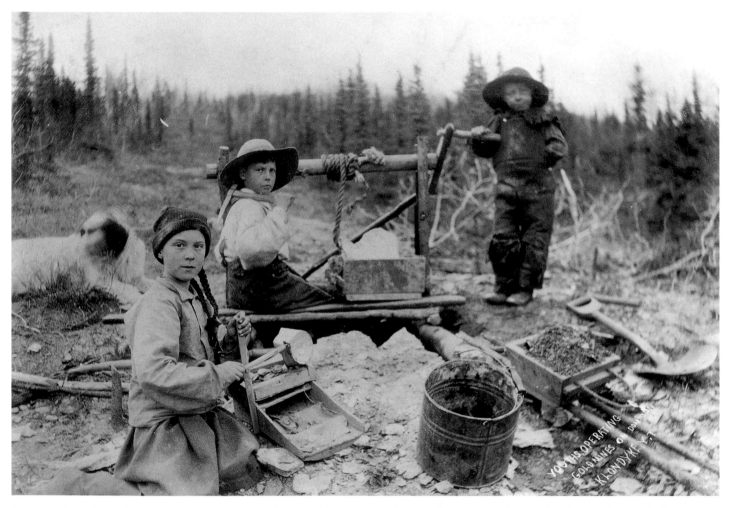

Children operate the rocker at a mine on Dominion Creek in the Yukon Territory in 1898. In all of America's gold rushes, children worked beside adults. ERIC A. HEGG

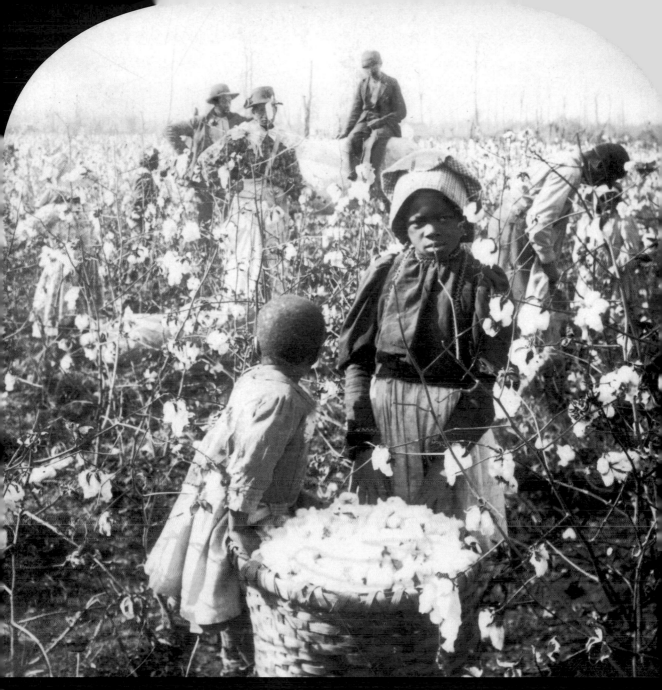

This girl was photographed in a cotton field on a Mississippi plantation, ca. 1890. Long after slavery ended in 1863, African American children still lived lives very close to it, including long days of backbreaking labor in the fields.

"Baby June" of the Sawtelles Dramatic Company poses in costume in this turn-of-the-century studio photograph. In music hall and vaudeville, as well as circuses and other forms of traveling entertainment, children were used without restrictions.

Two boys in the costumes of acrobats pose for a studio photographer in Chicago, Illinois, ca. 1890. Orphaned and abandoned children were exploited in "child orchestras," as background dancers and singers for vaudeville performers, and in many other situations where children were considered "cuter" than adults.

Children from the Long Beach Band of Aberdeen, Washington, were photographed in Seattle in 1909. FRANK H. NOWELL

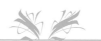

I AM A LITTLE ACTRESS. MY MAMA TRAVELS WITH ME. I AM GOING TO RIDE ALL night. I usually sleep in the top berth, but mama is kindly letting me sleep in the bottom berth this time. For I am going to ask the porter if he will please call me in time to see the sun rise. I have never seen it rise. But am going to try to, for once. I have seen the sun set. . . I am playing with *East Lynne*, and am playing the part of "Little Wille." I expect to be an actress when I grow up.

Lillian Ross, age eleven, in St. Nicholas *magazine, February 1909*

This group of breaker boys was photographed outside the Ewen Breaker in South Pittston, Pennsylvania, on January 10, 1911. Lewis Hine wrote this about the boys' work: "The dust was so dense at times as to obscure the view. This dust penetrated the utmost recesses of the boys' lungs. A kind of slave-driver sometimes stands over the boys, prodding or kicking them into obedience."

AT THE AGE OF EIGHT, I LEFT SCHOOL AND WAS given a job in the mines. I found it pretty hard getting out of bed at five-thirty every morning. The first two months, the road to work wasn't bad, but with the coming of snow, I found that I was much too small to make my way to work alone. Many times I was forced to wait by the side of the road for an older man to help me through the snow. Often I was lifted to the shoulders of some fellow miner and carried right to the colliery.

Anonymous miner

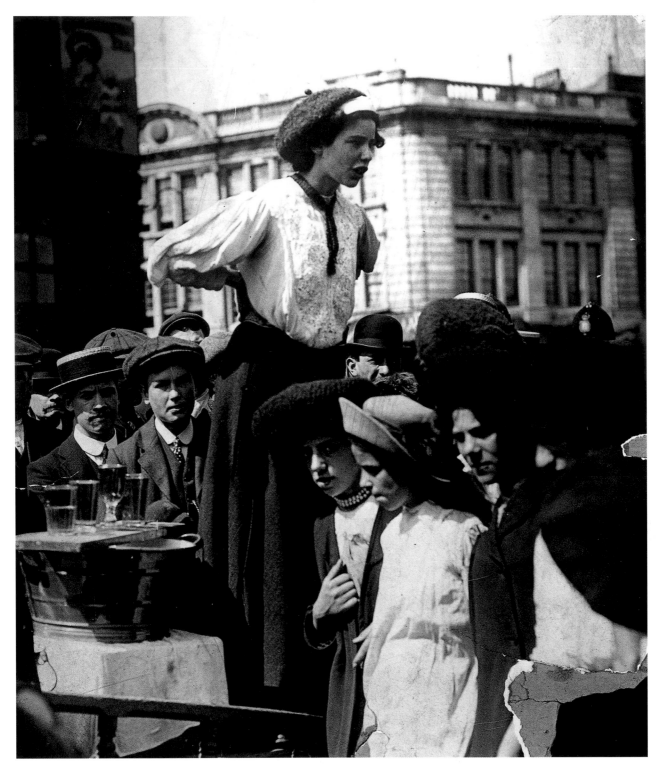

A teenage girl makes a speech in Chicago at the turn of the century. Whether as organizers, strikers, or recipients of retribution, children of all ages were involved in the labor movement.

IN THIS SHOP THERE IS A FOREMAN WHO IS AN EXPLOITER, AND HE SETS prices on the work. He figures it out so that the wages are very low, he insults and reviles the workers, he fires them and then takes them back. And worse than all of this, in spite of the fact that he has a wife and several children, he often allows himself to "have fun" with some of the working girls. It was my bad luck to be one of the girls that he tried to make advances to. And woe to any girl who doesn't willingly accept them.

Though my few hard-earned dollars mean a lot to my family of eight souls, I didn't want to accept the foreman's vulgar advances. He started to pick on me, said my work was no good, and when I proved to him he was wrong, he started to shout at me in the vilest language. He insulted me in Yiddish and then in English, so the American workers could understand too. Then, as if the Devil were after me, I ran home.

I am left without a job. Can you imagine my circumstances and that of my parents who depend on my earnings?

From a letter to the Jewish Daily Forward, *from a Russian Polish immigrant girl of seventeen*

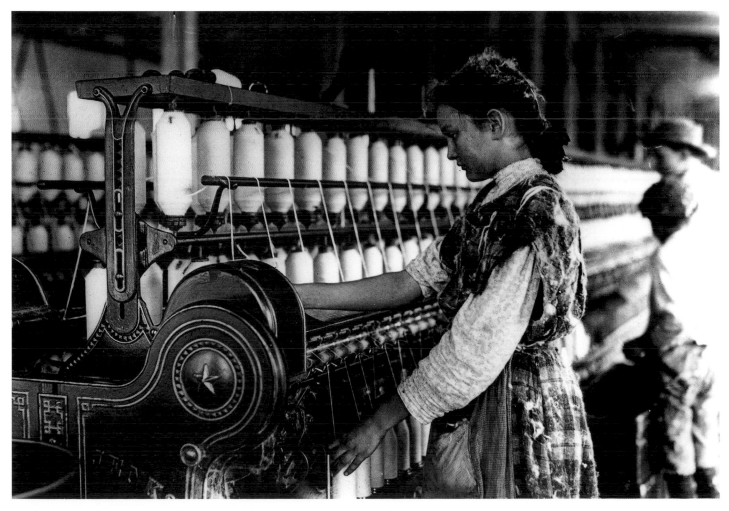

A spinner in the Vivian Cotton Mills in Cherryville, North Carolina, had already been working there for two years when this photograph was taken on November 10, 1908. LEWIS HINE

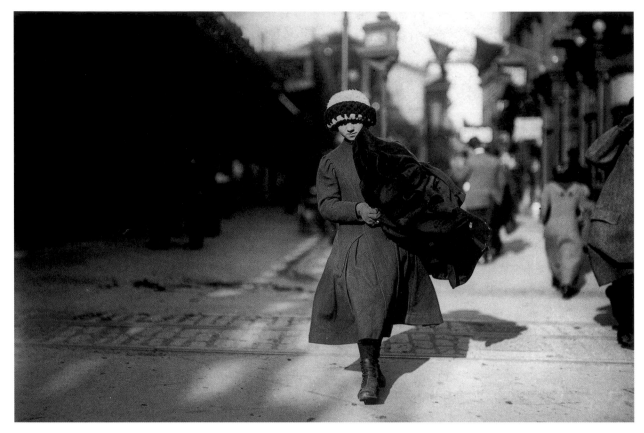

A girl in New York City carries a bundle of coats home to be finished on February 10, 1912. The garment trade was an enormous employer of children—as it still is today—whether in sweatshops or as homeworkers. LEWIS HINE

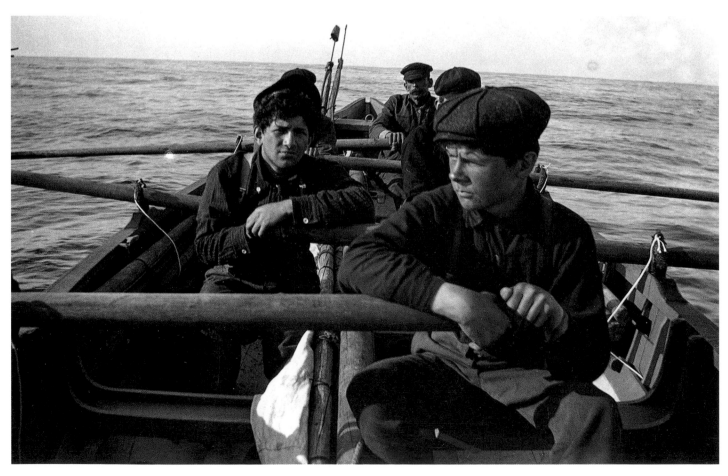

A whaleboat crew from the ship John R. Manta *was photographed in 1906.* A. C. CHURCH

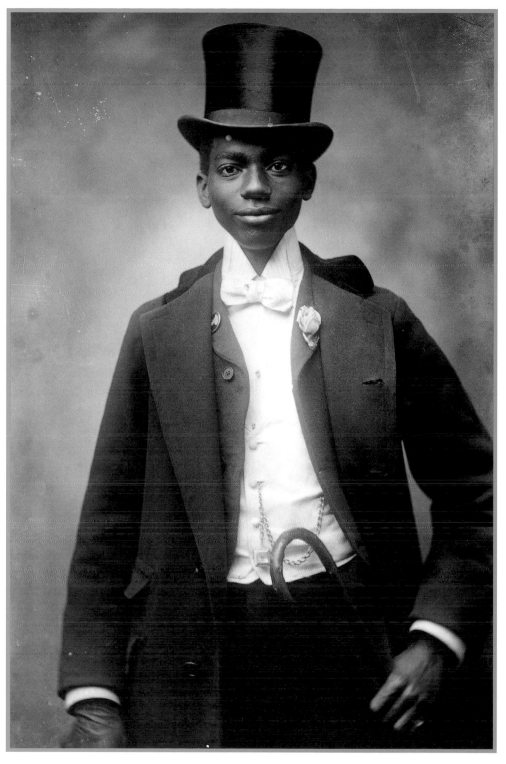

The boy in the photograph is identified as "Mr. Cook's Errand Boy." It was taken in about 1900 by either Huestis or George Cook, Richmond, Virginia, photographers.

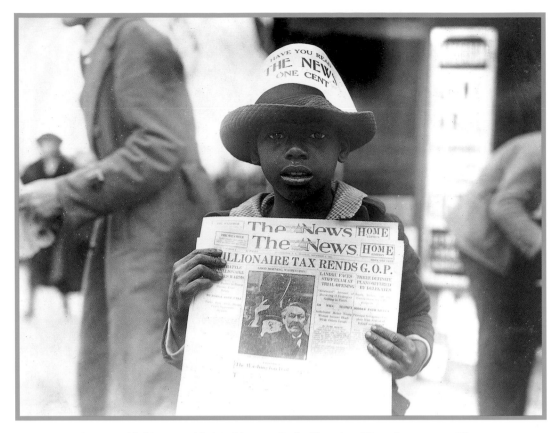

A young newsie poses with his papers (the Washington Daily News*) on November 8, 1921. The paper attached to his hat reads, "Have You Read the News?"*

This photograph of Chinese girls in San Francisco at the turn of the century was captioned "Rescued slave girls." No more information is given on who rescued them or where they were rescued from. Many Chinese slave girls were prostitutes, as were many street children, both boys and girls. The Children's Aid Society refused to help children who were known to have already prostituted themselves because they would taint the other "innocent" children who were in the Society's care. ARNOLD GENTHE

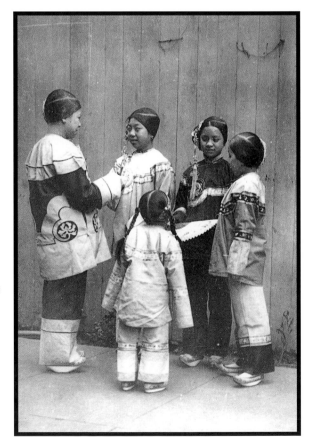

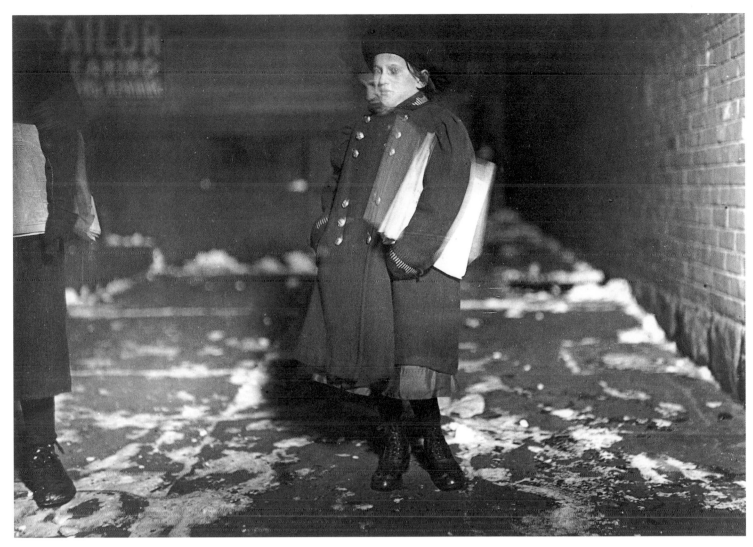

A nine-year-old girl who sold newspapers at night in Hartford, Connecticut, had been selling for two years when this photograph was taken on March 3, 1909. Lewis Hine noted that "she sold later than 8 P.M. sometimes."

THEY'D START YOU WATCHING YOUNG ONES AND GETTING WATER from the spring. That's on the day you stood up! By four you'd be doing feeding and a little field work, and you'd always be minding somebody. By six, you'd be doing small pieces in a tub every wash day and you'd bring all the clear water for the rinsing clothes. By eight you'd be able to mind children, do cooking, and wash. If you wasn't trained full by ten—you was thought to be slow. Still, even if you was slow, you had to do!

Pernella Ross, speaking of growing up on a tenant farm in North Carolina

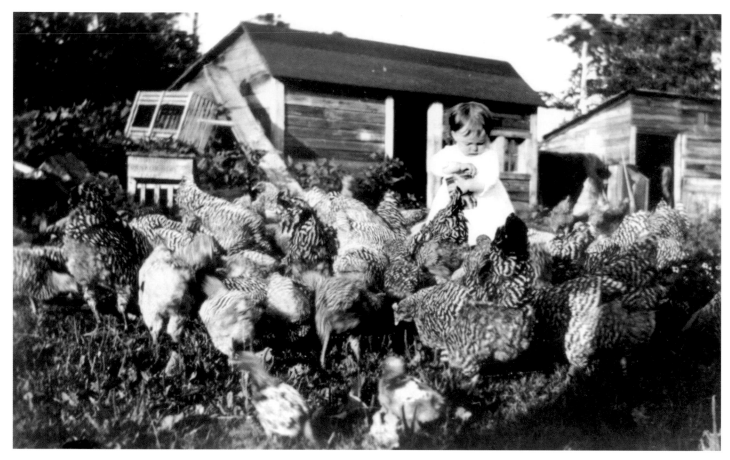

Vida feeds the chickens, sometime between 1900 and 1920. Even if not employed in full-time work, children began helping around the house and doing chores early, whether on the farm or in the city.

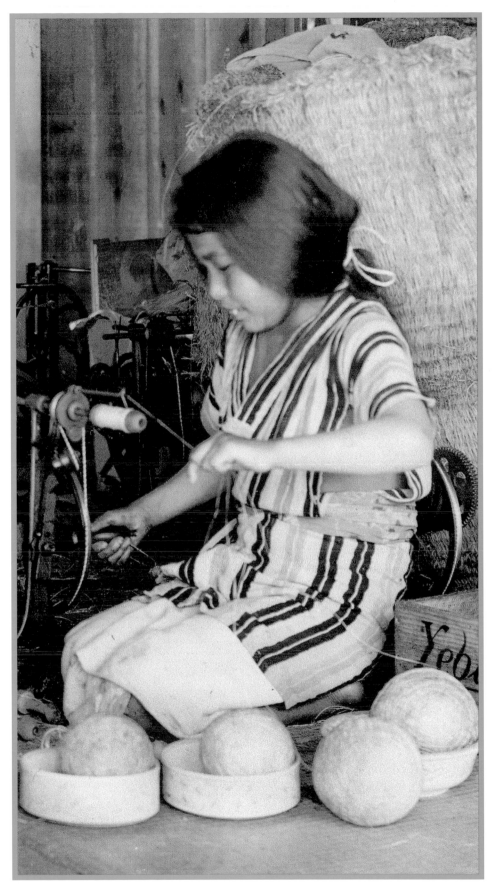

A Japanese girl in California makes balls of yarn, ca. 1920.

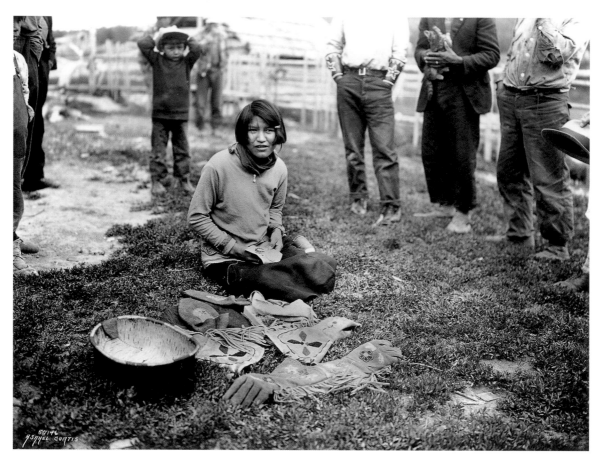

Ten-year-old Mary Ann Yacinth of the Athapascan tribe in Alaska beads gloves in 1930. ASAHEL CURTIS

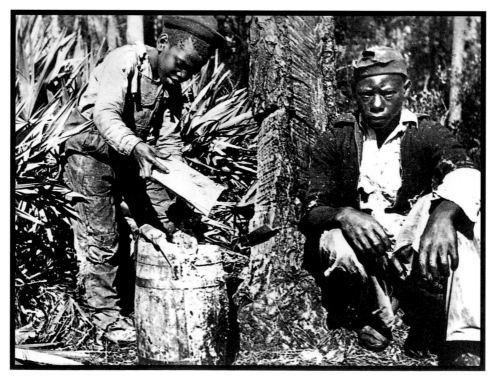

These boys, aged eleven and fifteen, were turpentine dippers in Georgia in 1936.

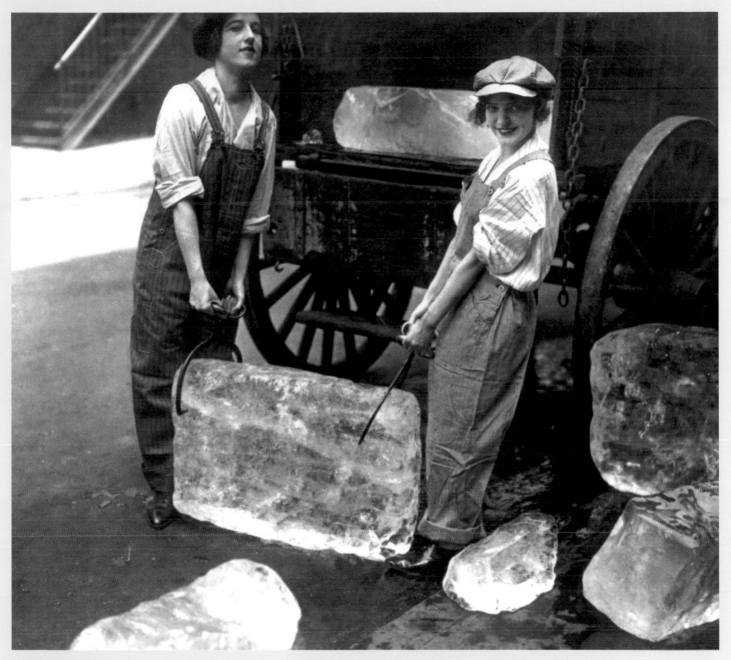

The original caption to this 1918 photograph reads: "Girls deliver ice. Heavy work that formerly belonged to men is now being done by girls. The ice girls are delivering ice on a route and their work requires brawn as well as the patriotic ambition to help."

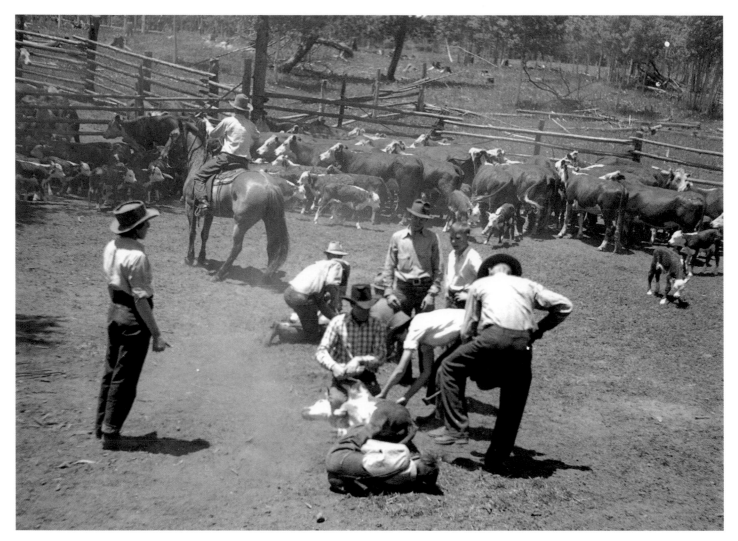

Boys help with branding cattle, probably at the Green Ranch northeast of Blackhawk in Gilpin County, Colorado, June 1940. DONALD KEMP

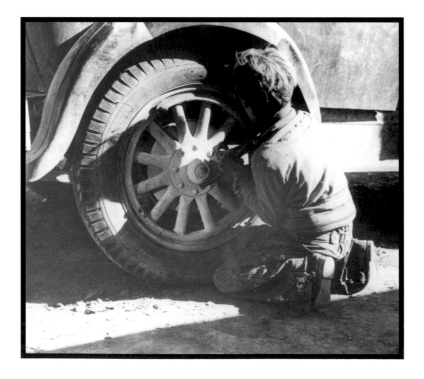

In November 1940, south of Eloy, in Pinal County, Arizona, Dorothea Lange photographed this ten-year-old migratory Mexican cotton picker changing the tire of the family car. She wrote: "He was born in Tucson. He is fixing the family car. He does not go to school now, but when he did go was in grade 1-A. Says (in Spanish) 'I do not go to school because my father wishes my aid in picking cotton.' On preceding day he picked 25 pounds of Pima cotton."

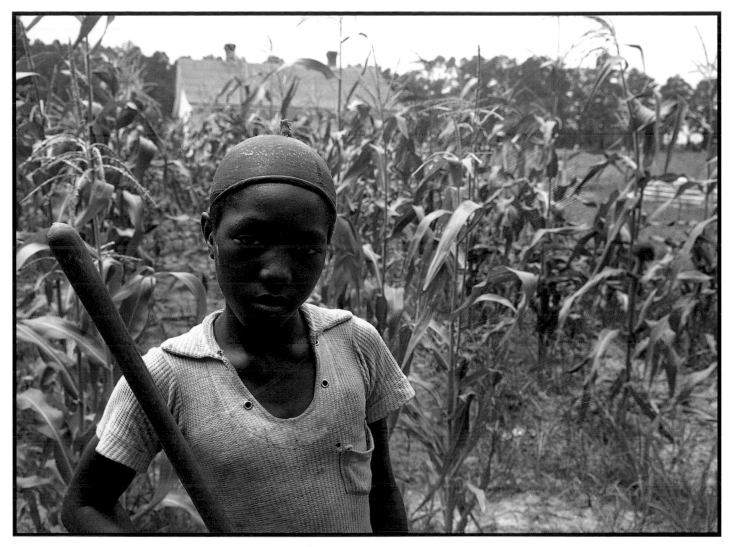

One of Harry Handy's children works in the household's garden in Scotland, Maryland, in August 1940. JACK DELANO

These boys were being trained, in 1936, in Arizona as "household workers" by the Works Progress Administration.

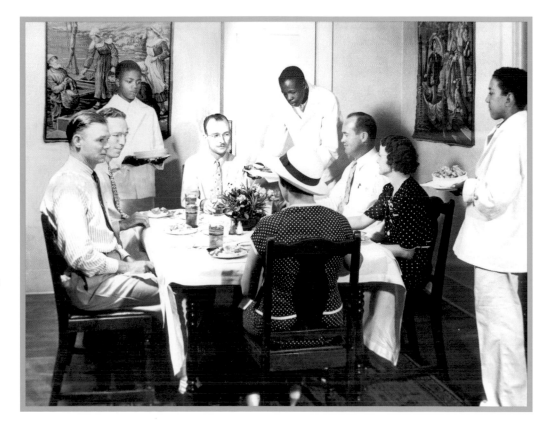

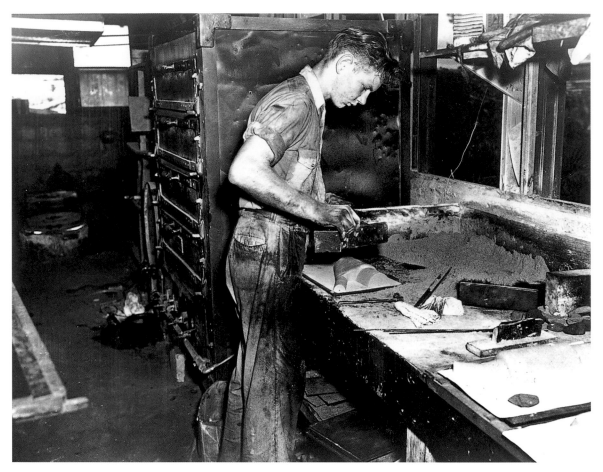

A teenager works in a print shop in 1947.

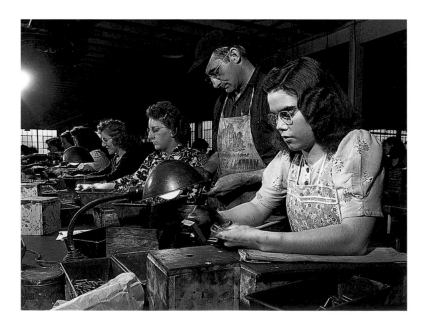

In Lititz, Pennsylvania, in November 1942, sixteen-year-old Josephine Young inspects bullets at the Animal Trap Company of America. MARJORY COLLINS

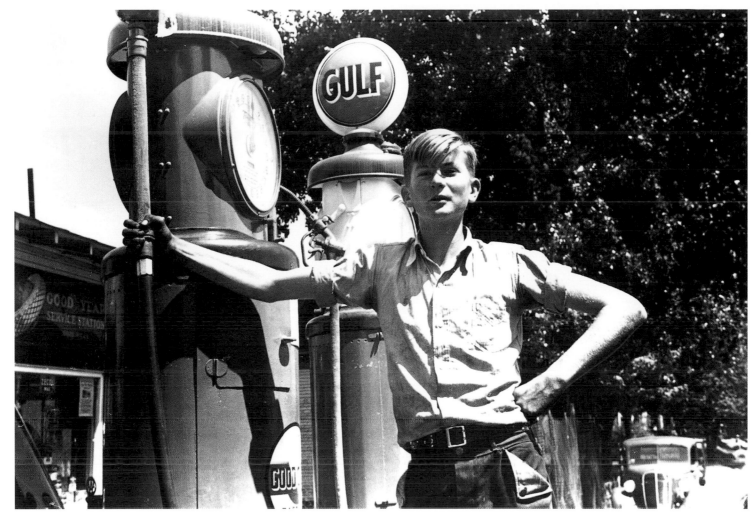

A young gas station attendant poses by the pumps in this National Youth Administration photograph, 1930s.

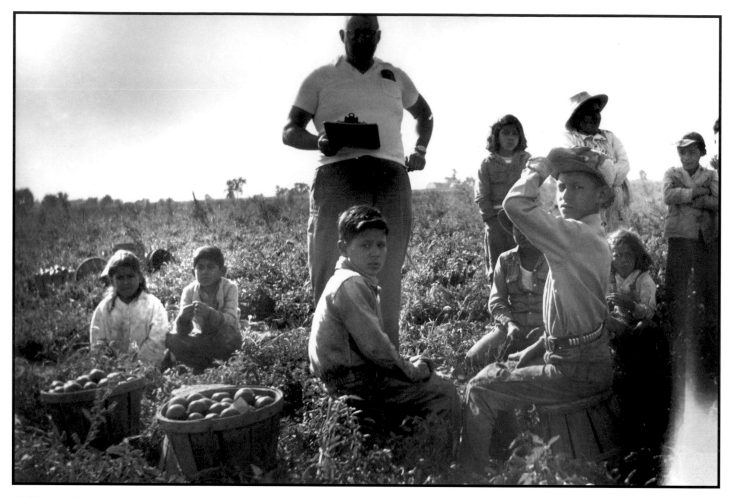

Children working in a tomato field on the Jack Gallant Farm in Michigan in 1952 are visited by a child labor inspector. The inspection report included these details: there were 14 minors of 37 workers and two of the minors were under the age of six "and therefore not required to go to school."

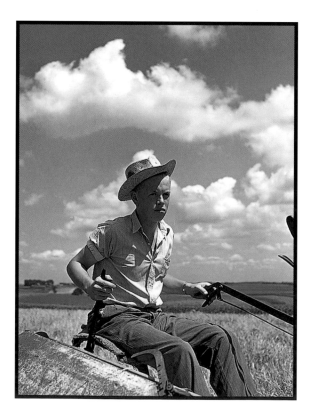

In Vernon County, Wisconsin, in 1942, Robert Saugstad runs the binder during the wheat harvest. A Child Labor Branch caption of this photograph reads: "A boy of this age should not be working on a binder, a dangerous job, but wheat is cut in the summer when school is out and no law protects him." ARTHUR ROTHSTEIN

AT FOUR YEARS OLD MY PARENTS BROUGHT me to Matamoros so we would be closer to the border. Our family tradition, and the way we were able to make ends meet, was for my brothers, my father, and my mother to go to the United States to earn the money we lived on. . . . We mostly picked cotton, in Brownsville and Matamoros, but in Matamoros they only paid twenty centavos a pound and on this side they paid twenty cents a pound. It was much more. When we were sent back by Immigration we had to work in Matamoros, but whenever we had another opportunity we would come back.

Ventura Gomez, speaking of her experience in the 1960s

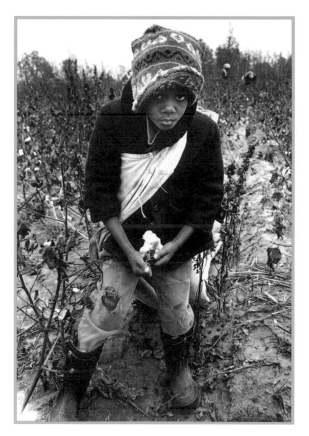

A child picks cotton in the South sometime during the 1960s or 1970s.

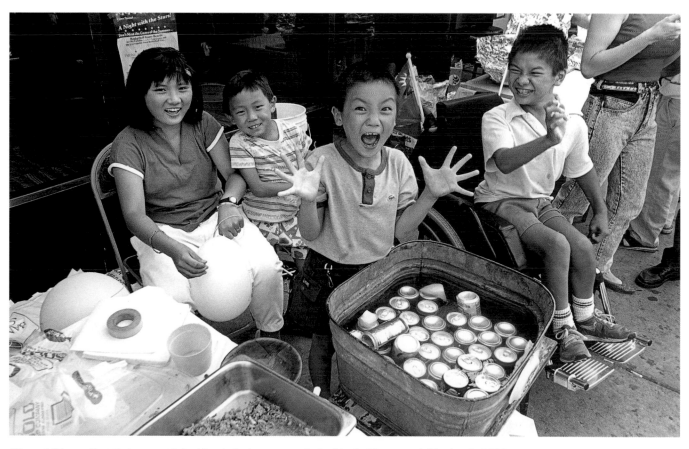

These children sell at their parents' food booth during a street festival in the Uptown neighborhood of Chicago. © JIM NEWBERRY

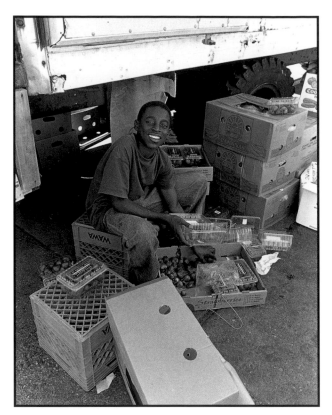

John, a recent immigrant from Africa, bags vegetables for a fruit truck in 1999. © VERA VIDITZ-WARD. ALL RIGHTS RESERVED.

Seventeen-year-old Jolanta Pasko works at a McDonalds on Milwaukee Avenue in Chicago. Two-thirds of American high school students are employed. Before 1950, fewer than one in twenty had school-year jobs. EUNICE HUNDSETH

Mary Bundy helps out by washing the family car in Shaker Heights, Ohio, in 2000.
ANN TOFFLEMIRE

Teenage workers in the corn fields of Illinois take a break in the bus during the summer of 2000. In 1998, twenty-six states had ten or fewer compliance officers, responsible for enforcing labor laws in the state, including child labor laws. NADIA OEHLENSON

COMFORT AND CARING

One girl comforts another at Wells Memorial Settlement House in Minneapolis in 1925.

Lulu Todi and Sara Adams at the Hupa Indian School in California in 1907. This was an "ethnographic portrait" of the girls. In the original caption, numbers that referred to a series of body measurements were included in parentheses next to the girls' names.

ALFRED L. KROEBER

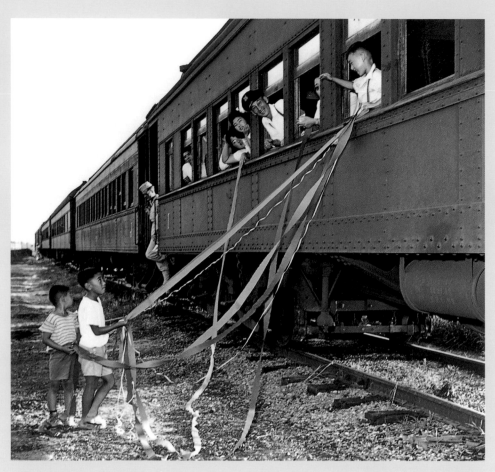

Boys say good-bye to each other at the closing of the Jerome Relocation Center in Denson, Arkansas, on June 19, 1944. They will hold on to the streamers while the trains pull away, maintaining their good-bye handshake until the tape breaks. CHARLES E. MACE

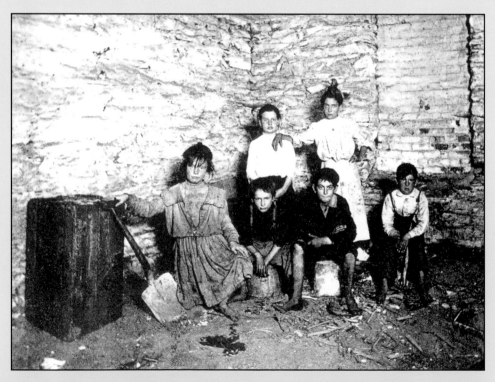

This rare photograph is taken from John Spargo's book The Bitter Cry of the Children, *published in 1906. No print or negative is known to exist. These children were illegally employed in New York City at the turn of the century. They lived in the cellar pictured in the photograph and were never allowed to go outside. They were found by settlement workers.*

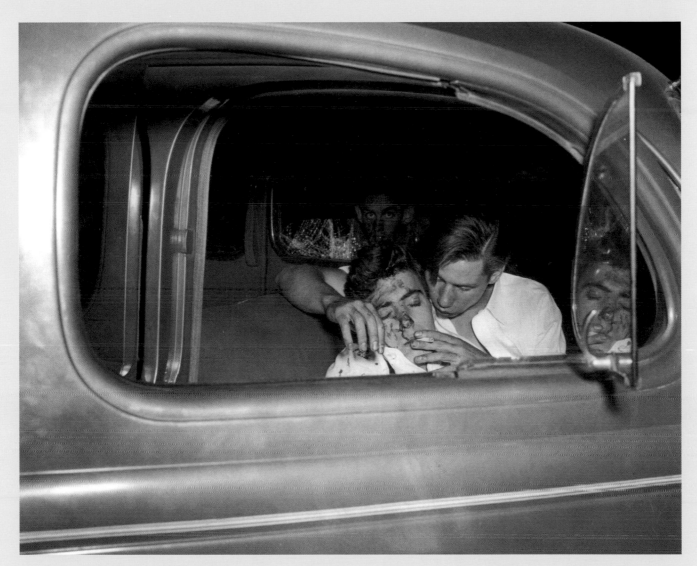

Comfort is given after the painful end of a joy ride in New York City in the 1950s. WEEGEE

PART FIVE

CHILDREN AND LEARNING

LEARNING IS A CHILD'S MOST IMPORTANT task and most time-consuming activity. Today, we equate learning with formal education in schools, but this is actually a very recent development. In colonial America, the formal education that existed was religious. The first elementary school on the continent was established by Spanish priests in 1523 in Mexico to teach Indian children the basics of Catholicism, as well as reading, writing, and arithmetic. The Puritans taught many children basic reading skills because they believed that Satan held people who didn't have direct access to the Scriptures. Education beyond the basics of religion was based on the perceived need for it. A male apprentice might be taught to write or do basic math because that was needed for his trade. Poor, enslaved, and girl children rarely, if ever, received formal educations.

Despite some earlier attempts, the idea of a public educational system did not begin to become a reality in this country until the middle of the 1800s. At that time, proponents tied their cause to democracy and Protestant morality; by the end of the century, they had established the ideal that American children had the right to a basic, formal education. Catholics, understandably, did not want their children educated in Protestant morality and so began the parochial school system that is still important today.

Of course, education has always reflected not only the ideals of society but also its more painful realities. African American and Asian children were denied equal access to schools. Thousands of Indian children attended boarding schools or mission schools where, in an effort to make them "American," teachers denied them their language, culture, and religion. Schools for minority or poor children were overcrowded, dirty, poorly built, or all three. Discipline was a serious problem, corporal punishment was the norm, and many children attended school for only a few weeks a year.

In 1890, only 203,000 students were enrolled in secondary school. By 1916, that number had increased to 915,000, of whom 259,000 graduated—about 13.8 percent of all 17-year-olds. By 2000, 80 percent of adults in this country had finished high school or earned a GED. As more children stayed in school until their late teens, the purpose of their education came into question. Vocational classes, such as shop and typing, were instituted to train children who would not go on to college. After school hours, work remained an important training ground, and parents still passed on their skills to their sons and daughters, preparing them to take over the farm or the business or the running of a household.

By the second half of the century, with the system firmly established, inequities were increasingly confronted. An 1896 Supreme Court decision had stated that public facilities could be separate for the races, so long as they were equal. In 1954, the Brown *v.* Board of Education court decision clarified that separate could never be equal in education. Title IX, passed in 1972, banned sexual discrimination in the public schools, and in 1975, Congress passed the Education for All Handicapped Children Act. Programs were introduced for gifted children. Children with developmental disabilities were placed in mainstream schools, and early childhood programs began the process of formal education earlier and earlier.

Today, concerns abound that the quality of education has diminished, along with the standards to which children are held. Changes in the educational system have had unintended repercussions. Yet, for all the bad news, more children from a larger variety of backgrounds are being educated to a more advanced level than ever before.

In this section, there is a striking example of the significance of the source of an image. From the 1880s through the 1910s, photographs of American Indians were very popular. Some were openly racist and demeaning, while others were meant to be romantic and exotic, and yet others were anthropological attempts to record the "dying race." We have chosen to feature a portion of a ledger painting that is also a winter count, created by Baptiste Good, a Brule, or Sichangu, Lakota. This genre of painting was done on pages from ledger books, by Native Americans who executed traditional tribal art forms on materials acquired from white culture, often while prisoners of war. The departure of children from the reservation to a white school shows the significance of the event to the tribe, undiluted by white perceptions of it. We have flanked the ledger painting with two photographs by unknown, probably white photographers. In one, girls are participating in traditional tribal play that teaches girls about setting up a camp. In the other, a group of children pose a day after their arrival at an Indian school. Like *Winter Count*, this photograph was created as an historic record. It is an "after" photograph depicting the beginning of the "civilizing" effort: hair cut off and uniforms put on. Looking at this photograph today, the children seem unbearably sad and what is being recorded so proudly, simply wrong.

Daily on some fond page to look

Lay nearer sports aside

And let thy needle and thy book

Thy youthful hours divide

Ede Prescott, 1820, Vermont, lines from a sampler

A child learns to read "at her mother's knee" in Amsterdam, New York, in this watercolor sketch by the Baroness Hyde de Neuville in 1808. Until the middle of the 19th century, most children learned at home, not in a formal school situation.

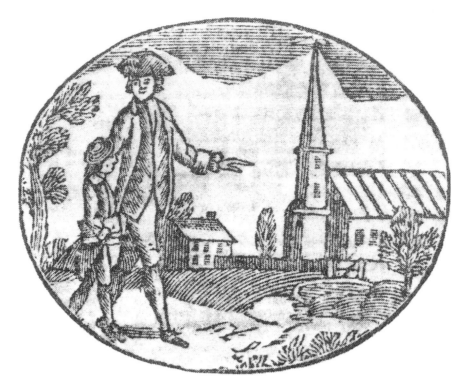

In the New England colonies, some upper-class boys did have an advanced education, particularly to train them for the clergy. Boys (but never girls) went to college by the age of twelve.

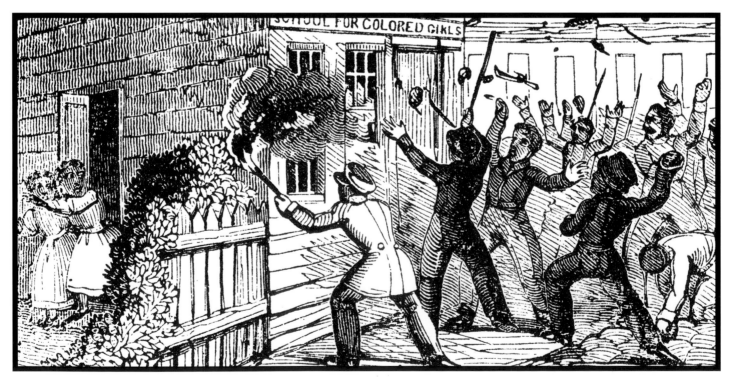

In 1833, the citizens of Canterbury, Connecticut, burned down a school for black girls founded by white teacher Prudence Crandall. A caption accompanying this engraving in the Anti-Slavery Almanac of 1839 read: "When schools have been established for colored scholars, the law-makers and the mob have combined to destroy them;—as at Canterbury, Conn., at Canaan, N.H., August 10, 1835, at Zanesville and Brown Co., Ohio, in 1836." Black children faced terrible obstacles to education, as the white population rightly feared that educated African Americans would not accept their assigned position in society.

These girls are going with their teacher "into the forests and on top of the hills to gather the very precious fruit, called Pitahaya." They were painted at the Mission of California by the Jesuit priest Ignacio Tirsch in 1767.

I WAS FIRST OFF MY HORSE. WATCHING THE BULL, I SLIPPED OUT OF SHIRT and leggings, letting them fall where I stood. Naked, with only my bow in my right hand, I stepped away from my clothes, feeling that I might never see them again. I was not quite nine years old.

The bull saw me, a human being afoot! He seemed to know that now he might kill, and he began to paw the ground and bellow as I walked carefully toward him.

Suddenly he stopped pawing and his voice was still. He came to meet me, his eyes green with anger and pain. I saw blood dripping from his side, not red blood now, but mixed with yellow.

I stopped walking and stood still. This seemed to puzzle the bull, and he too stopped in his tracks. We looked at each other, the sun hot on my naked back. . . .

I knew that the men were watching me. I could feel their eyes on my back. I must go on. One step, two steps. The grass was soft and thick under my feet. Three steps. "I am a Crow. I have the heart of a grizzly bear," I said to myself. Three more steps. And then he charged!

A cheer went up out of a cloud of dust. I had struck the bull on the root of his tail! But I was in even greater danger than before.

Two other boys were after the bull now, but in spite of them he turned and came at me. To run was foolish. I stood still, waiting. The bull stopped very near me and bellowed, blowing bloody froth from his nose. . . .

I stepped to my right. Instantly he charged—but I had dodged back to my left, across his way, and I struck him when he passed. This time I ran among the horsemen, with a lump of bloody froth on my breast. I had had enough.

Chief Plenty-Coups, of the Crow tribe, describes how he was taught courage in a trial, set him and his friends by the men of the tribe, against a wounded buffalo.

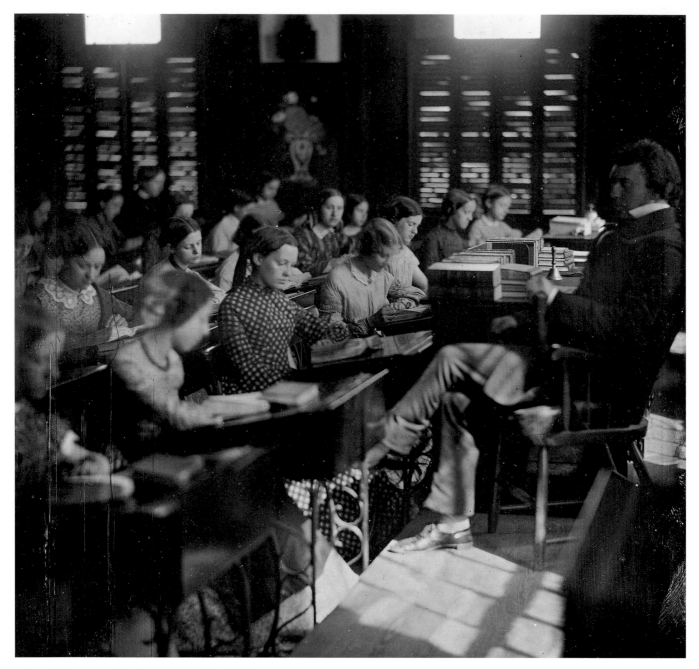

These girls are attending the Emerson School in the 1850s, when private schooling for the upper classes was still the most common type of formal education in the country.

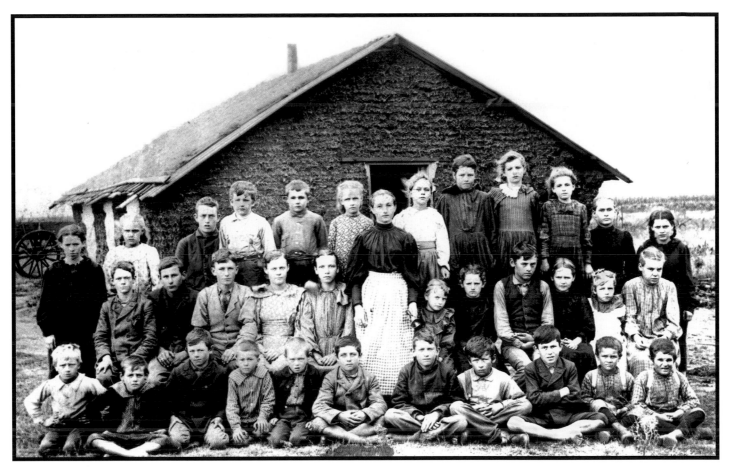

The students standing here in front of their sod school house in Wood County, Oklahoma Territory, in 1895, were homesteaders. Their families were required by homestead laws to live on their "160 acres," so the children traveled some distance every day to get to school. They were taught together in one room by one teacher, regardless of age.

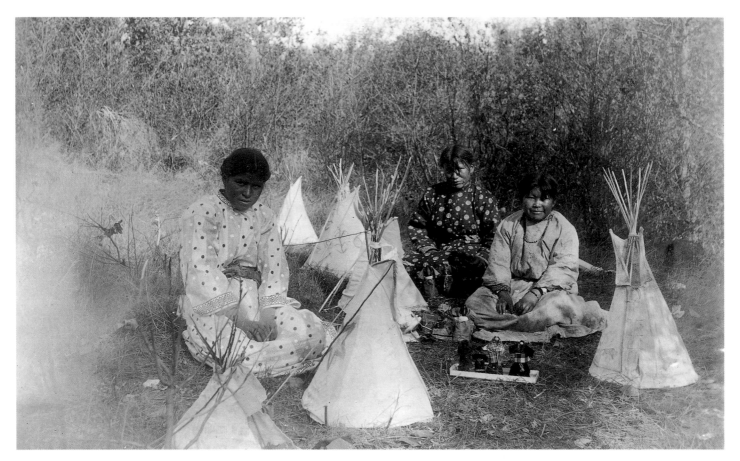

In 1909, near Lame Deer, Montana, these girls learned to set up a camp by playing with small teepees.

"Winter counts" were used by the Sichangu, or Brule, Lakota tribes to record events of significance each year (or "winter"). These memorable incidents included the death of a leader, meteoric disturbances, fights with neighboring peoples, or seasons of plenty and want. This detail, from Winter Count, created by Baptiste Good, notes the departure of eighty-four Brule children from the Rosebud and Pine Ridge Reservations to the Carlyle Indian School in Pennsylvania.

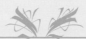

MY NAME AMONG MY OWN PEOPLE WAS "AH-NEN-LA-DE-NI," which in English means "Turning crowd" or "Turns the crowd." But my family had had the name "La France" bestowed on them by the French some generations before my birth, and at the institution my Indian name was discarded, and I was informed that I was henceforth to be known as Daniel La France.

It made me feel as if I had lost myself. I had been proud of myself and my possibilities as "Turns the crowd". . . . Daniel La France to me was a stranger and a nobody with no possibilities.

Ah-nen-la-de-ni, a member of the Mohawk tribe
who was born in New York in 1879

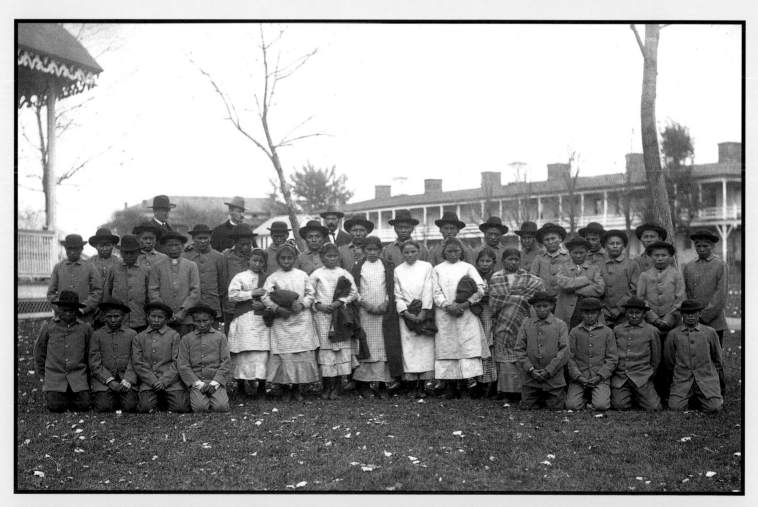

These Chiricahua Apache children were photographed twenty-four hours after arriving at the Carlisle Indian School from the prison at Fort Marion, Florida. Often after arriving at an Indian school, the children had their hair cut or shaved off and were given uniforms. The primary purpose of the many boarding schools set up by the federal government was to "civilize" students, forcing them to give up their language and customs.

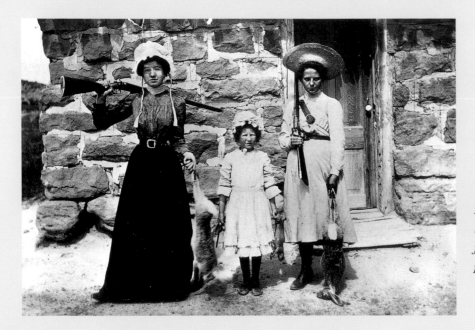

Helen Irving poses with her gopher between Katherine and Frances Roberts, who have scored jackrabbits. A great deal of learning always takes place outside classrooms.

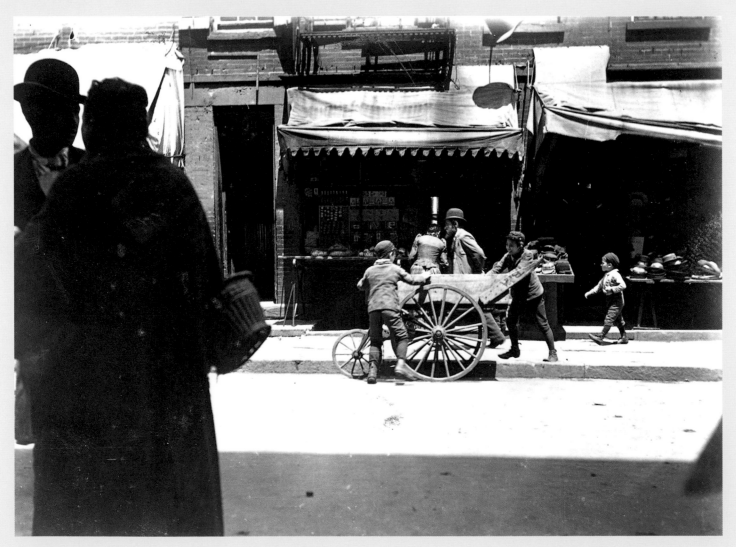

Jacob Riis captioned this photograph, ca. 1890s, "What boys learn on the street playgrounds." The boys were stealing from the pushcart.

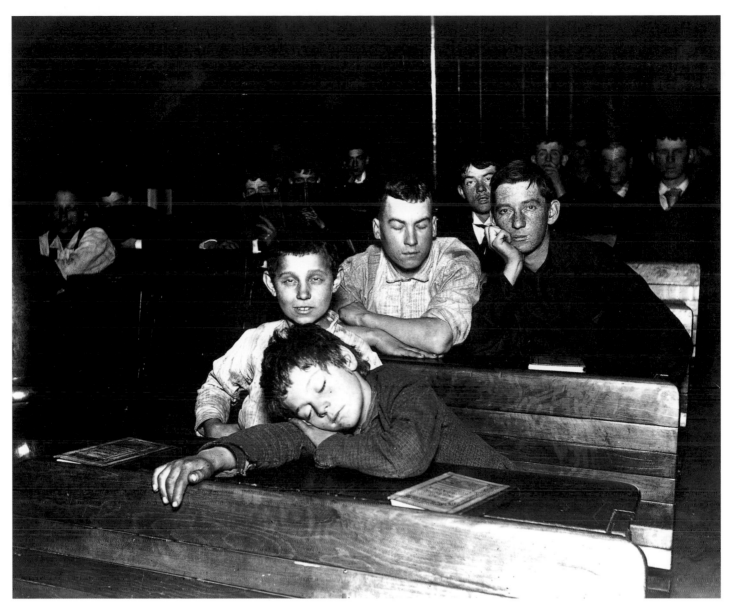

These boys studied at night, after work, in a crowded classroom at the Seventh Avenue Lodging House in New York City. By the 1890s, the idea that all children should have some type of schooling was well established in America. In fact, the child labor movement allied itself with the education movement in order to try to change child labor laws. JACOB RIIS

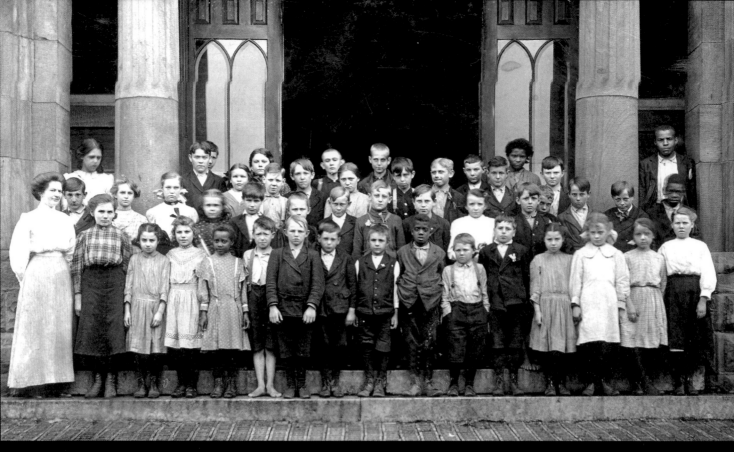

A class from southwestern Ohio poses near the turn of the century. The children represent a variety of ethnic and class backgrounds.

MARCH 25

Went to school. Had declamatory contest. I won in Humorous Reading. A Fudge girl was after me. In Dramatics a Fudge girl won. Also had spellings. Walter, La Verne, then James went down first. I was the 5th to last. I went down on Recipe. Name of my piece was Jimmie Jones Likes Geography. Worked on things in school I stained 3 boards. Couldn't take bikes. I got haircut.

Diary of Robert Bly, age eleven, 1930s

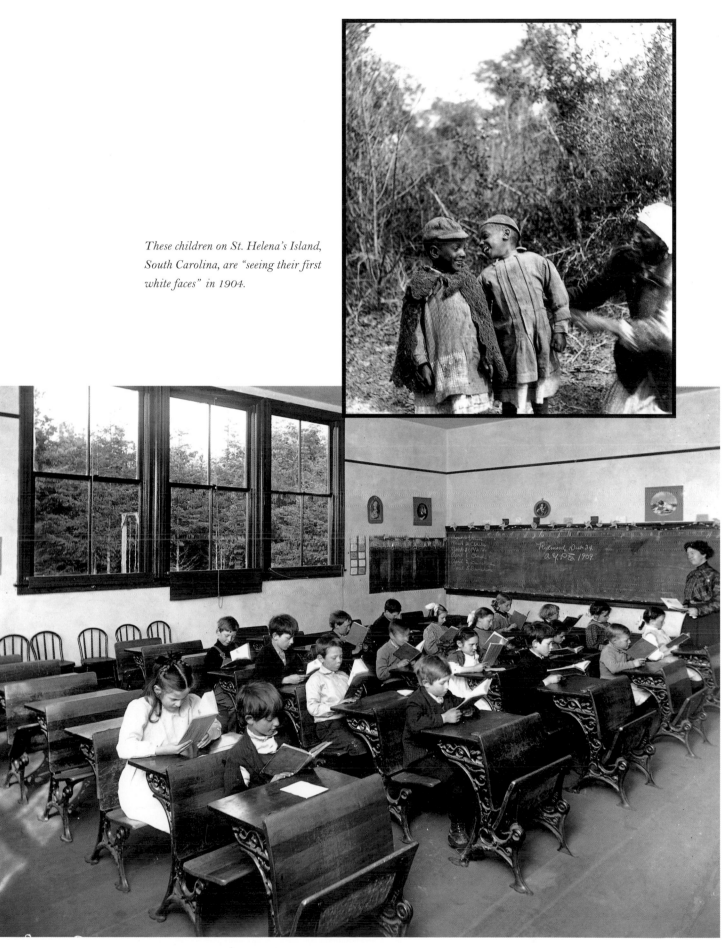

These children on St. Helena's Island, South Carolina, are "seeing their first white faces" in 1904.

Children study in a classroom in Redmond School District 34 in Washington State in 1909.

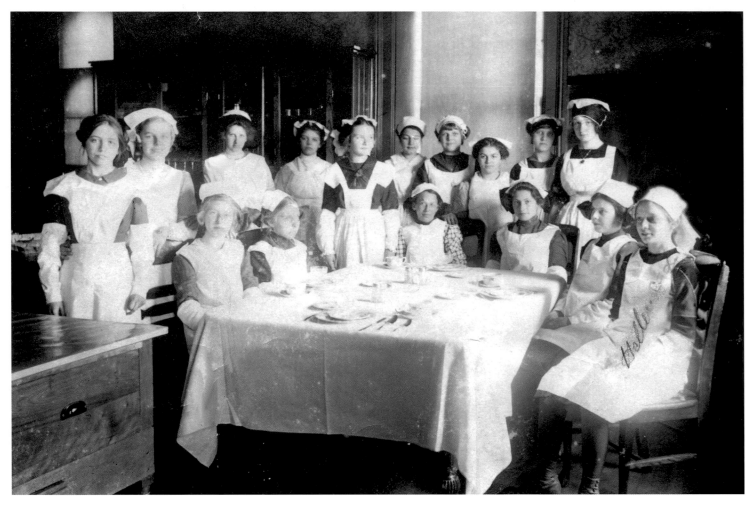

The girls in this class were training to be domestics. Well into the early 20th century, higher education for most children meant training for a trade.

Aunt Grace watches gleefully as Glenn learns about mirrors.

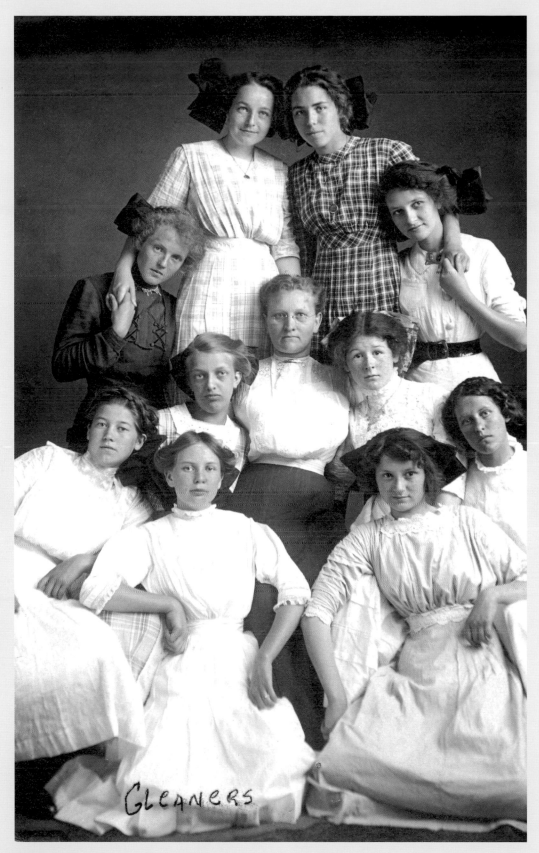

GLEANERS

Religious education remains an important force in the educational life of American children, as it was in 1911 when this portrait of a Bemidji, Minnesota, Methodist Sunday School class was taken.

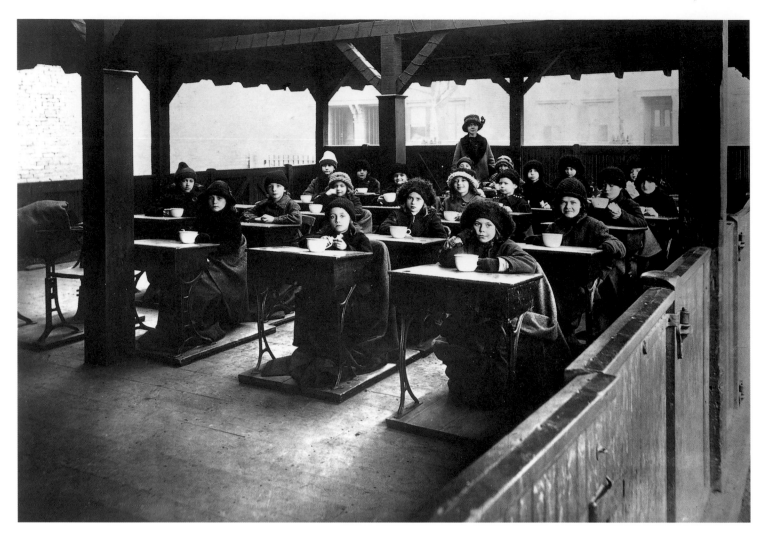

Open-air schools were created for children with tuberculosis. This class was in South Boston, Massachusetts, sometime in the early 20th century.

IN THE OPENING EXERCISES ONE MORNING, THE TEACHER read a selection from the literature book and followed this by a brief talk in which the Jews were designated as "peculiar" people. A number of the pupils discussed the matter in earnest and concluded that even though the teacher knew everything else, she was quite mistaken about them. It hurt to be held up as strange.

Elizabeth Stern, recalling her experience in the early 20th century

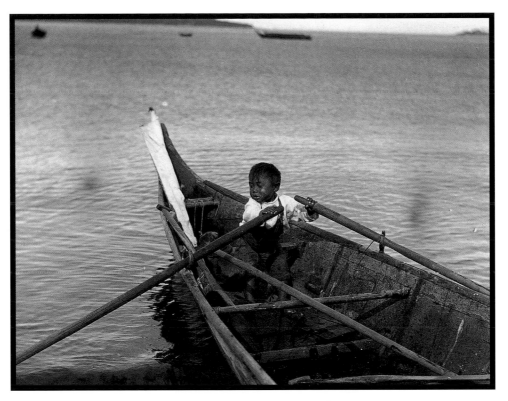

A young Makah boy learns how to row a large cedar canoe on Neah Bay, ca. 1900.

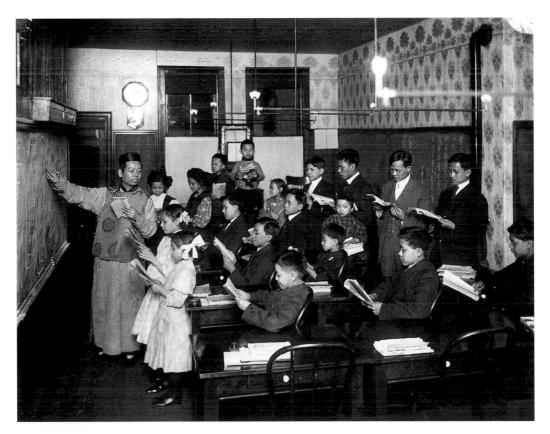

These children are attending a Chinese class in Chicago around 1910. The children of immigrants often attended special classes to learn the language and culture of their parents and grandparents. Many Asian children during this period, particularly on the West Coast, were not allowed entry into the public schools and had to attend either missionary schools or separate public schools.

*A boy's face reflects his attitude in a one-room school in Haskell County, Kansas, 1941.
Irving Rusinow wrote of the schools he photographed there, "People here are much interested
in all their schools, far more than is true in many sections of the country, and it is the general
rule that every non-Mennonite child graduates from high school. Many go to college."*

In Pinal County, Arizona, in November 1941, the children of migratory cotton pickers were picked up at 7:30 A.M. from the Farm Security Administration mobile camp to go to the district school. DOROTHEA LANGE

FIRST GRADE. HAVING THIS SACK LUNCH. OH MY GOD, THIS was the most embarrassing thing during that time. To have your mother give you a tortilla. Oh, my God, how awful. It was terrible. We would have given anything to have Wonder Bread, just to be normal. But no, a tortilla—with chorizo. Of course the red grease would seap through, right? And you'd have this terrible mark on your bag. Oh my God, I hated that. I hated it because you knew you were slime. . . . We put our lunches down row by row. First of all I didn't have a lunch box. God, I would have given anything for a lunch box, but no, a bag, okay. I remember my heart going really fast thinking, Oh my God, are they going to see my lunch bag? I need to go get that thing out of there and turn it around so they won't see the big greasy stain. I remember screaming out at the nun. She let me do it, thank God. It's so vivid in my mind.

Maria Aguirre

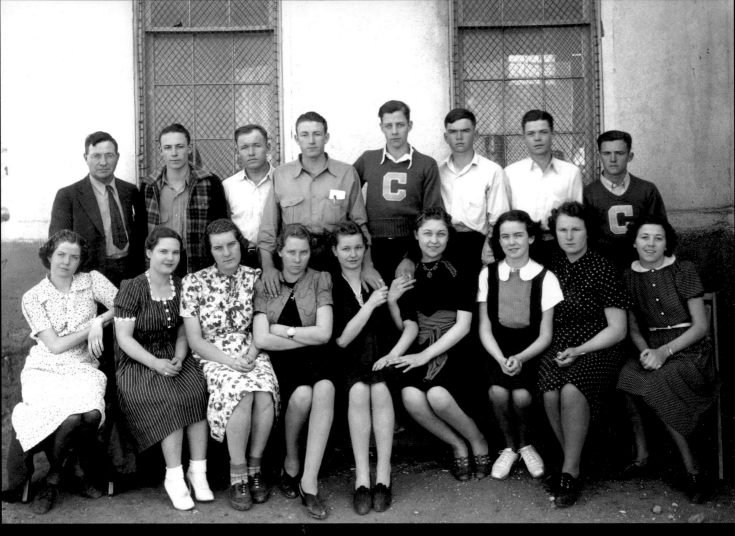

The class of 1939 of Crawford High School, Oklahoma, poses for their graduation picture.

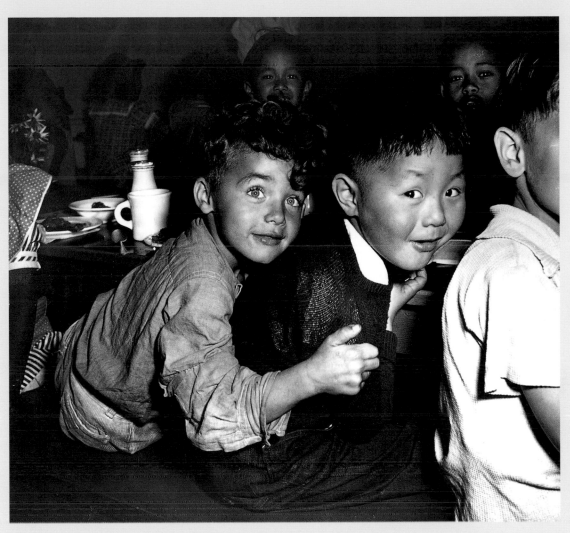

Lunchtime in the cafeteria at the Raphael Weill Public School in San Francisco, California. The Japanese boy was evacuated to a Relocation Center shortly after this photograph was taken in April 1942.

DOROTHEA LANGE

I WILL START OUT MY LETTER BY WRITING ABOUT THE worst thing. I do not want to go away but the government says we all have to go so we have to mind him. It said in the Japanese paper that we have to go east of the Cascade Mountains . . . to Idaho. . . . If I go there I hope I will have a teacher just like you. And rather more I hope that the war will be strighten out very soon so that I would be able to attend Washington school again.

A student of Ella C. Evanson, of Washington Junior
High School in Seattle, March 20, 1942

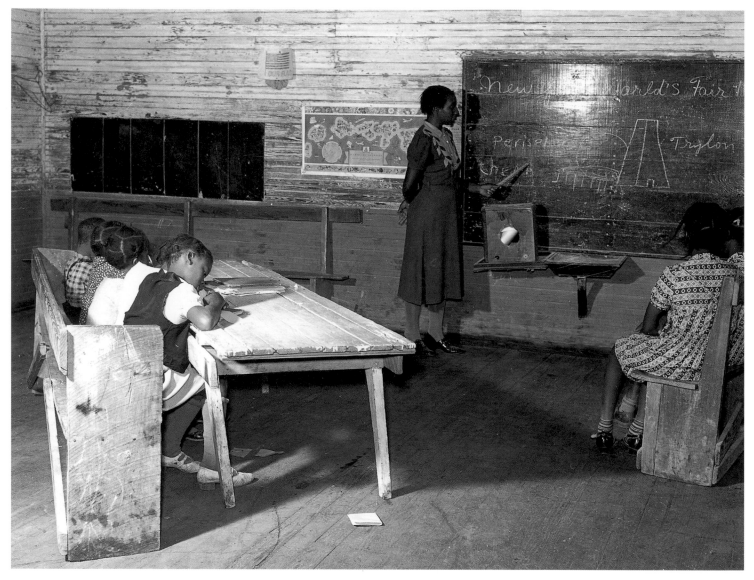

Many schools for black children, particularly in the South, were often dismally lacking in funds and modern improvements. This school on the Mileston Plantation in the Mississippi Delta was photographed in 1939, but schools that looked much the same were used into the 1950s and '60s.

MARION POST WOLCOTT

In this 1959 photograph, Ed Kromberg prepares his project for the Lee High School science fair in Jacksonville, Florida. In the South, white schools received the bulk of a state's education funds.

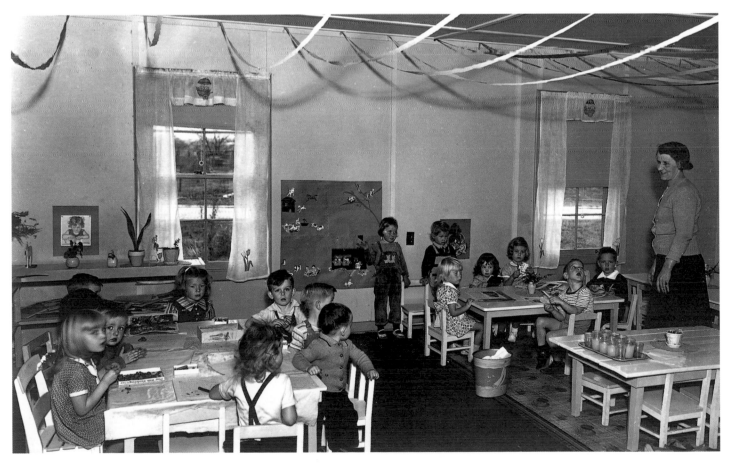

These children are attending a nursery school in Jacksonville, Florida, in 1924. Early childhood education rose in popularity during the 20th century.
JACK SPOTTSWOOD

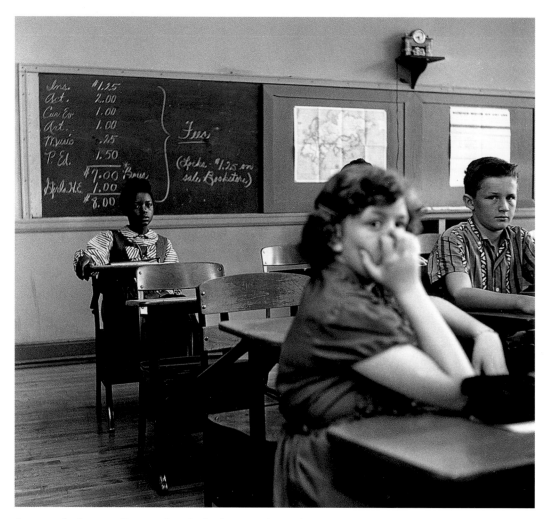

In 1954, the Supreme Court outlawed school segregation in this country (Brown v. the Board of Education). Three years later, on September 4, 1957, Delois Huntley desegregated Alexander Graham Junior High in Charlotte, North Carolina.

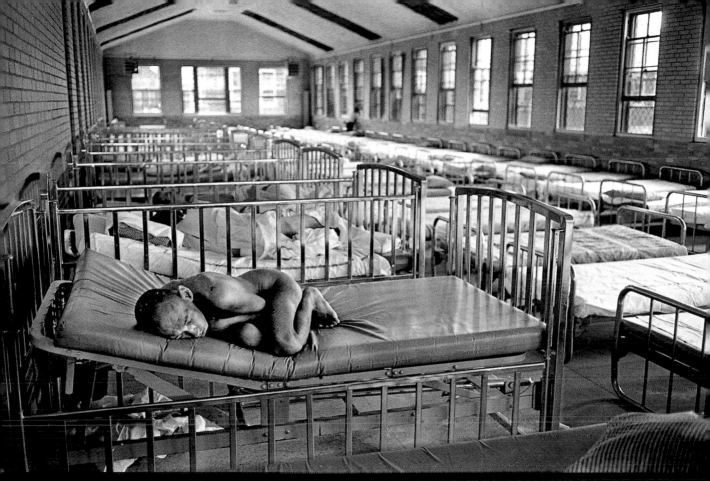

A child lies in bed at the Dixon State Hospital and School for the Retarded in Illinois in 1971. In one ward of the institution, there were four aides to care for 100 children; in another, one aide for 112 children. An aide was quoted for the accompanying Chicago Sun-Times article: "With enough help, we wouldn't have all this. These kids are human beings. . . . they need care—oh, much more care. They can sense when they get more affection, and they can tell when people who are overworked get a little hostile to them." As a result of the Sun-Times article, Illinois decided not to cut the funding for the State Department of Mental Health, which it had scheduled, but to keep it at the same level. This photograph by Jack Dykinga won the Pulitzer Prize

In the 1980s and 1990s many parents, distressed with the state of American schools, decided to homeschool their children. Here, Stephen Rutledge teaches his son Joel about tree rings in the Olympic Peninsula rain forest.
NAN RUTLEDGE

Senior Dwayne Blunt is checked by a security guard with a hand-held metal detector at Collins High School in Chicago. All Collins students pass through metal detectors every morning.
KAREN KRING

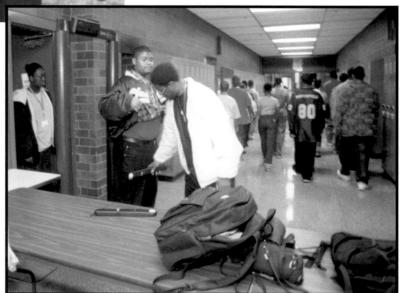

Working mothers and a modern emphasis on early childhood development have spurred the growth of preschool programs for children under the age of five. In Quinault, Washington, Makenzee Rauck on her first day at preschool has fallen asleep on the one thing that smells like home, her diaper bag.

HOLDING STILL (4)

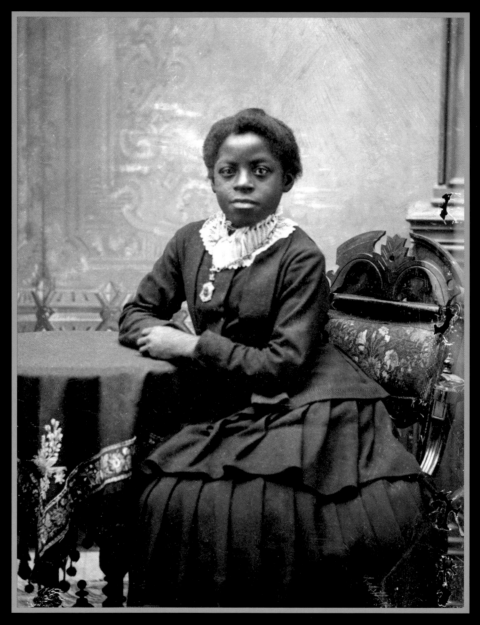

Studio portrait, 1890s.

Stereoview, Underwood and
Underwood, "Comrades," 1894.

Family snapshot, A. Axness, age
thirteen, 1910s.

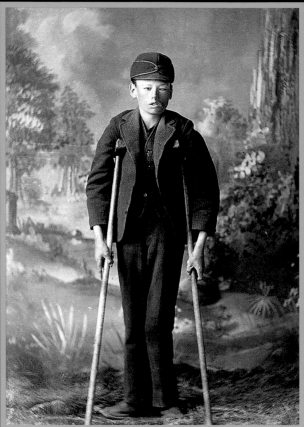

Studio portrait, Artie Post, 1920s.

Children's Bureau photograph, Juan Gasca at work, January 1952. His parents drowned while crossing the Rio Grande into the United States. He was staying with friends until the U.S. authorities decided what to do with him.

Snapshot, Jennifer, age nine, photographed by Carolina, age twelve, Logan Square, Chicago, 2001.

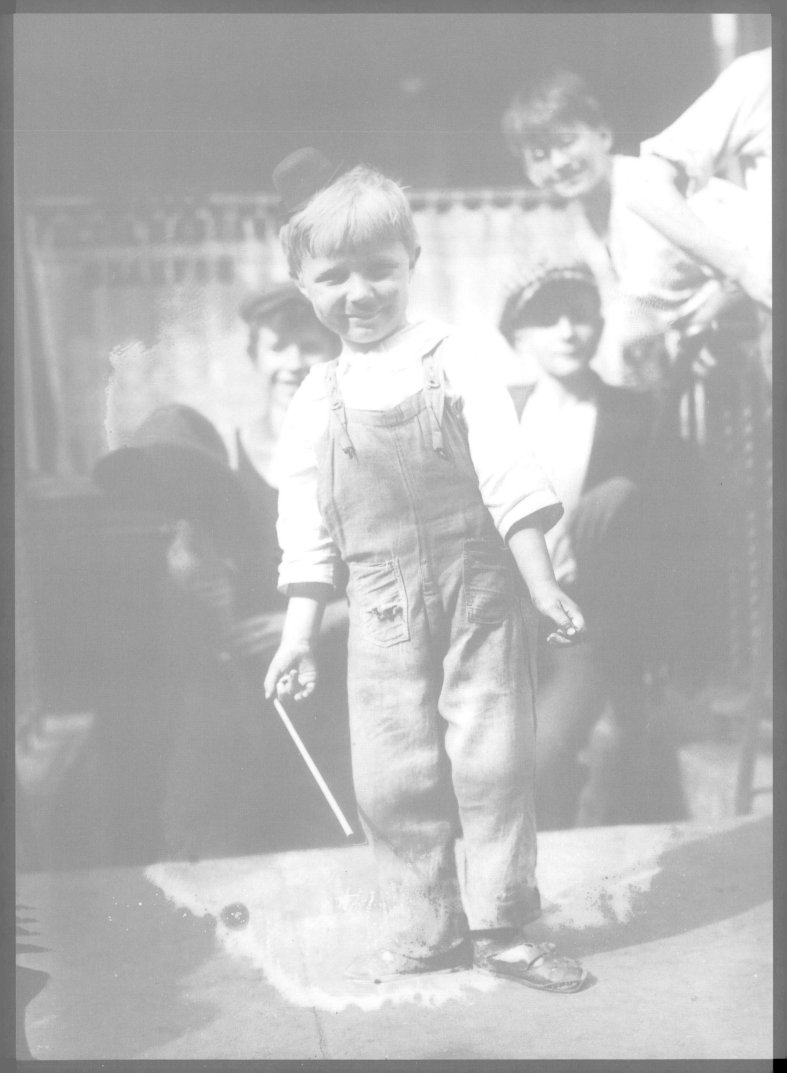

PART SIX

CHILDREN AT PLAY

EVERY PART OF A CHILD IS ENGAGED IN play and, today, we know that playing is a child's job, a way to learn about the world and the people in it. However, we have not always known this. For a long time, childhood was just a time when a person was smaller and couldn't do as much work. Children from all backgrounds participated in adult recreation in a way that might now be considered inappropriate or shocking. Children drank and gambled alongside adults, and adults played what we now consider children's games, such as leapfrog. Both enjoyed games we would recognize, such as tag and marbles, and both flew kites and rolled hoops. Iroquois children have been playing what we now call lacrosse for centuries. African American children were taught the songs, dance, stories, and games of Africa by their elders. Gradually, however, childhood came to be seen as a time of innocence that needed to be prolonged and protected. At least among the educated and affluent, children were segregated from the evils of the adult world. In late colonial and early federal portraits, for instance, a much larger variety of recognizable, child-specific toys began to appear.

It took a century or more for the separation between childhood and adulthood to begin to affect all groups and classes of Americans. And all this time, children played when and as they could. Nippers in coal mines, sitting alone for hours in a dark tunnel, played games with rats. A farm girl talks of counting the times she could skip across a creek while her grandmother milked two cows. City children caught rides on the backs of trucks and played in gutters. Then, in the early twentieth century, to provide for a growing urban middle class, toys began to be mass produced. At the same time, new concepts about childhood development became popular. As a result of all of these factors, children's play began to be designed, examined, and organized by adults. Concern that children were too sedentary sitting in school all day led to the introduction of physical education classes in the schools. As literacy rates rose, reading became a more common activity and children's literature became a huge industry.

Radio and television both had child-centered programming almost as soon as they were invented. Early childhood development theories have led to adult-organized play for younger and younger children. Today, experts debate whether this trend has gone too far. Is play too organized? An April 22, 2001, *Time* magazine article by Walter Kirn with Wendy Cole entitled "Whatever Happened to Play?" reported that in 1981 the average school-age child in the United States spent 60 percent of the day sleeping, eating, attending school, and participating in other organized activities. About 40 percent of the day was "free time." In 1997, free time was down to 25 percent of a child's life.

For children throughout the ages, play has been a form of education, a means of survival, and an introduction into the spiritual world of the community. Yet it is also recreation—just plain fun. And happily, even today, many children haven't forgotten how to invent games, play hopscotch, and climb trees.

Family snapshots form the core of this selection of images. While not professional and certainly not objective, a talented father, mother, cousin, or friend who captures a moment in a child's life provides an immediacy of great value to the visual record of childhood. Sometimes, like a member of the family, a local newspaper photographer can also record children with an intimate knowledge that is unique. There are few better examples of the importance of such photography than Charles "Teenie" Harris, who worked for the *Pittsburgh Courier*, an African American newspaper. If Harris and hundreds of photographers like him hadn't recorded daily life in African American communities all over the United States, little record would exist

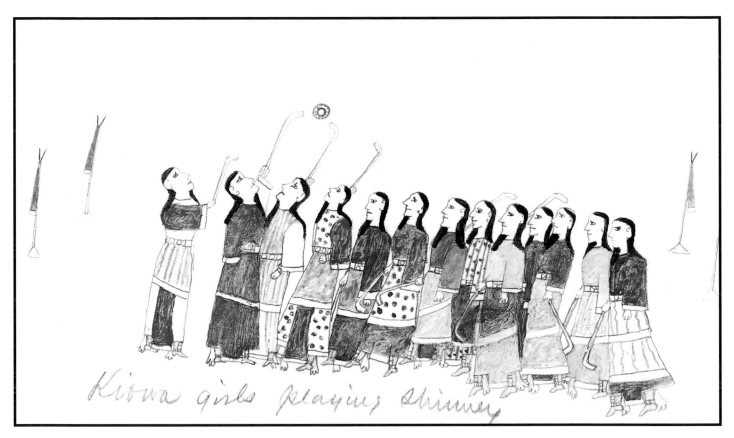

This ledger painting created by an Indian prisoner at Fort Marion, in St. Augustine, Florida, in about 1875 shows Kiowa girls playing a ball game called Shinny, a traditional Kiowa women's game similar to lacrosse.

MY EARLY BOYHOOD [WAS SPENT] IN playing with the other boys and girls, colored and white, in the yard, and occasionally doing such little matters of labor as one of so young years could. I knew no difference between myself and the white children; nor did they seem to know any in turn. . . . When I began to work, I discovered the difference.

Lunsford Lane, The Narrative of Lunsford Lane
(Boston, 1842)

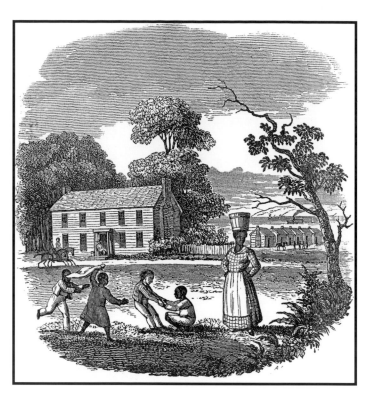

Created in the 1840s, this apparently idyllic scene of plantation life reflected a reality for at least a few enslaved children, who would play alongside plantation owners' children when they were very young. At an early age, however, enslaved children were put to work and the barrier of race and ownership went up. ALEXANDER ANDERSON

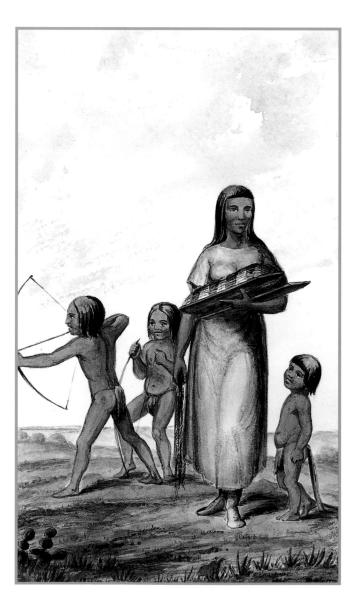

Kiowa children play at the feet of their mother in this 1845 drawing by Lieutenant James W. Abert.

In this engraving from Frank Leslie's Illustrated News *in 1865, three boys drag a dog down the street while a group of people watch men carry a coffin out of a tenement in the Five Points district of New York City.*

THE BOYS THAT I FELL IN COMPANY WITH WOULD STEAL AND swear, and of course I contracted those habits too. I have distinct recollection of stealing up upon houses to tear lead from the chimneys, and then take it privily away to some junk-shop, as they call it; with the proceeds I would buy a ticket for the pit in the Chatham-street Theatre, and something to eat with the remainder.

John Brady, remembering his childhood in Five Points, New York City, in the 1850s

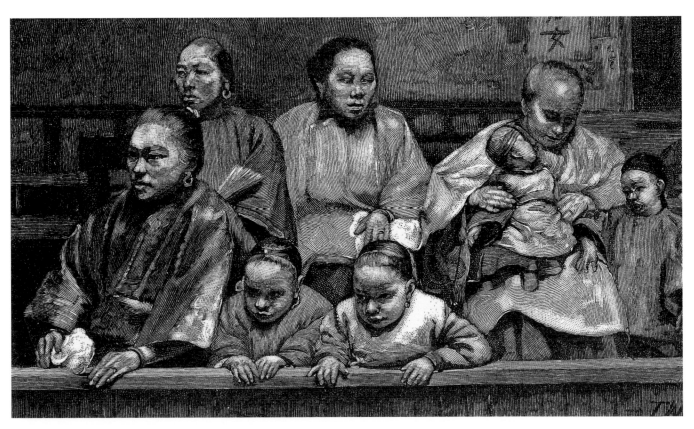

Chinese children and their mothers attending the Chinese opera are pictured in an engraving from an 1884 Century *magazine article. They sit separately from the men.*

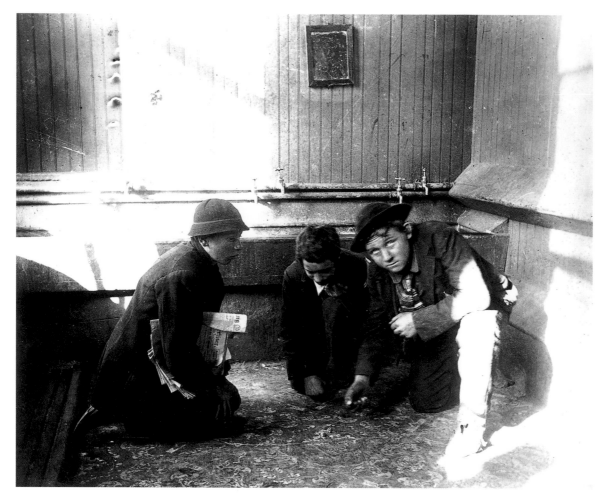

Jacob Riis captured these newsboys playing craps in the hall of their lodging house in the early 1890s. It wasn't until this period that public sentiment about the need for "appropriate play" reached lower-class children.

Young boys play on a cannon, possibly at Castillo de San Marcos, in Saint Augustine, Florida, in 1902. WILLIAM HENRY JACKSON

In this photo captioned, "first Inkster school: built in 1889," children play the eternal circle and ball games and participate in the perennial recess pastime, "hanging out." FRED HULTSTRAND

FEB. 2ND

Friday. At recess, during the game, Annie Phips and I got to fighting, a real wrestling match, and the girls joined hands and formed a ring round us, watching our evolutions with interest, and Mary Fifield called out that *she* bet on me; I suppose she felt justified in doing so, having herself felt some specimens of my strength. Annie Phips pulled me down upon the bank, but she was undermost, and I kept her so, and the girls crowded round and offered me their congratulations, to the huge disgust of A. Phips, who protested that she was the victor. M. Fifield told me she had betted on me, and I crushed her by answering that I did not approve of betting. At cross tag I Crossed Sadie Wilson, with whom I am in love, and of course was caught at once, and she gave me "her warmest gratitude" which I was happy to receive.

Alice Stone Blackwell, fourteen, in 1872

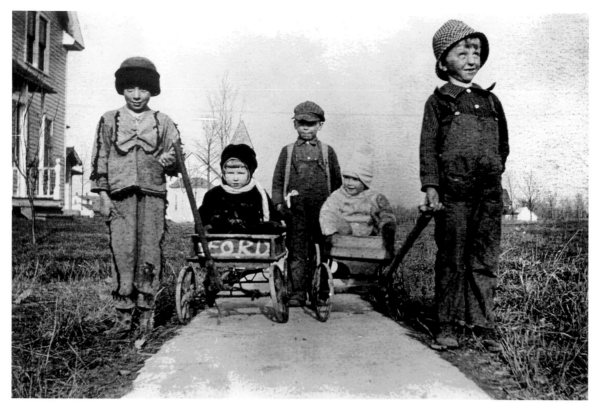

Kids salute the almighty Ford, 1910–1920.

A boy creates his own team of horses at the turn of the century.

Evva and Mary Taft play with their dolls outside their new home in Washington, D.C., ca. 1903. HENRY ARTHUR TAFT

During World War I, Lula plays "Red Cross nurse" with her brother, Vida, in Washington State.

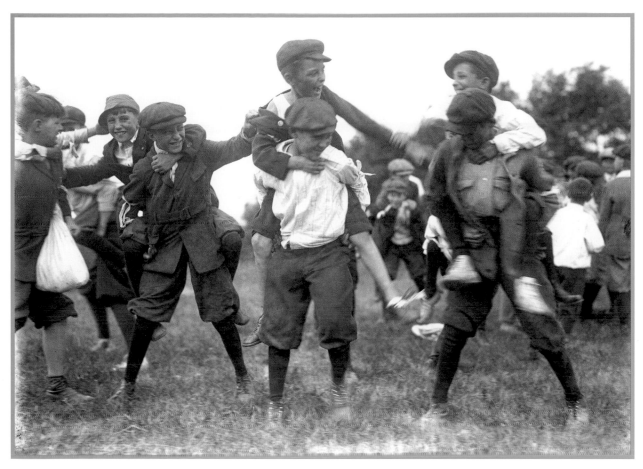

Boys play "Horses and Riders" in Durand-Eastman Park in Rochester, New York, in July 1919. ALBERT R. STONE

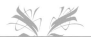

I USED TO HAVE FISTFIGHTS, FOR NO PARTICULARLY GOOD REASON.

Bud, born 1920

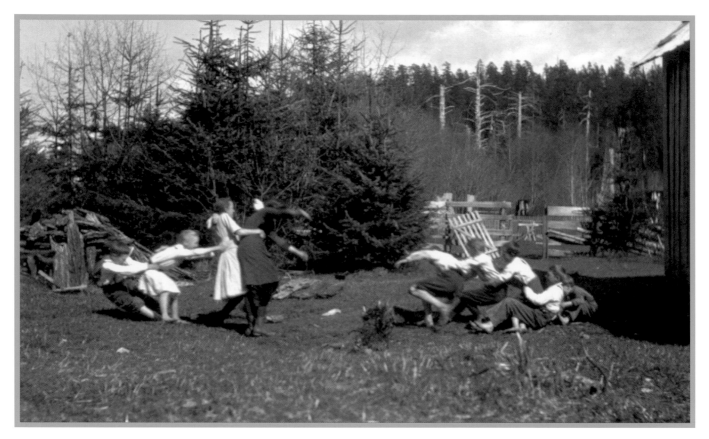

Teacher Doris Huelsdonk snapped a photo at the crucial moment of her students playing tug-o'-war without a rope at the Big Creek School near Quinault, Washington, 1917–1918. The children include the Peterson kids, the Osborn kids, and Roxie Beebe.

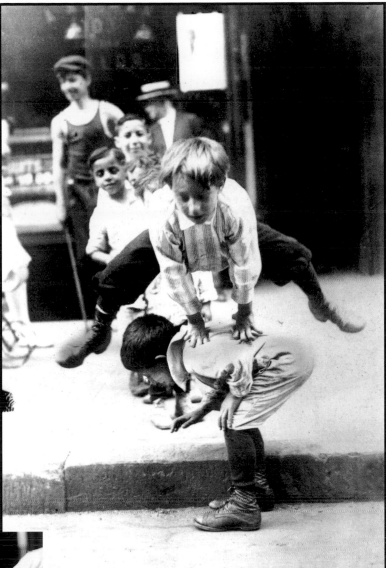

Children play leapfrog on a New York City street, 1908–1915.

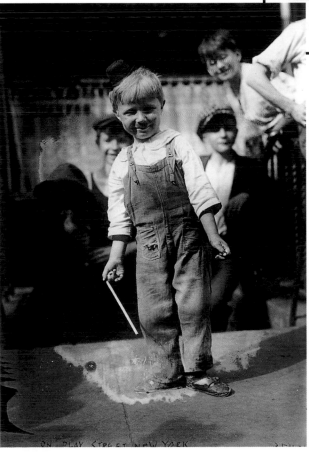

A young boy imitates Charlie Chaplin on a "play street" in New York City, ca. 1915.

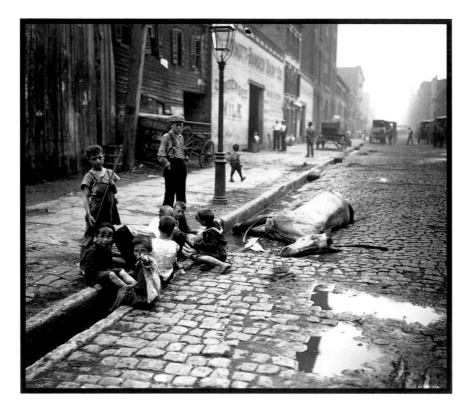

Children play in the street, one noticing the photographer, while a dead horse lies next to them.

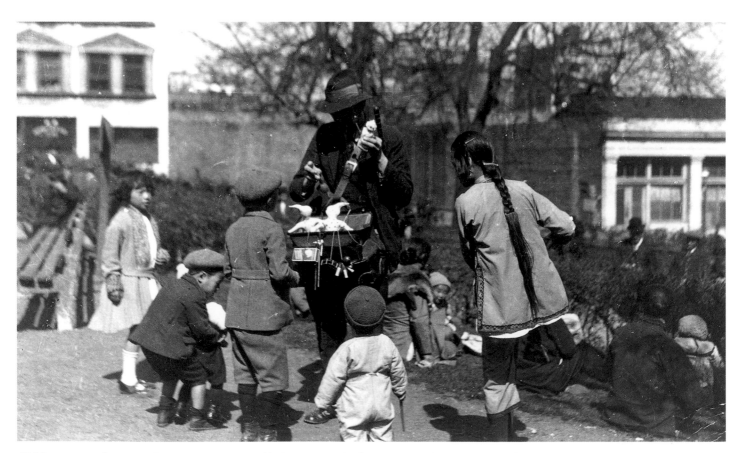

Children surround a toy peddler in Chinatown, possibly in Portsmouth Plaza, sometime between 1896 and 1906.

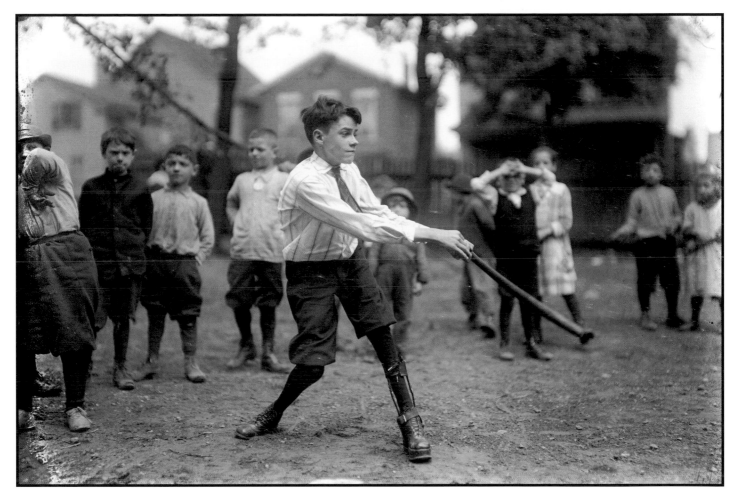

Clarence Lehr swings during a game of baseball in 1921. He hit two home runs during the game. This photo was printed in the Rochester Herald *on May 15.* ALBERT R. STONE

MARCH 23

Went to school. La Verne wasn't there. James batted ball into ditch full of water, and it went into culvert. It lodged in middle of culvert. It got lost at last recess. Worked all last recess and til almost 4:15 after school. We still didn't get it out. Rode bikes.

March 24

Went to school. La Verne did come. I brought fish pole and James a flash. Rode bikes. The fish pole was not long enough to reach a ball. We sent in Walter's dog but it didn't do any good. Then we blocked up one end and washed it out. James took fish pole and flash home. I took lunch buckets and my kite. La Verne had kite in school.

Robert Bly, diary entry written in Minnesota in 1938

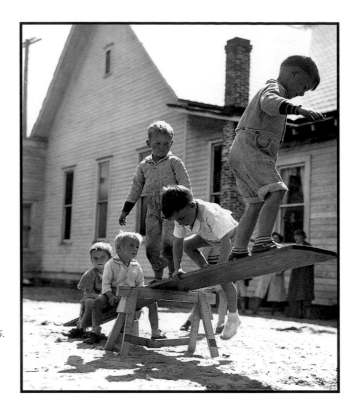

Children play on a homemade teeter-totter at the Panama Park Nursery School in Jacksonville, Florida, in 1935.

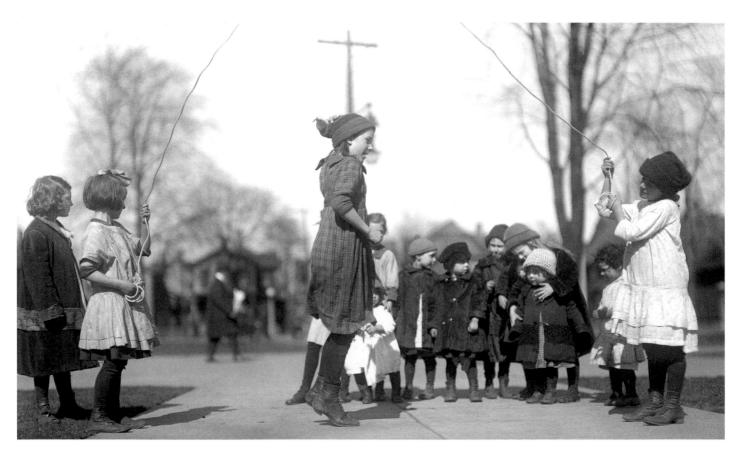

Girls jump rope in Rochester, New York, in March 1918. ALBERT R. STONE

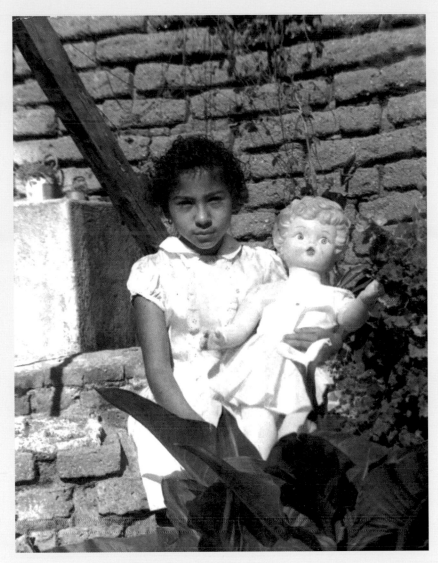

BOY! WAIT UNTIL THE MANGOE season is in full blossom, by that I mean when they get ripe, and that's not far-off—it is next month, and I'll surely do some climbing again. I haven't climb trees for so long, it seems. Oh well, it won't be long now. I told Esperanza about it, and she sayd "That's good," cause that means, we don't have to ask any boys to get mangoes for us we can get them ourselves.

Angeles Monrayo Raymundo, eleven,
Waipahu, Oahu, T. H., in her diary on
January 10, 1924

A Mexican American girl poses with her doll in the 1940s.

Boys make kites in San Francisco in 1944.
JAMES WONG HOWE

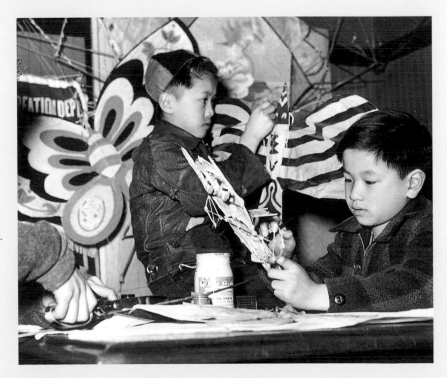

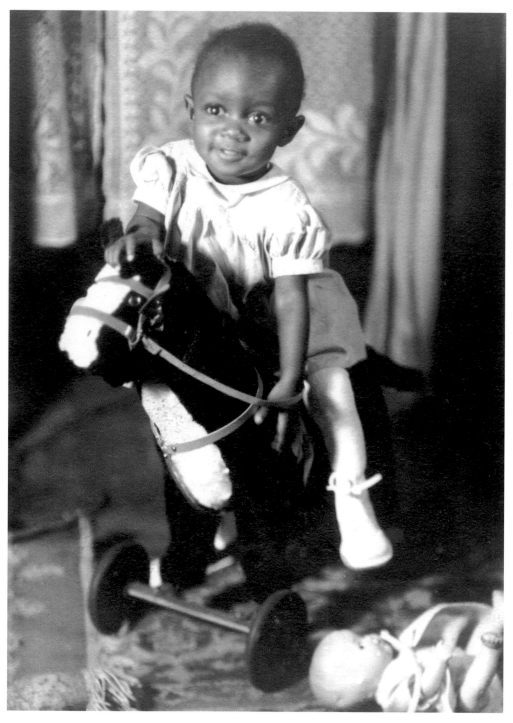

A little girl enjoys her hobbyhorse while a doll lies at her feet, ignored, in this 1920s studio photograph.

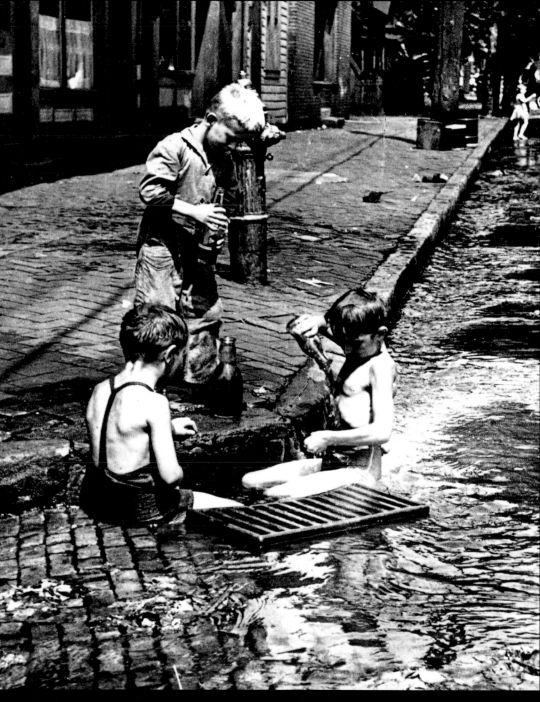

Three boys find a way to cool off sometime during the 1940s. JOHN ALBERT

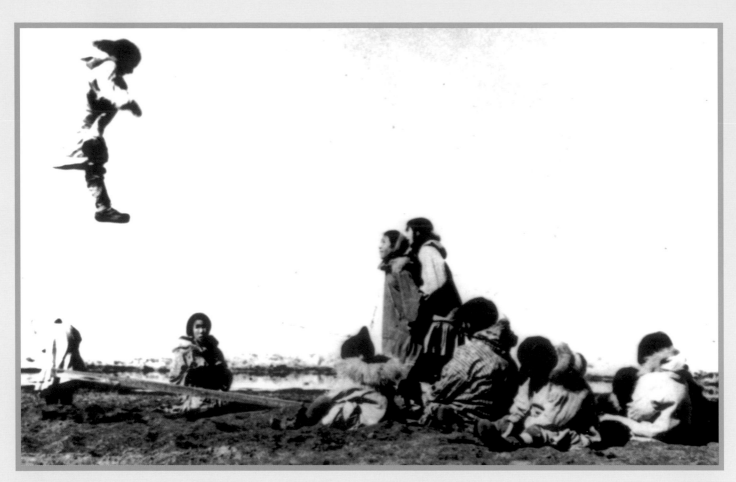

The photographer wrote this caption for this 1948 photograph: "Eskimo seesaw is considerably more rugged than the Stateside version. The players stand on either end of a plank balanced on a driftwood log. Each jumps to toss his partner skyward. Skilled players can jump many times, but the reward for a 'miss' is a rough tumble on a rocky beach."

WHEN THERE WASN'T ANYBODY ELSE around, I felt like I could run faster than any other girl in the world.

Pat, remembering her childhood in the 1950s

Kathy Clayton runs on a beach in Westport, Washington, in this photograph taken by her father, Chris Christiansen, in 1950.

Tracy plays on a tractor on the Stauber farm in Oklahoma in 1949.

Craig learns to ski in the early 1960s.

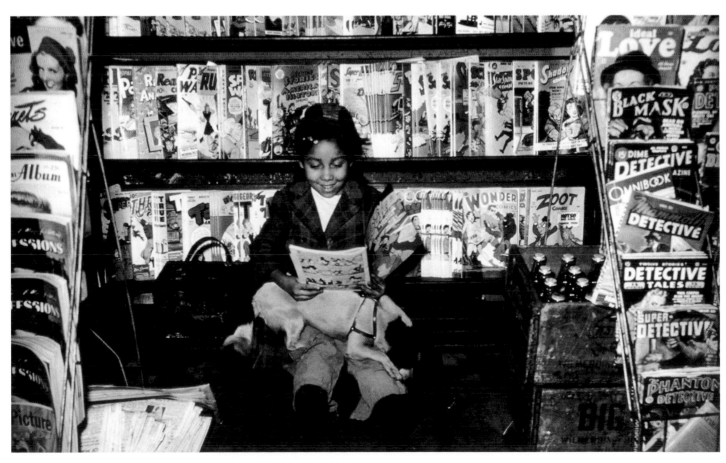

A young girl reads a comic book in a Pittsburgh newsstand in 1949. CHARLES "TEENIE" HARRIS

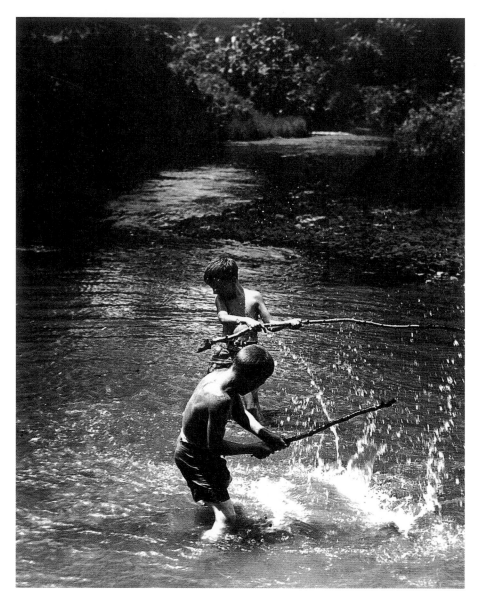

Boys play in a stream in Appalachia in the 1950s. EARL PALMER

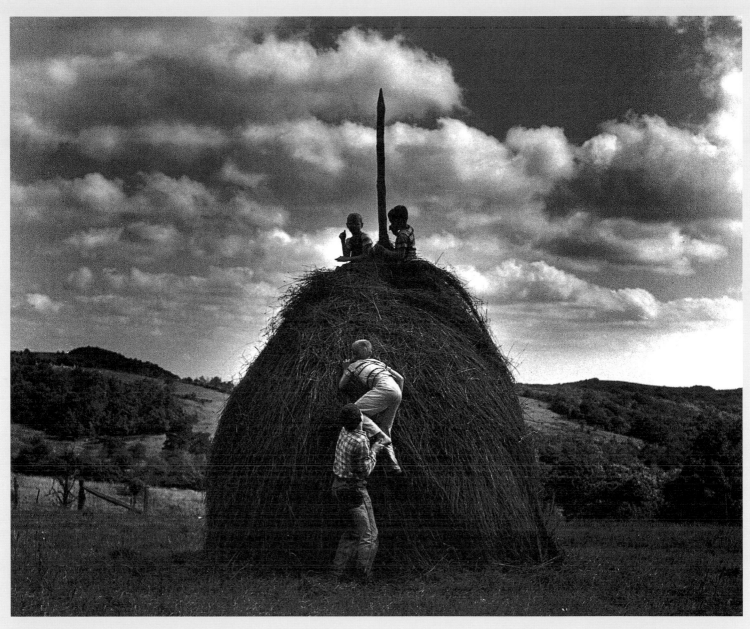

Boys sneak up on friends in Appalachia in the 1950s. EARL PALMER

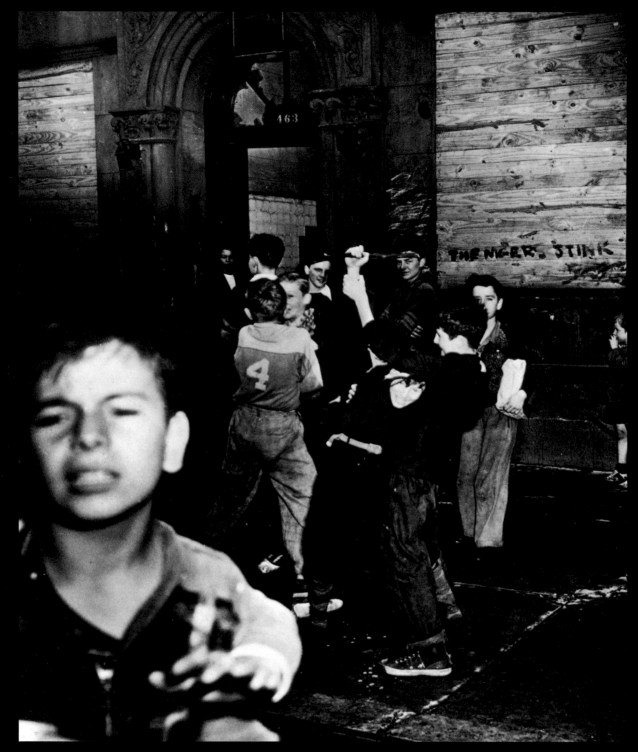

Boys attack each other after school in New York City in the 1950s. WEEGEE

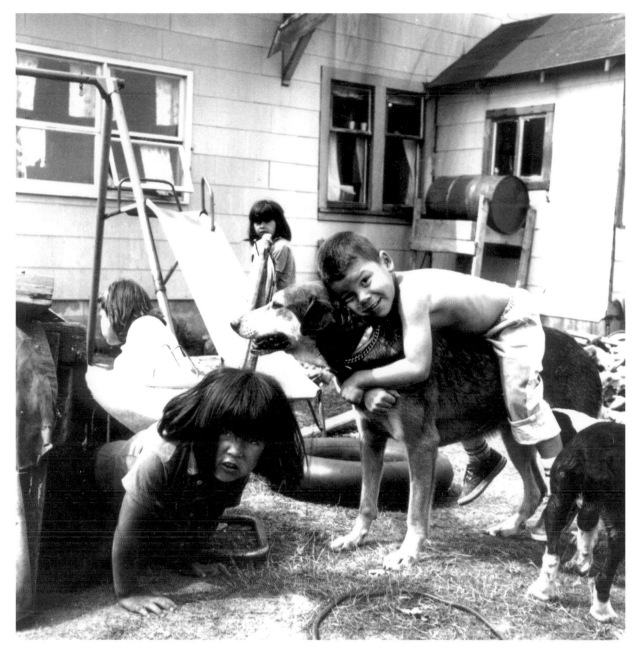

Children play in their front yard on a reservation in Neah Bay, Washington, in the 1960s.

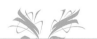

MY MOTHER WOULD GO GROCERY SHOPPING ONCE A WEEK. AND WHEN MY sister was old enough Mom left her in charge of all of us. . . . So we moved all the furniture to one side of the living room, pulled the mattresses off the beds, put them in the living room, had all the pillows, all the blankets, the whole living room was just padded. And we'd get up and run around the house, get to the beginning of the mattresses, do flips, get up and run around the house again, do flips, and we did this for hours. . . . Then my sister had it timed, I mean, almost exactly. She said, "Okay, that's it." Everybody cooperated and put everything back away and folded everything back up, put the furniture back, cleaned it all off, and when my mom would show up we'd all just be, you know, sitting around waiting. We'd all run out and help bring the groceries in.

Maria Jimenez, speaking of her experiences in the 1970s

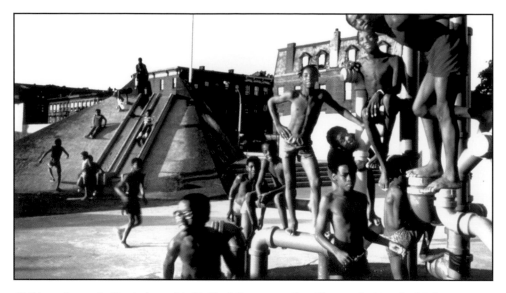

Children play at the Kosciusko pool in Bedford-Stuyvesant, Brooklyn, on the Fourth of July, 1974.
DANNY LYONS

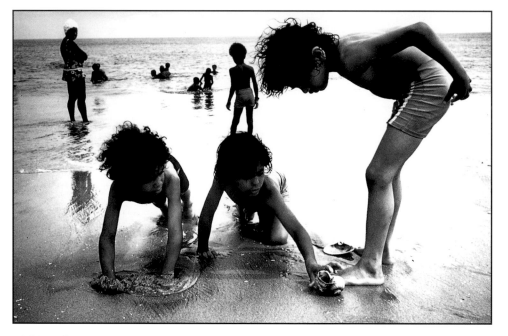

Children play at Reis Park, a public beach in Brooklyn, New York, in July of 1974. DANNY LYONS

AUGUST 18, 2001

Anyway, Katie's party was last night, and that was a lot of fun. Reminder to self: I am not stable on people's shoulders, and end up moving my feet and um . . . injuring my partner where it counts. I should not chicken fight anymore, especially on guy's [*sic*] shoulders, sorry eric.

Also last night I got in a pink tube and after I had just eaten I kept spinning around really fast for about 3 minutes while listening to people talk.

I did not feel so good afterwards.

greeneyez4, age 15

Children play on a beached whale in Panacea, Florida, in the 1960s.

A young boy finds a solitary form of entertainment in August of 1982.
BETTYE LANE

Two children cross a fallen tree in the Quinault Rain Forest on the Olympic Peninsula. LYNN SHERARD-STUHR

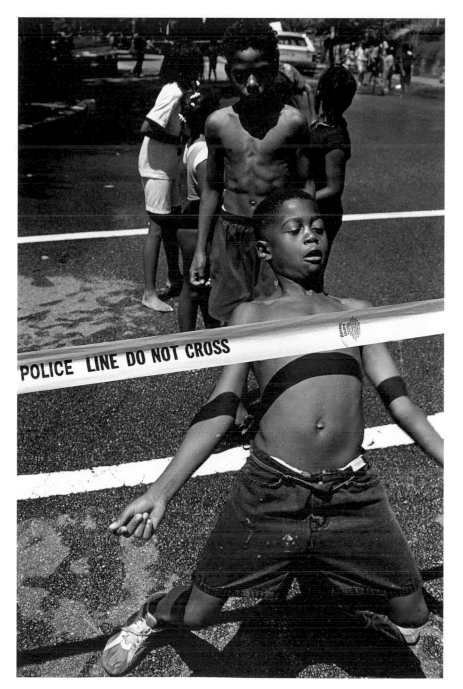

"Crossing the Line." *A boy limbos under a police line in Washington, D.C., 1990s.*
NESTOR HERNANDEZ

TAKING A BITE OUT OF LIFE

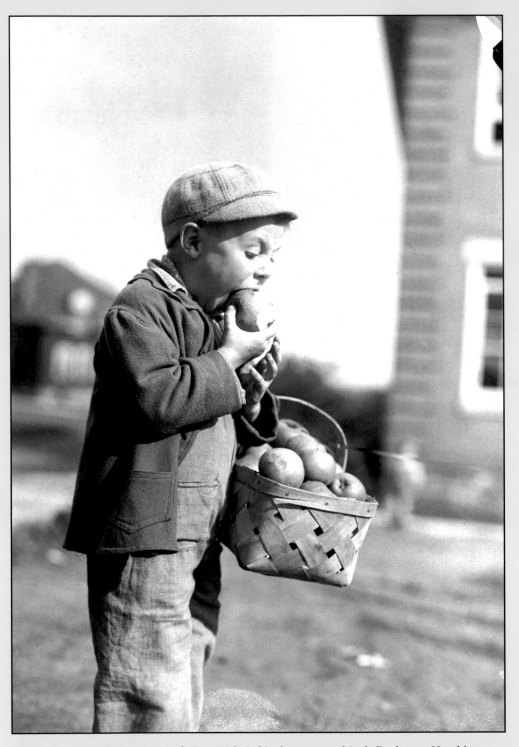

Originally captioned "Starting Apple Day Right," this photo appeared in the Rochester Herald *on October 20, 1914.* ALBERT R. STONE

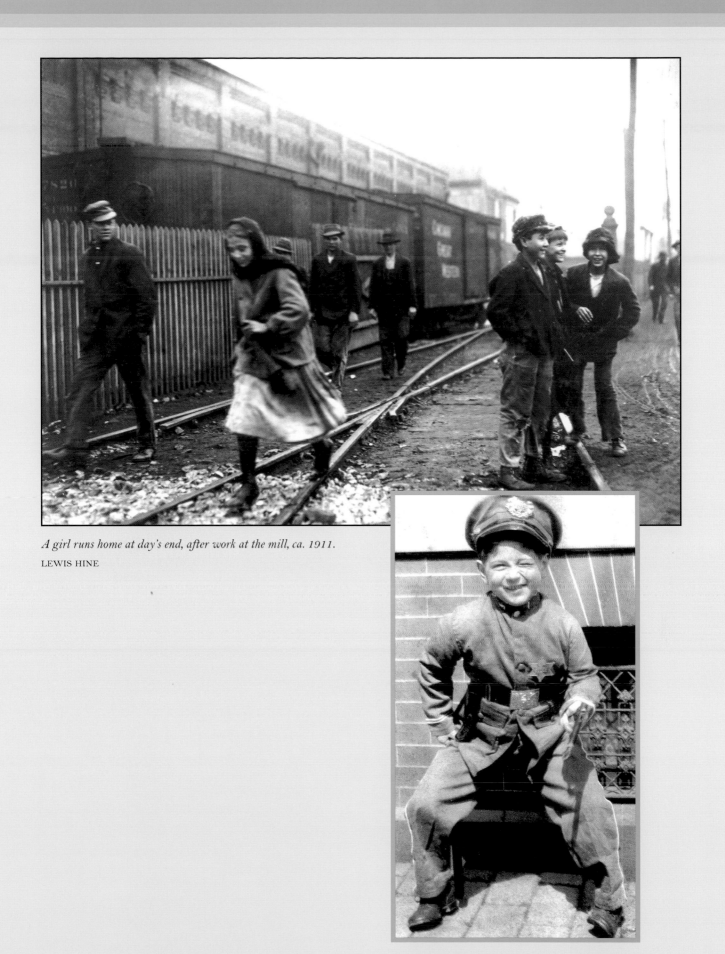

A girl runs home at day's end, after work at the mill, ca. 1911.
LEWIS HINE

Stanley Falk draws on the bad guys in Baltimore, Maryland, in 1932.

Jeannie "Muscles" Irwin poses for a photographer in Oklahoma City in 1940. ROBERT A. TOLBERT

This photograph of boys in New York City in 1948 was originally captioned "The Wrestle of Spring."

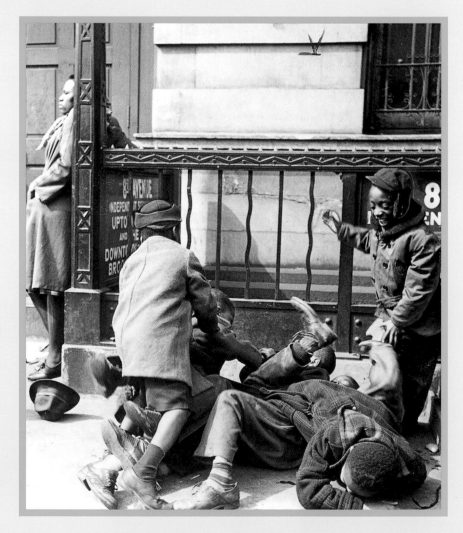

Light from the sunset catches a cartwheel on a beach in Washington State in 2001. NAN RUTLEDGE

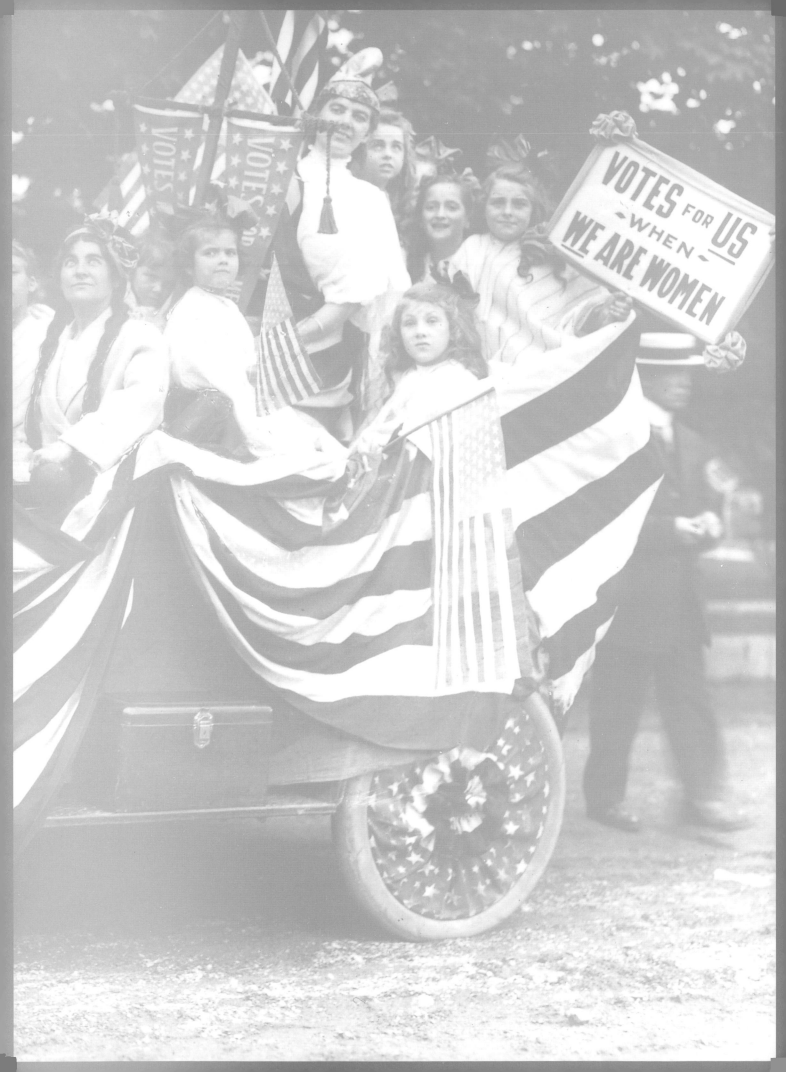

PART SEVEN

CHILDREN IN THE MAKING OF AMERICA

HUNDREDS OF THOUSANDS OF CHILDREN were among the 10 million people brought to this country specifically to work, to create settlements and colonies, between 1492 and 1820. They almost always came, not with their families, but alone. Virtually all African children and a great many Europeans were brought by force. Since those early days, children have built our farms, worked in our factories, helped their elders tar and feather and lynch, hopped freight trains, and worked in political movements for freedom and equality. They have written books and led strikes and died for their country.

Children have fought in every American war. Tribal warriors in their teens fought to defend their nations against European depredations. In the Revolutionary War, drummer boys as young as seven years old walked into battle with the Continental Army. Less than a century later, one out of five of the soldiers who served in the bloody Civil War was between twelve and seventeen years old, while black teenage girls served as nurses, cooks, and laundresses. During the Indian wars of the nineteenth century, children were slaughtered on both sides. They also fired some of the bullets and shot some of the arrows that ended other young lives. For many years, the United States has refused to sign an international Children's Rights Treaty because it would mean that the U.S. military could no longer accept seventeen-year-olds. About 3,000 youths of that age are serving in the U.S. military at any given time.

In the nineteenth century, children worked beside their parents on the Underground Railroad, helping enslaved people escape the South. They took the same risks and, sometimes, suffered the same consequences. There were also children among the slaves who escaped. When pioneers headed out West, fathers in search of new frontiers took with them families who, without having any say in the decision to go, underwent terrible hardships and frequent death.

In the twentieth century, children worked to help their families survive the Great Depression. They walked past angry mobs to integrate schools, the first move in the desegregation of our entire society. They marched against inequality and an unjust war. And in spite of all this, children today face a world in which their age seems often to be seen as a disability, rendering them unable to contribute to the serious business of making America.

Many of the photographs in "Children in the Making of America" are, not surprisingly, news photographs. Others are by commercial photographers who knew that they were living in a place and at a point in time that was historically important. During the second half of the nineteenth century thousands of photographers, such as John Grabill—"Official photographer of the Black Hills and Fort Pierre Railroad and Home State Mining Company"—worked in the West with the full knowledge that what they recorded was both historically important and eminently salable to an Eastern population curious about the "Wild West." In the late twentieth century many photographers, such as Bettye Lane, Eunice Hundseth, and Ilka Hartmann, also knew that they lived in a historic place at a historic time and recorded the demonstrations, sit-ins, and marches of the period. Sometimes, however, a simple record of a small detail of life can later take on historic significance, such as Marc St. Gil's photograph of a teenager smoking pot in the 1970s.

By some estimates, up to 95 percent of the children of the eastern tribes died from European diseases such as smallpox before the Puritans settled Plymouth. The devastation of European diseases on the tribes cannot be underestimated, nor can its influence on the history of this country.

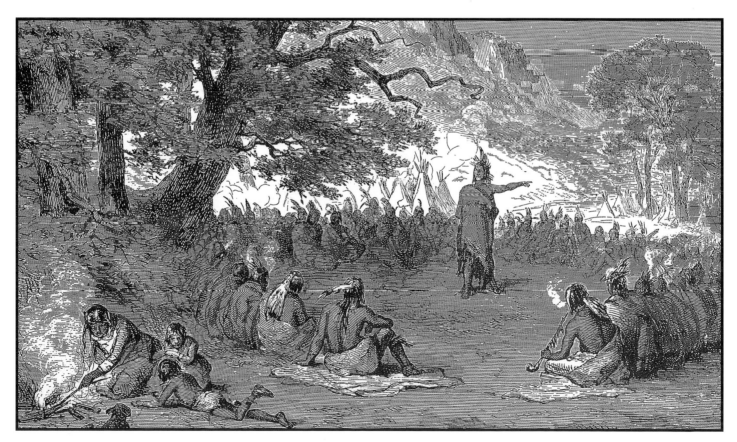

This woodcut from a later date shows two boys attending a meeting where Chief Pontiac, son of an Ottowa father and Ojibwa mother, united the Ottowa, Pottawaton, and Ojibwa tribes to fight against the English in the late 18th century. Pontiac almost won.

The Hessian Third Guard Regiment included an African American drummer boy. This engraving by J. C. Muller is based on a drawing by J. H. Carl, ca. 1784.

HERE I DID DUTY AS A SOLDIER three months mounted guard several times. The first time that I was detached was on the main guard and I prepared my breakfast the night before so as to be ready, at the call of the little bell, and not to get a caning from him (the sergeant) for negligence as some others did.

Daniel Granger, who joined the Continental Army in December of 1775 at the age of thirteen and served as a guard over both stores and prisoners

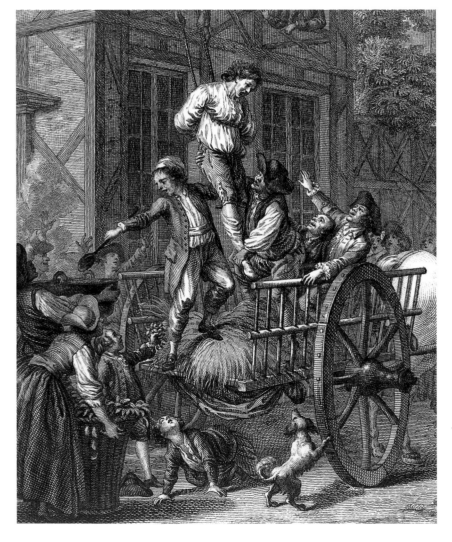

This detail from a 1784 engraving shows children both helping with and observing the tarring and feathering of John Malcom, a tax collector, on January 20, 1774.

This image came from a broadside poem, "American Sailor Boy," printed in 1814. Impressment, like involuntary indenture and enslavement, was a way in which children were forced to work under conditions not of their own—or their family's—choosing.

Children resisted slavery along with adults. Maria Weems was fifteen when she disguised herself as a boy and ran away from the man who owned her.

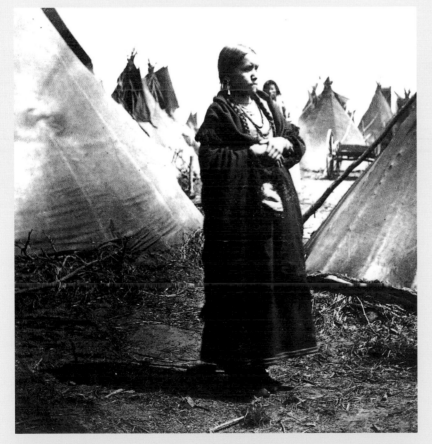

This Santee Dakota girl is being held at the Fort Snelling prison compound in 1862 or 1863. During the Indian wars, which lasted , on and off, from the 16th century through the late 19th century, Native American children were frequently under attack.
BENJAMIN FRANKLIN UPTON

THURSDAY, MAY 25, 1854

Did not intend to write this evening, but have just heard of something which is worth recording:—something which must ever rouse in the mind of every true friend of liberty and humanity, feelings of the deepest indignation and sorrow. Another fugitive from bondage has been arrested; a poor man, who for two short months has trod the soil and breathed the air of the "Old Bay State," was arrested like a criminal in the streets of her capital, and is now kept strictly guarded,—a double police force is required, the military are in readiness; and all this is done to prevent a man, whom God has created in his own image, from regaining that freedom with which, he, in common with every other human being, is endowed.

Charlotte Forten Grimke, seventeen years old

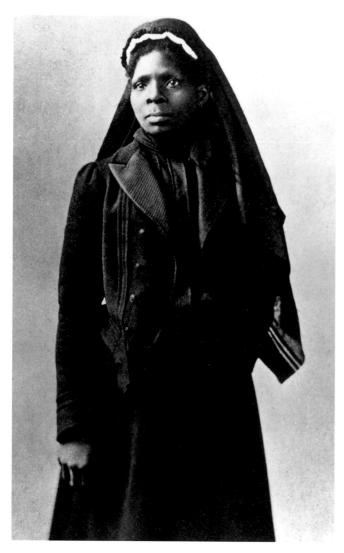

OUTSIDE OF THE FORT WERE MANY skulls lying about; I have often moved them to one side out of the path. The comrades and I would have wondered a bit as to which side of the war the men fought on, some said they were the skulls of our boys; some said they were the enemies; but as there was no definite way to know, it was never decided which could lay claim to them. They were a gruesome sight, those fleshless heads and grinning jaws, but by this time I had become used to worse things and did not feel as I would have earlier in my camp life.

Susie Baker King Taylor, nurse, Union Army, from Reminiscences of my Life in Camp with the 33rd U. S. Colored Troops, Late 1st S. C. Volunteers

Susie Baker King Taylor, once enslaved, was fourteen when she worked as a nurse during the Civil War.

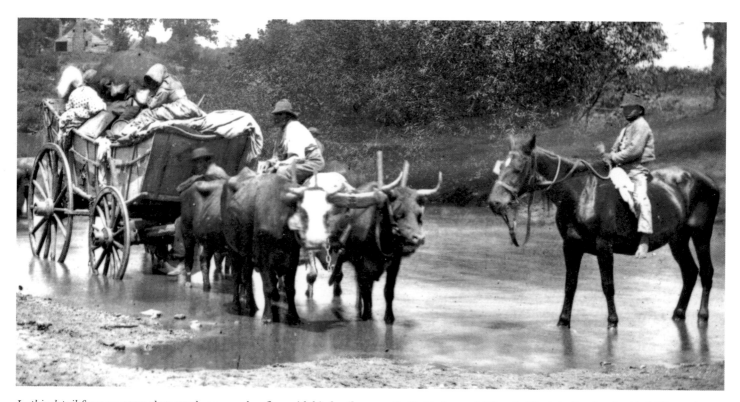

In this detail from an 1862 photograph, a young boy flees with his family across the Rappahannock River in Virginia. During the Civil War, seeing an opportunity for freedom, thousands of enslaved Americans fled to the Union lines. TIMOTHY H. O'SULLIVAN

I PASSED . . . THE CORPSE OF A BEAUTIFUL BOY IN GRAY WHO LAY with his blond curls scattered about his face and his hand folded peacefully across his breast. . . . His neat little hat lying beside him bore the number of a Georgia regiment. . . . At the sight of the poor boy's corpse, I burst into a regular boo-hoo and started on.

John A. Cockerill, sixteen years old, a Union regimental musician
who had become separated from his unit after the attack at Shiloh

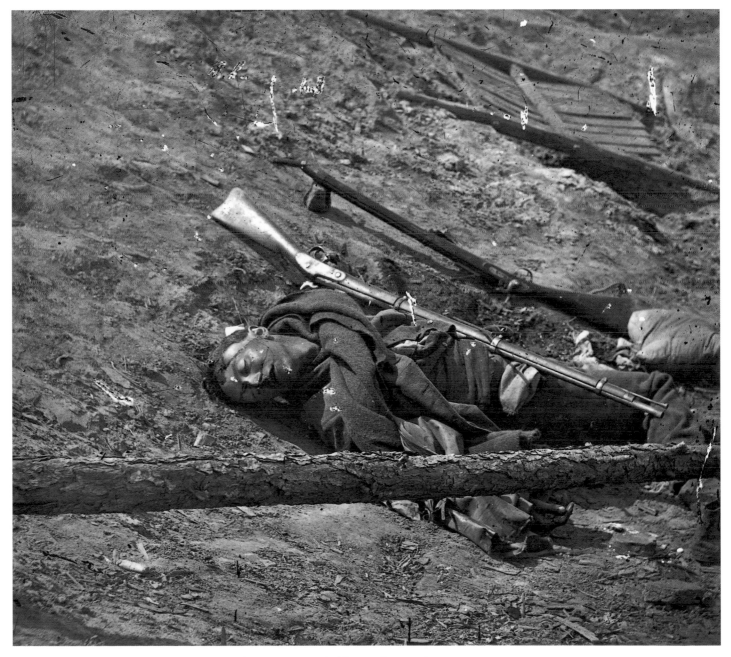

A young soldier lies dead in the road at Fredericksburg, photographed by Matthew Brady on May 3, 1863.

The boys and men of Big Foot's band of
Miniconjou Lakota were photographed at a Grass
Dance on August 9, 1890. Most of these people
were massacred at Wounded Knee a year later.
Three hundred and seventy Lakota died at
Wounded Knee, many killed as they hid in the
shelter against a creek bank. One Indian witness
remembered: ". . . after most of [the women and
children] had been killed a cry was made that all
those who were not killed or wounded should come
forth and they would be safe. Little boys . . . came
out of their places of refuge, and as soon as they
came in sight a number of soldiers surrounded them
and butchered them there."
JOHN C. H. GRABILL

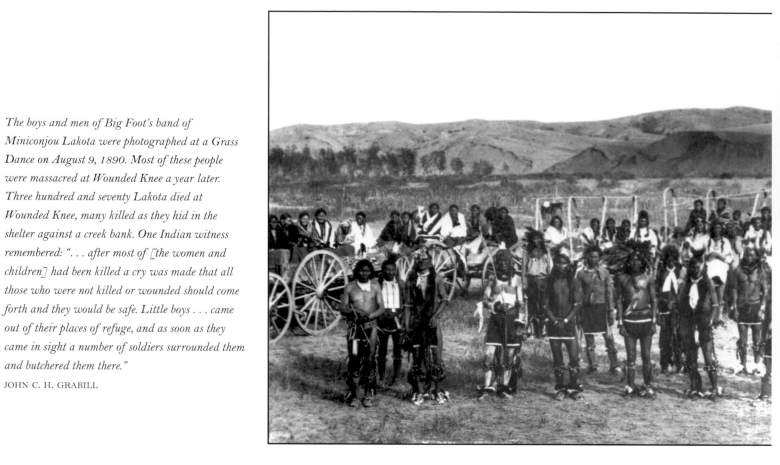

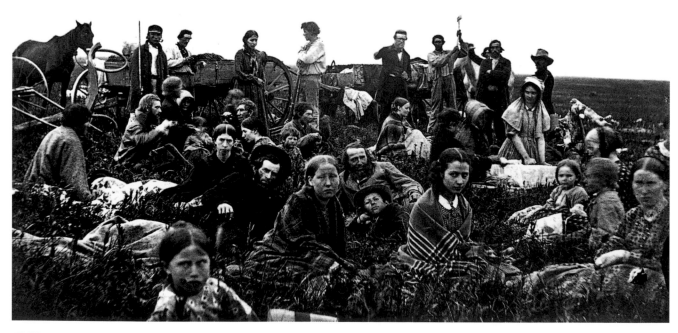

Children and their families were "photographed by one of their party" as they fled from Fort Ridgley, Minnesota, on August 21, 1862,
during the uprising of the Mdewakanton and Wahpekute bands of Santee Dakota. The uprising lasted more than a month, and up to 800
settlers were killed. ADRIAN J. EBELL

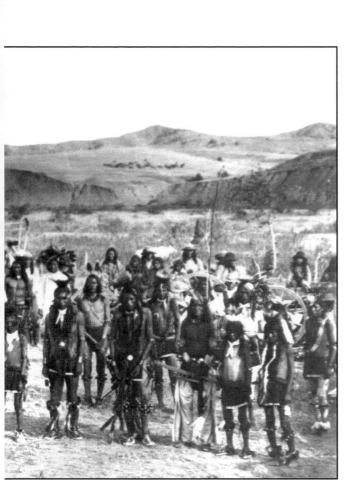

WHAT A FRIGHT WE ALL GOT ONE MORNING to hear some white people were coming. Everyone ran as best they could. . . . My aunt said to my mother: "Let us bury our girls, or we shall all be killed and eaten up." . . . So our mothers buried me and my cousin, planted sage bushes over our faces to keep the sun from burning them, and there we were left.

[W]e lay there all day. It seemed that night would never come. . . . At last we heard some whispering. Then I heard my mother say, "T'is right here!" Oh, can anyone in this world imagine what were my feelings when I was dug up by my poor mother and father? . . . Those were the last white men that came along that fall. This whole band of white people perished in the mountains, for it was too late to cross them. We could have saved them, only my people were afraid of them.

Sarah Winnemucca, remembering the passing
of the Donner party

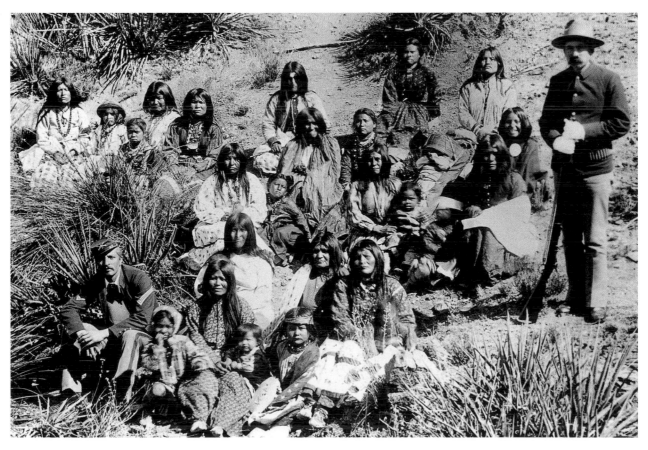

A group of Apache children and their mothers are held prisoner by the U.S. Cavalry.

Bertram S. Flint, who served with Troop G, 8th U.S. Cavalry, was sixteen years old when he had his photograph taken in 1898.

USS *MAINE*

Havana, Cuba

Dear Father,

I received your loving letter a few days ago and was pleased to hear from you. I would have written sooner but owing to us having to been ordered to sea so soon. I didn't have any chance. We are now in Havana Cuba. We arrived here yesterday after a five hour run around a place called Dry Tartogos a small Florida reef. We were out to sea when the orders came for us to proceed to proceed at once to Havana. We are the first American ship that has been here in six years. We are now cleared for action with every gun in the ship loaded and men stationed around the ship all night. We are also ready to land a battalion at any moment. By the looks of things now I think we will have some trouble before we leave. We steamed the whole length of Cuba and about every mile you can see puffs of smoke and the Spainards firing on the rebels. There are three German ships (?) loading. here was Old Moro Castle stands at the entrance of the harbor, there are thousands of Spanish inside you can see them all sitting on the walls at any time of the day. This is a landlocked harbor but I think we could get out of it all right although we are in a pretty dangerous position at the present time and we hardly know when we are safe. Well dear Father I will now have to close sending my best love and wishes to all and hoping that I may be alive to see you all again.

I remain your loving son. Charles

U.S.S. *Maine* in the charge of Council General of the United States

Havana, Cuba

> *Charles Hamilton, a seventeen-year-old crewman of the battleship* Maine.
> *The envelope bears the date February 5, 1898. Charles was lost*
> *when the ship exploded ten days after this letter was written.*

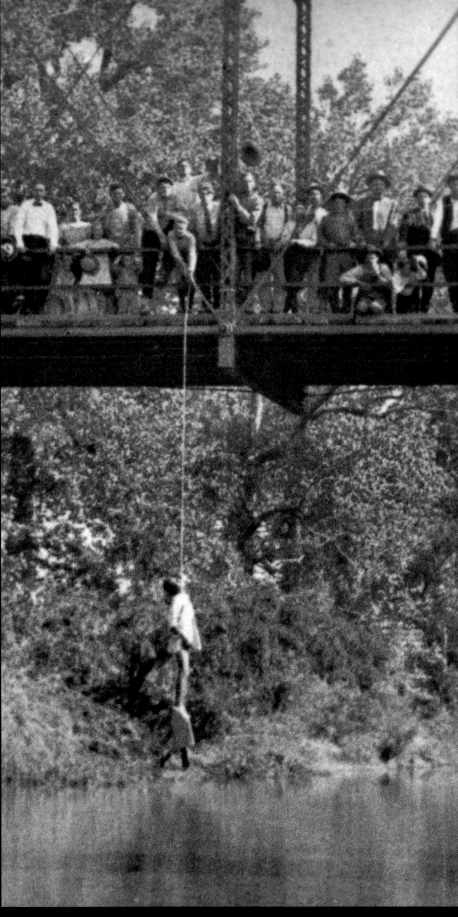

Fourteen-year-old L. W. Nelson was lynched alongside his mother, Laura Nelson, in Okemah, Oklahoma, on May 25, 1911. The local paper reported, "Hundreds of people from Okemah and the western part of the country went to view the scene."

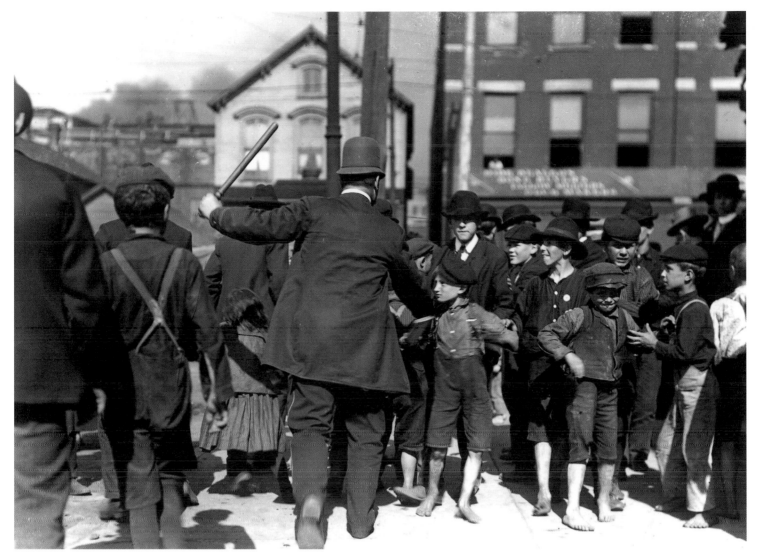

Police push back onlookers, most of them children, during the stockyards strike in Chicago in 1904. At the height of the labor movement, children—who were workers as well as sons and daughters of workers—participated by organizing, picketing, and throwing rocks with their families and adult co-workers.

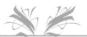

IF THE UNION HAD WON WE WOULD HAVE BEEN SAFE. TWO OF OUR demands were for adequate fire escapes and for open doors from the factories to the street. But the bosses defeated us and we didn't get the open doors or the better fire escapes. So our friends are dead.

Rose Safran, after 146 young women, many teenagers, died in the Triangle Shirtwaist fire in 1910

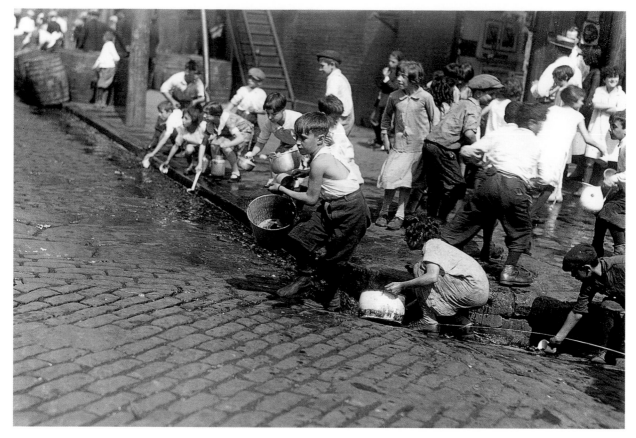

In Brooklyn, in 1926, children went to work to save what they could after the police broke open barrels of wine.

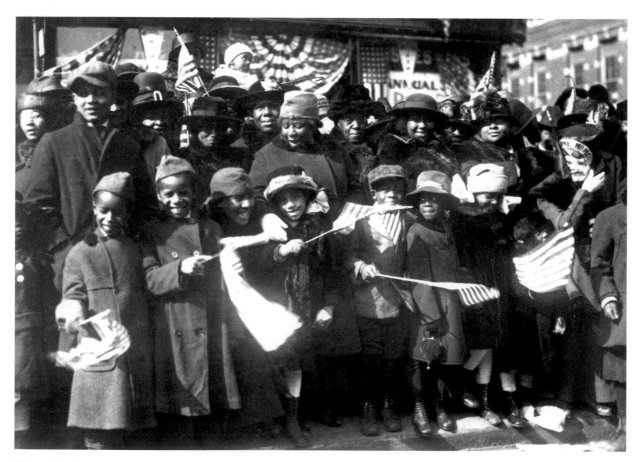

The original caption to this photograph reads: "Famous New York regiment . . . children gathered along line of march to extend [a] royal welcome to their daddies of [the] 369th regiment as the famous fighters pass up 5th Avenue in welcome home parade."
UNDERWOOD AND UNDERWOOD

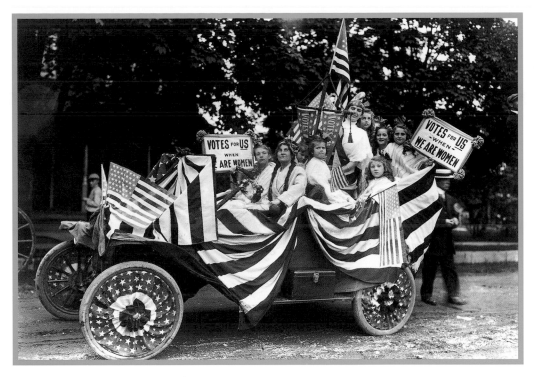

Girls participate in a suffrage parade on May 9, 1913.

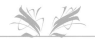

FEB. 6, 1918, WED.

Mrs. Righetta read about a German persisting that he was *not* a *enemy*. I went to hear a woman speak at the church in the evening. We had Esther for dinner. Stuart has Poison-oak. I heard Mr. Vaile of experiment shop speak on home gardens.

FEB. 7, 1918, THURS.

Today was Thrift Day! Mrs. Righetta read a part of my composition to the class. The girls gave a spread in honor of Eleanor because today is her birthday. I made a lot of Valentines.

FEB. 18, 1918, MON.

Mrs. Righetta ensigned Margaret S., Florence J., Kathryn P. and myself. We have to dress up in Colonial costume. I and two others are going to take advance Arithmetic. It snowed and rained. It snowed enough to cover everybodies lawn with snow. Stu went to San Pedro and got a job in the ship yards.

FEB. 21, 1918, THURS.

We had the pageant today. Everything went off fine, only Florence Johnson swore and went off the stage stamping her foot, but it was the first time had she had been on the stage and then the boys made faces at her and she lost her temper. It made Glen feel so bad that he didn't sing the next song. Mother told me a secret. I went to a committee meeting and then had K. P. for supper.

Kathryn Wheeler, twelve years old, Claremont, California

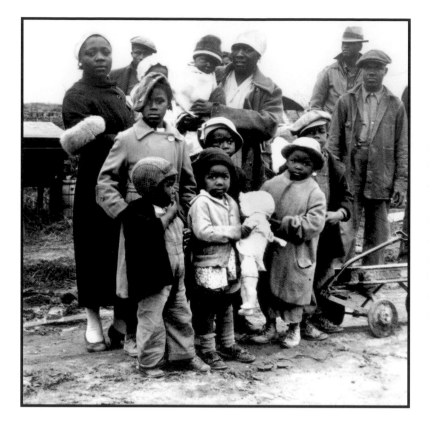

These children were evicted—legally, though at gunpoint—from their homes on the Dibble plantation near Parkin, Arkansas, in January 1936. Plantation owners charged, and the court granted, that, because the parents belonged to the Southern Tenant Farmers Union, they were engaging in a "conspiracy to retain their homes." These families lived by the side of the road until they were moved to a tent colony. JOHN VACHON

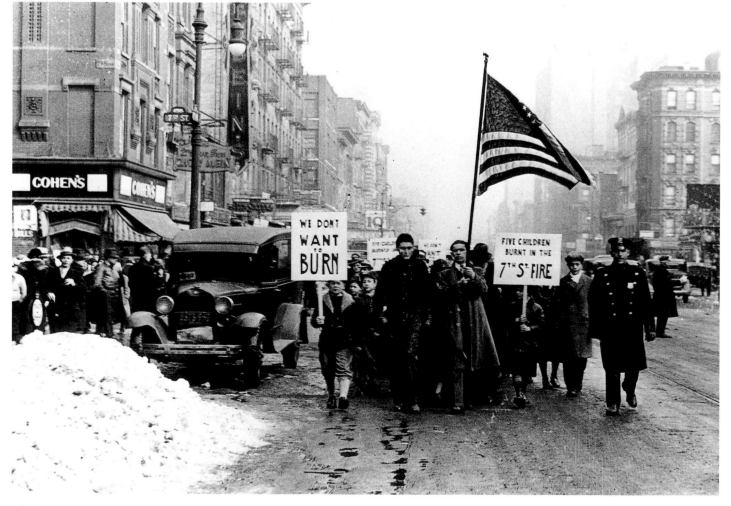

Children march down a New York City street in a protest for better housing, ca. 1930.

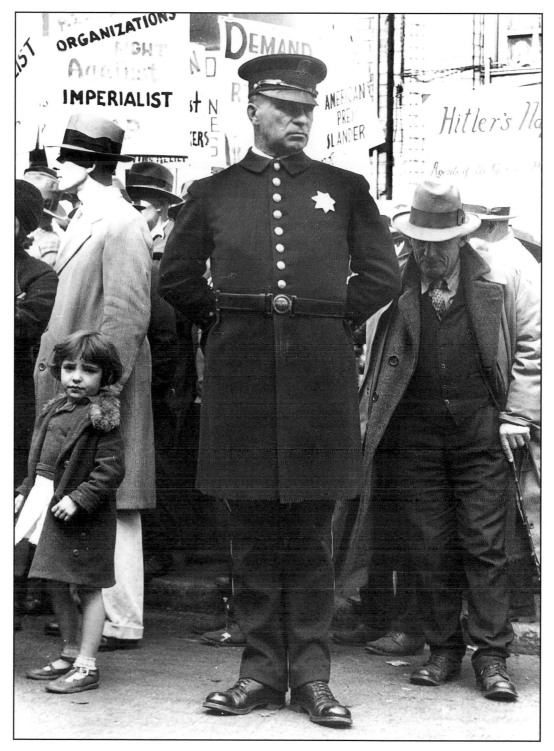

A little girl attends a street meeting in San Francisco in August 1936. DOROTHEA LANGE

Junior Commandos collect metal scrap for the war effort in Roanoke, Virginia, in October 1942.

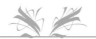

DEAR GENERAL D. MACARTHUR:

This is not a humorous letter but a letter of plea. I've asked the President, I've asked the Senator & Congressmen if they would answer my letters. I have never gotten an answer. I am asking you to at least to answer this letter. I am a girl of 12 years old (when this letter gets to you). I know this letter will sound funny to you, but I am an American and I have rights. I think I should fight for those rights. I have tried to organize clubs, but they just don't turn out, so now I'm taking more drastic steps and asking you to put me in the army. Even if it is only to be a nurses' helper (I know quite a bit about bandaging.) I suppose you'll say, "you'r needed on the home front," but I'm not—I don't do anything. . . . I want to hold a gun and take orders and get down in trenches and mow these Germans down 5 by 5. Please answer this letter and tell me that I can do what I want.

Yours truly,

Patricia A. Coyle

Teenagers face off against the Ku Klux Klan in Lakeland, Florida, on September 1, 1938. The civil rights movement did not begin in the 1950s. It is an ongoing struggle that began at Emancipation and continues through to the present day.

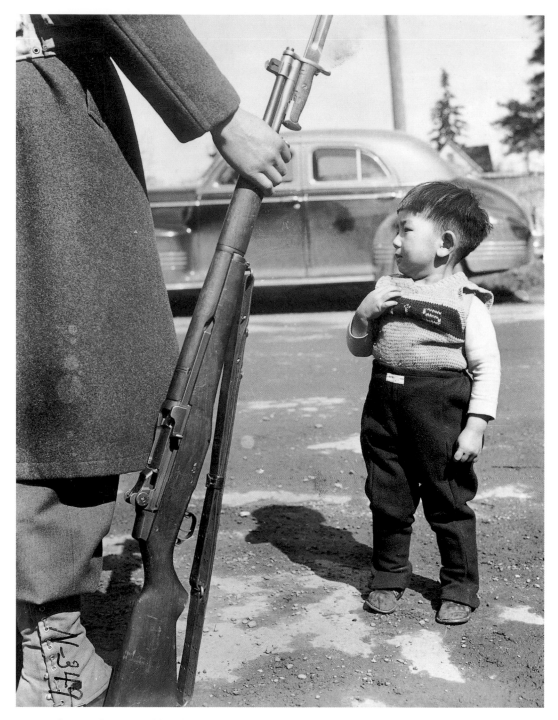

A young boy stands near a soldier during the evacuation of Japanese families on Bainbridge Island, Washington, in 1942.

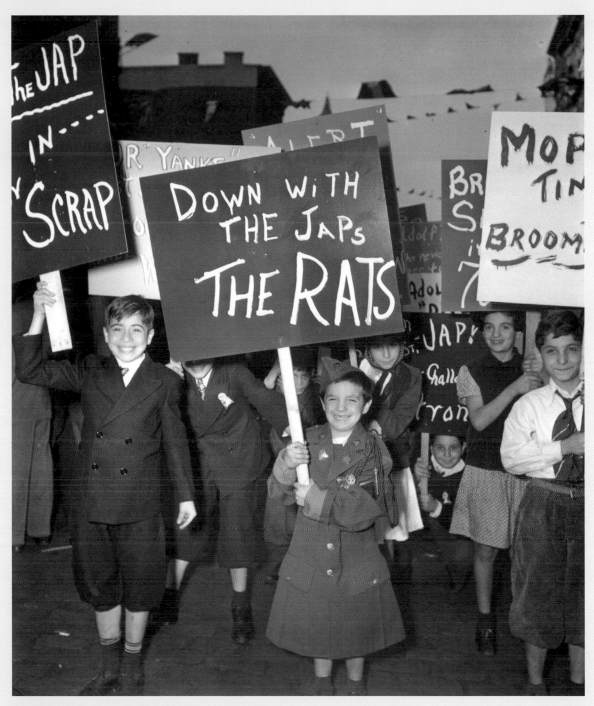

Children participate in an anti-Japanese demonstration during World War II. WEEGEE

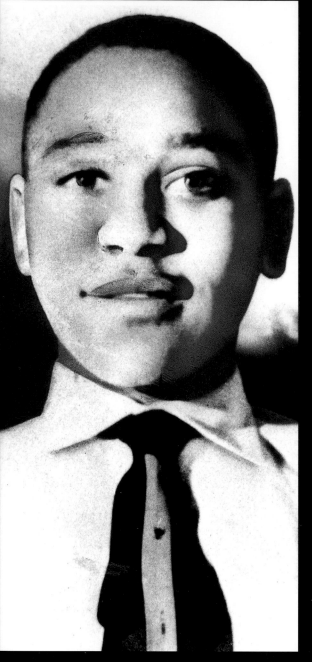

Fourteen-year-old Chicagoan Emmett Till was tortured and murdered when he was accused of being fresh to a white woman while he was on a visit to cousins in Mississippi in 1955. Jet magazine ran a photograph of Emmett in his open coffin. Seeing his brutalized body brought the insanity of white terrorism in the South home to many people. His mother Mamie Bradley's crusade to tell her son's story changed the civil rights movement forever.

DURING THOSE SUMMERS IN OREGON WHEN I walked past the country store where thick-necked loggers drank beer while leaning on their big-rig trucks, it seemed like Emmett's fate had been a part of my identity from birth. Averting my eyes from those of the loggers, I'd remember the ghoulish photo of Emmett I had seen in *Jet* magazine with my childhood friends Tyrone and Lynette Henry. . . . Mesmerized by Emmett's monstrous face, Lynette, Tyrone, and I would drag a flower-patterned vinyl chair from the kitchen, take the Emmett *Jet* from the bookcase and spirit it to a back bedroom where we played. Heads together, bellies on the floor as if we were shooting marbles or scribbling in our coloring books, we silently gazed at Emmett's photo for what seemed like hours before returning it to its sacred place. As with thousands of Black children from that era, Emmett's murder cast a nightmarish pall over my youth. In his pummeled and contorted face I saw a reflection of myself and the blood-chilling violence that would greet me if I ever dared to venture into the wilderness.

Evelyn C. White, remembering her childhood in the 1950s

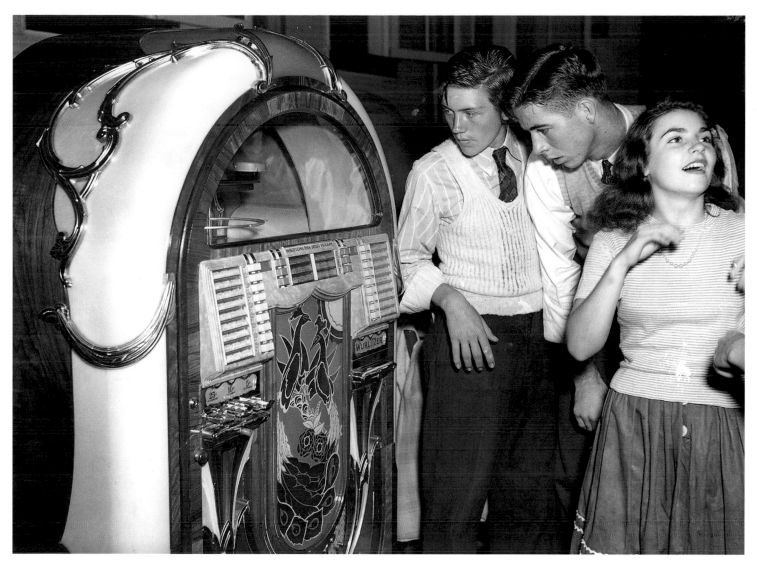

Teenagers stand next to a juke box in a Richwood, West Virginia, dance hall in September 1942. The 1940s and 1950s saw the rise of "the teens" as a separate time in life. It was no longer simply early adulthood. It was also marked by the beginning of mass marketing specifically to that age group and the beginning of rock 'n' roll music, which would later have an enormous effect on both social and political history. JOHN COLLIER

These girls in St. Paul, Minnesota, examine a friend's new vaccination puncture in 1955. The polio vaccine created by Jonas Salk meant that children no longer died from, or were paralyzed by, the polio epidemics that had ravaged the world.

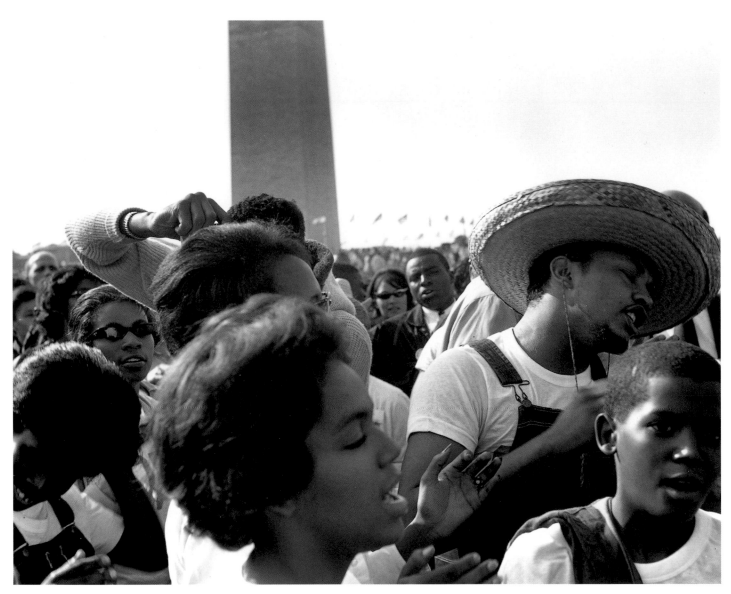

Children participated in the civil rights movement in many ways, including the 1963 march on Washington. They were often responsible for bringing their parents and grandparents into the movement.

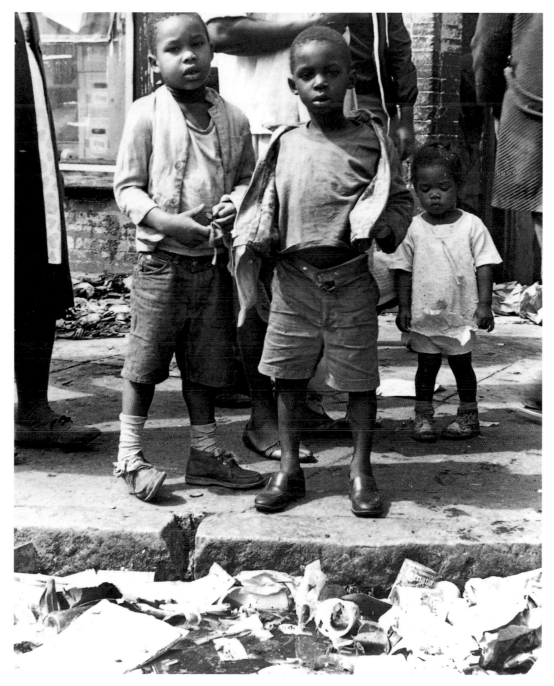

These children were photographed during the sanitation workers' strike in Memphis, Tennessee, in 1968.

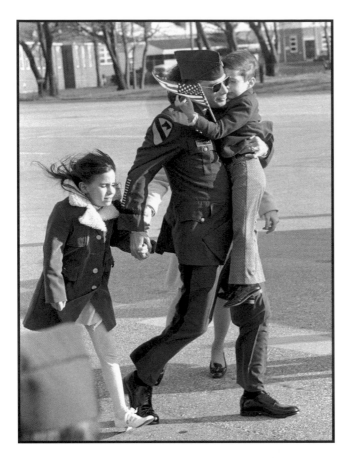

Six-year-old Michael and nine-year-old Tonie Jean Kushner hold on to their father, Major Floyd Kushner, after greeting him upon his release from a North Vietnamese prison camp. Michael had never before seen his father, who had been a POW since 1967. The photograph was taken on March 19, 1973.

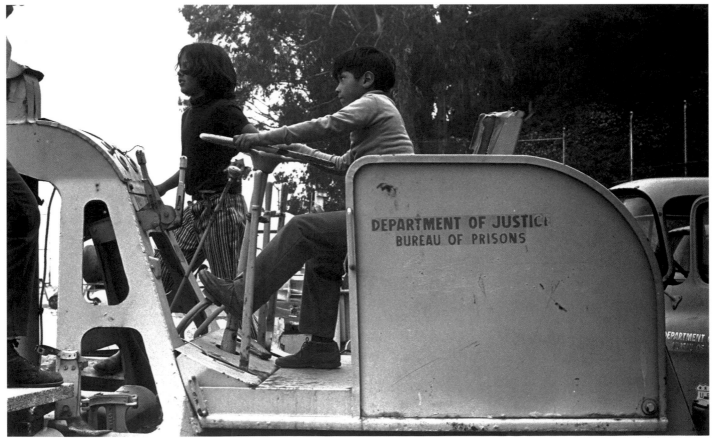

These children play on machinery on Alcatraz Island on May 31, 1970. On November 9, 1969, a group of Indians—residents of the Bay Area and some students—began a nineteen-month occupation of the island. They were later joined by Indians, both adults and children, from all over the country. It became the longest occupation of a federal facility by Indians in U.S. history and caused a number of changes in this country's Indian policy. © ILKA HARTMANN, 2002

MY DAD WOULD CORRECT THE HIS-
tory like Pancho Villa and the Alamo, and say,
"This is a bunch of lies. These *gringos* are telling
you a bunch of lies." So I started thinking for my-
self. I remember once the nuns wanted us to sign
some papers they were going to drop over China
and I didn't sign them. My sister Lupe didn't sign
it either. She was the only one in her class and I
was the only one in mine. I said, "How do I know
communism is wrong? How do I know that
they're not right and I'm wrong." White people
have been lying to us all these years, and they
have discriminated against us in Texas, so how
come they're supposed to be so good? They broke
all those treaties with the Indians and treated
them like dogs, and now they're going to tell me
that they're good and the Chinese are bad. . . .
What the heck, I was born here, but if I said any-
thing against the United States they would say,
"Why don't you go back to Mexico?" Well, why
don't you go back to Europe?

Juan Cadena, describing his experience in the 1960s

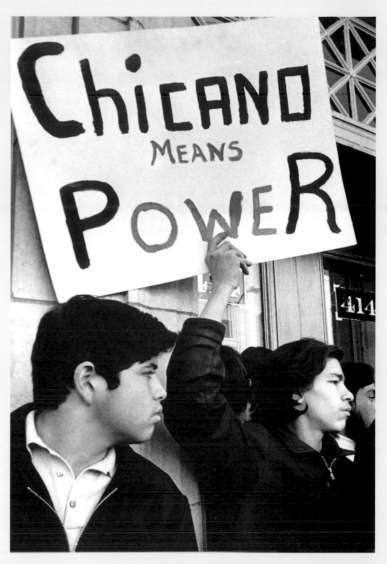

Teenage boys are part of a protest against the arrest of a Mexican American for a bus bombing in Denver in 1970. HOWARD BROCK

A young girl, helped by her father, reads a sign during an Equal Rights Amendment demonstration in Chicago. The civil rights movement of the 1950s and 1960s led to the various power movements of the 1970s. Children, particularly teenagers, were deeply involved in all of them. EUNICE HUNDSETH

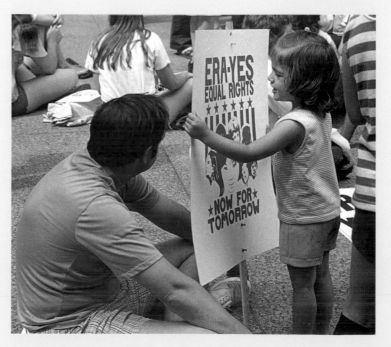

This teenage girl in Leakey, Texas, in May 1973 gave full consent to the photographer who took this picture of her smoking a joint. Throughout history, where there has been alcohol and drug consumption, children have participated alongside adults. In the 1960s and 1970s, however, widespread use of illegal drugs among teenagers and young adults became a statement of rebellion. The illegal drug culture gave rise to a huge illegal drug industry, in which children are also involved. MARC ST. GIL

As drug and alcohol use among teenagers rose, so did deaths connected to them. In this picture, sixteen-year-old Katie Hardgrave from Clearwater, Florida, testifies before a Senate Commerce Committee that is considering a twenty-one-year-old drinking age bill. She is showing a picture of her boyfriend, who was killed in a drunk driving accident.

These children join an anti-abortion protest in front of offices of Planned Parenthood in New York City on January 22, 1988. BETTYE LANE

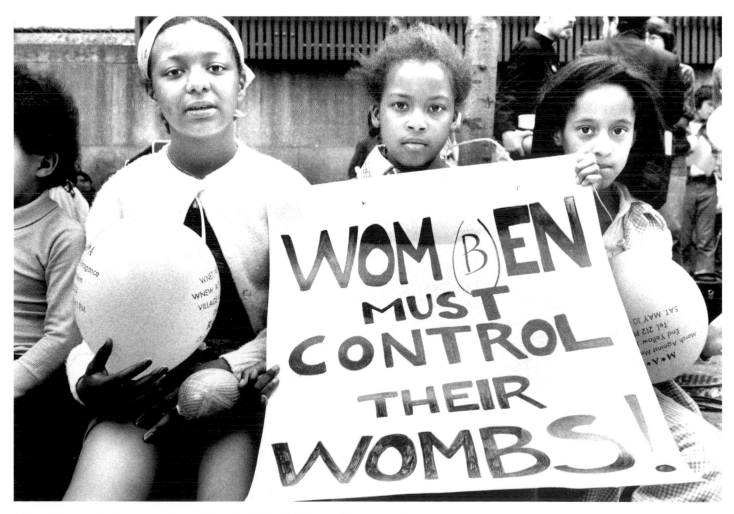

These girls are attending a pro-choice rally at the United Nations on May 10, 1975. BETTYE LANE

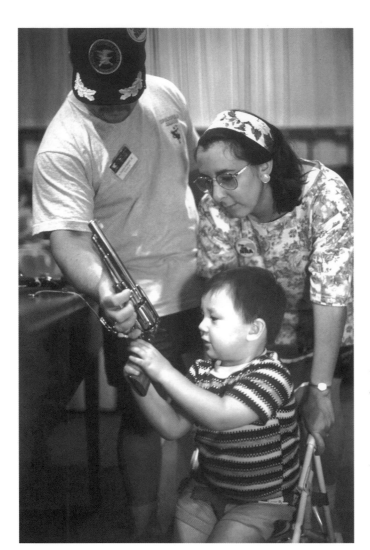

A couple shows their son a revolver at a gun show. About half of households in the United States contain firearms. In 1996, more than 1,300 children aged 10 to 19 committed suicide with firearms.
JEFFRY SCOTT

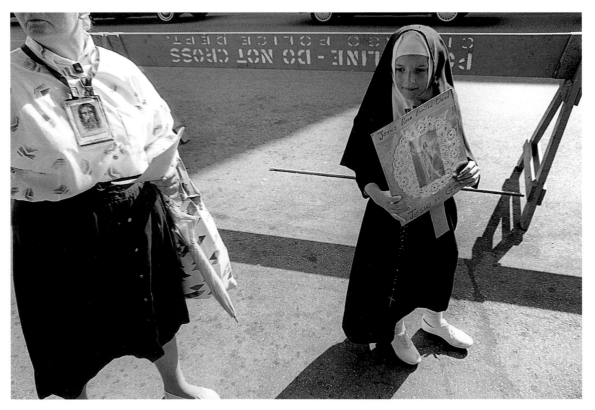

This young girl participates in a protest against Martin Scorcese's film The Last Temptation of Christ *at the Biograph Theatre in Chicago, Illinois, in 1988. The rise of the religious right in American political life during the 1980s affected the lives of many children.* © JIM NEWBERRY

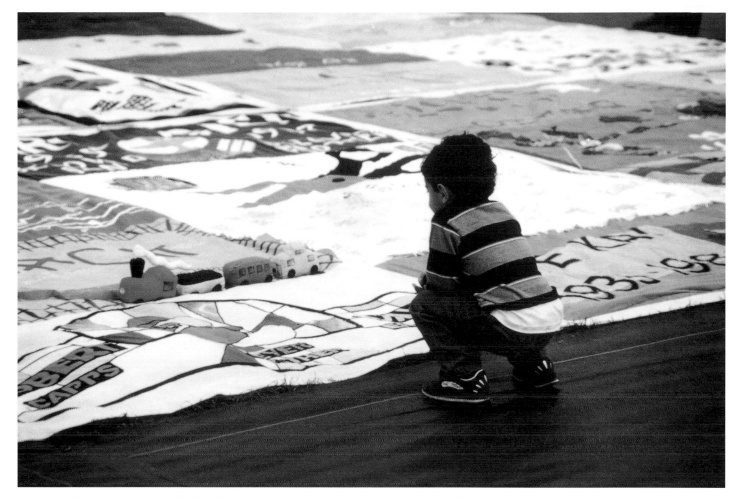

A little boy looks at a panel of the NAMES project AIDS Memorial Quilt in Washington, D.C., in October 1989. The panel was created in memory of a young child who died of the disease. The AIDS epidemic has orphaned and killed thousands of American children. "Drug cocktails," while extending the lives of many people suffering from AIDS, have also helped foster a belief that unsafe sex is "safe" again. Today, unfortunately, HIV infection is on the rise among sexually active teenagers. CATHIE LYONS, NEW YORK CITY

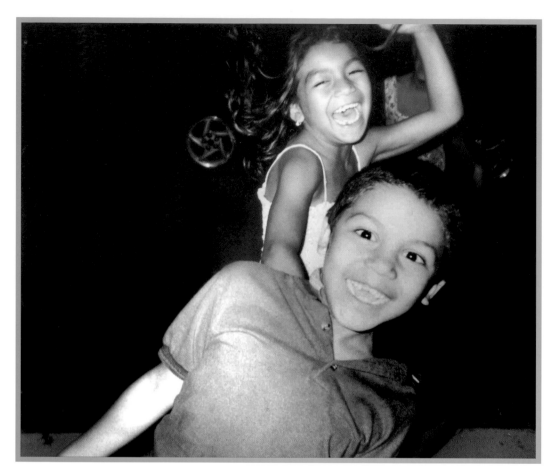

Junior and Michelle play on the street in the Humbolt Park neighborhood of Chicago on the evening of September 11, 2001. The next day in school they would learn how to respond to the tragedy.
KATHLEEN THOMPSON

SEPTEMBER 12, 2001

this is a poem about nothing. this is a poem about nothing

or, i don't know

maybe it's something

or maybe i have something to say

i could write about politics,

love and beliefs,

happiness, sadness,

mourning and grief

i've never read a poem about nothing

because everyone has something to say.

but it seems to me that the best way to say something

is in the most subtle way

there's millions and millions of things

to write

about my problems, my dog, that cat

but why trouble others

with things they don't care about?

this is a poem about nothing

or, i don't know

maybe it's something

maybe i have something to say

i could write about politics,

love and beliefs,

happiness, sadness,

mourning, and grief.

okay, that's how i feel today, nothing happened (although i did find out what being bored to death was like, even though i'm not dead, but i sure felt dead!) i saw monty today, no attacks anywhere as far as i know, and i don't have much homework, dad and mom got mad at me, and i still don't like my brother, so, yes, today was officially a boring day.

lata,

Random, 15 years old

HOLDING STILL (5)

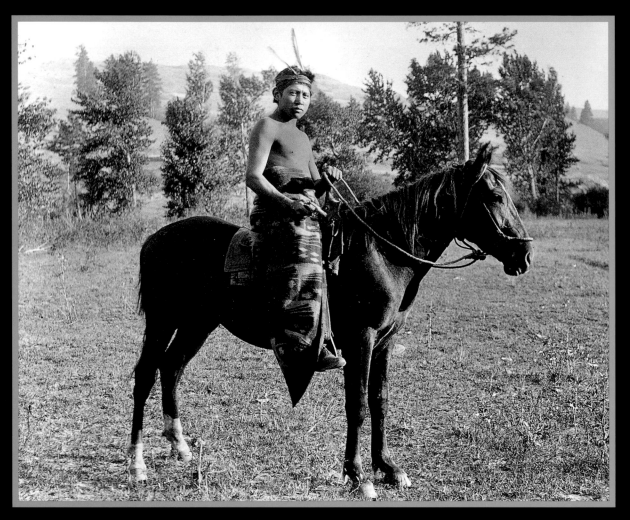

Formal photograph, Colville, Washington, near Spokane, ca. 1907. FRANK PALMER

Photo booth photograph, Sabina Szantyka, sixteen, ca. 1939.

Studio portrait, James Moore, Charlottesville, Virginia, November 3, 1917. RUFUS W. HOLSINGER

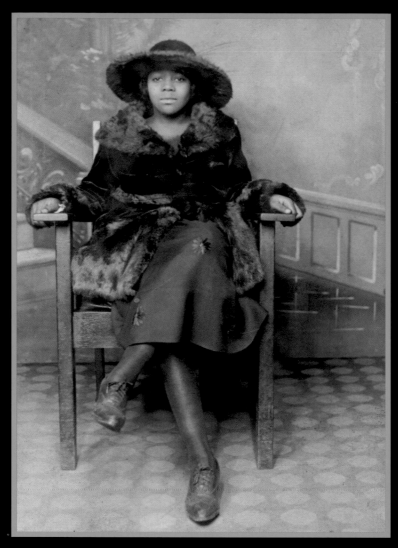

Studio portrait, 1920s.

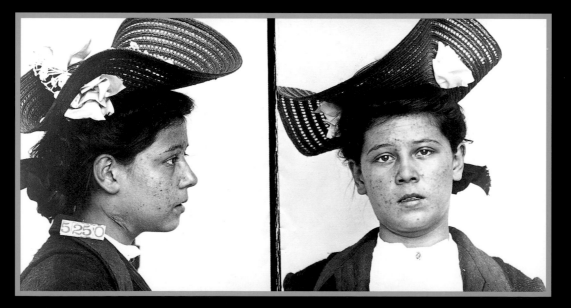

Mug shot, Lizzie Cardish, fifteen, arsonist, 1906.

Family snapshot, Tony, ca. 1950s.

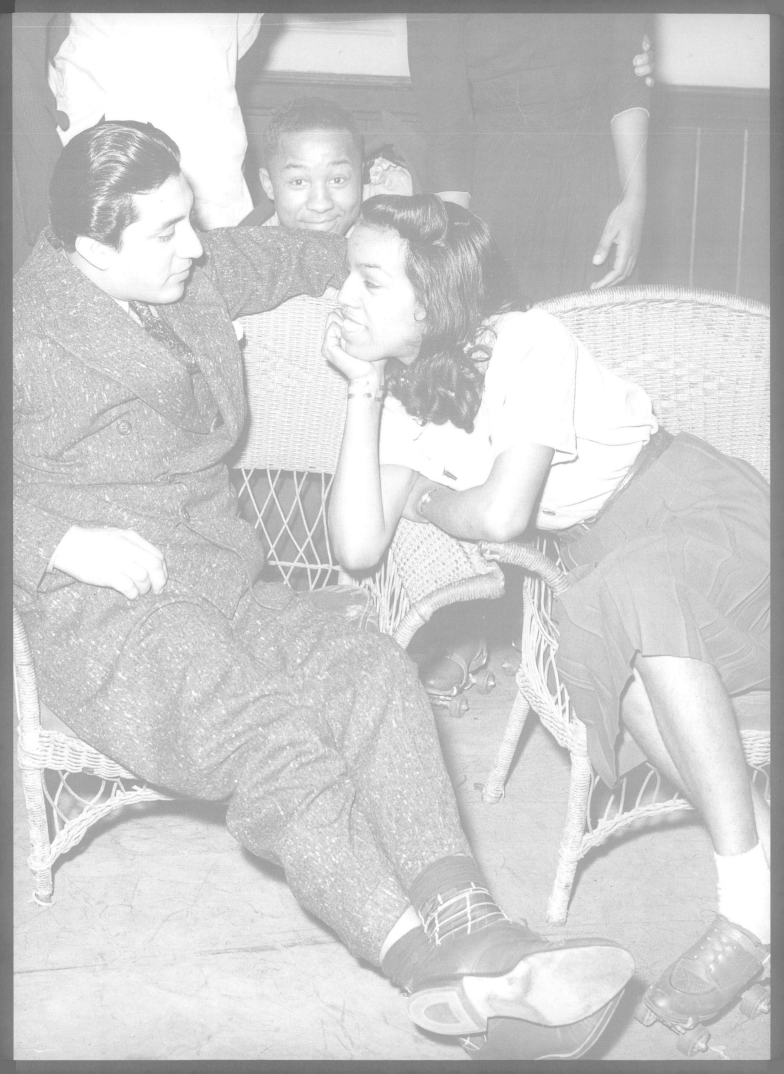

PART EIGHT

COURTSHIP
AND MARRIAGE

CHILDREN COURT, ENGAGE IN A VARIETY of sexual activities, and get married. They even give birth to more children. This has always been true and will almost certainly always be true. And it makes most Americans profoundly uncomfortable. We would like to think that, when children have sex, either they're not really children or it's not really sex.

Part of our ambivalence arises from the fact that since the Victorian era Americans have tried to equate sex with marriage. And marriage often signals the taking on of adult responsibilities. But the ever-lengthening period of adolescence makes this equation less and less tenable. Today, people are biologically ready to have sex long before society considers them ready for marriage.

Before European settlement, American tribal societies considered children ready for courtship and marriage when they were sexually mature and had mastered the skills necessary to support a household, perhaps at fifteen for girls and a few years older for boys. European colonists varied in this respect. In New England, fathers often used their control of the land to keep their sons at home well into their twenties. In the Chesapeake, on the other hand, young people, especially girls, were often married at fifteen or sixteen. Enslaved young women were usually married in their late teens.

Courtship also varied. In the North, where marriages came later, there was considerably more sexual freedom in courtship. During the 1780s and 1790s in rural New England, about a third of all young women were pregnant when they got married. Sexual activity among young people was accepted and even expected, so long as a couple married when the girl became pregnant. In the South, where marriages came earlier, courting was a more closely chaperoned affair. Both cultures seemed to recognize that people are going to have sex during adolescence. Society, therefore, must either shorten adolescence and let people marry early (the South) or let them have sex without marriage (the North).

This situation changed in the nineteenth century. By 1840, in most New England towns, only about one bride in five was pregnant, and by 1860 the rate had dropped to one in twenty. That shift reflected the sentimentalizing of chaste womanhood that accompanied the Industrial Revolution and the reign of Queen Victoria in England. Childhood, equally, was cast in a rosy and romantic light. The line was ever more strictly drawn between child and adult, and the post-puberty, pre-marriage period of life was dealt with in a most Victorian way. Middle-class adolescents, these essentially new creatures, were occupied making fudge and playing charades. Eventually, these strange American courtship rituals would produce the modern teenager, who only fully emerged in the 1950s.

By this time, the marriage age had begun to drop again. In 1959, 47 percent of all brides were under nineteen. As a result, courtship also began earlier. Children of twelve or thirteen began dating, often with the full support of their parents and communities. The other corollary to early marriage—stricter sexual limitations before marriage— also became the norm.

Since the 1950s, the age at which people in America marry has risen steadily, for reasons that include better education and job opportunities for women. At the same time, physical puberty has begun earlier, and there has been considerable societal approval for the early appearance of courting customs such as makeup and dancing. Judging from the past, this long adolescence should mean that society will tolerate more sexual activity from people before marriage. And sure enough, we do. But at the same time, we have decided that childhood extends through the teenage years and decry the sexually explicit behavior of teenagers on Main Street and MTV.

The progression of images in this section, from a formal post-wedding photograph taken in California in the 1850s to a documentary photograph of two teenagers necking taken in Texas in the 1970s by a photographer for the Environmental Protection Agency, reveals a parallel progression in courtship in America. While illustrators might record the casual, even bawdy, side of courtship, images of actual individuals almost always show us what was socially acceptable at any given time in our history. Crucial turning points in courtship are revealed in images such as that of the couple sitting next to an automobile, which presented an unprecedented opportunity for privacy.

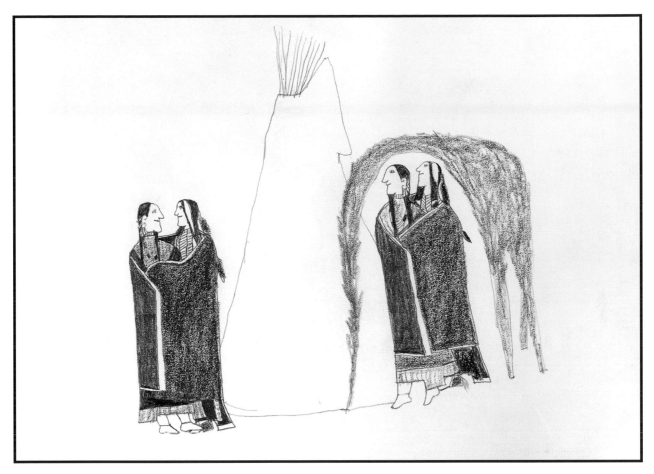

Kiowa artist Wo Haw portrayed these courting couples in a ledger painting done in about 1870.

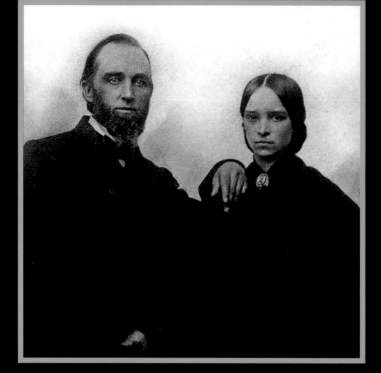

*Ascension Sepulveda de Mott, age sixteen or seventeen, poses with her
new husband, Thomas Dillingham Mott, ca. 1861.*

OCTOBER 20

Well, here comes the glory, the Major, so bashful, so famous, &c. He shou'd come before the
Captain, but never mind. I at first thought the Major cross and proud, but I was mistaken.
He is about nineteen, nephew to the Gen'l, and acts as Major of brigade to him; he cannot
be extoll'd for the graces of person, but for those of the mind he may justly be celebrated;
he is large in his person, manly, and [has] an engaging countenance and address.

OCTOBER —

The Gen'l still here; the Major still bashfull

OCTOBER —

I was diverting Johnny at the table, when he [the Major] drew up his chair to it and began
to play with the child. I ask'd him if he knew N. Bond. 'No, ma'am, but I have seen her often.'
One word brought on another, and we chatted the greatest part of the evening. He said he
knew me directly he saw me. Told me exactly where we liv'd.

OCTOBER 29TH

I walk'd into aunt's this evening. I met the Major. Well, thee will think I am writing his his-
tory; but not so. Pleased with the encounter, Liddy, Betsy, Stodard, and myself, seated by
the fire, chatted away an hour in lively and agreeable conversation. I can't pretend to write
all he said; but he shone in every subject that we talk'd of.

Sally Wister, a Quaker girl of fifteen, in her diary in 1777

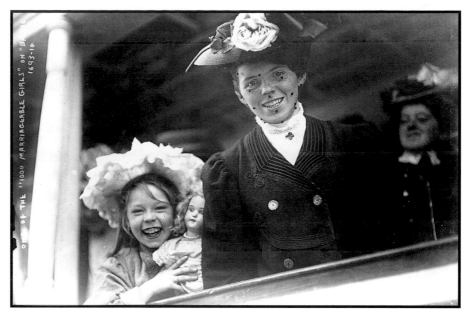

"One of 1000 marriageable girls" arrives at Ellis Island in 1907.

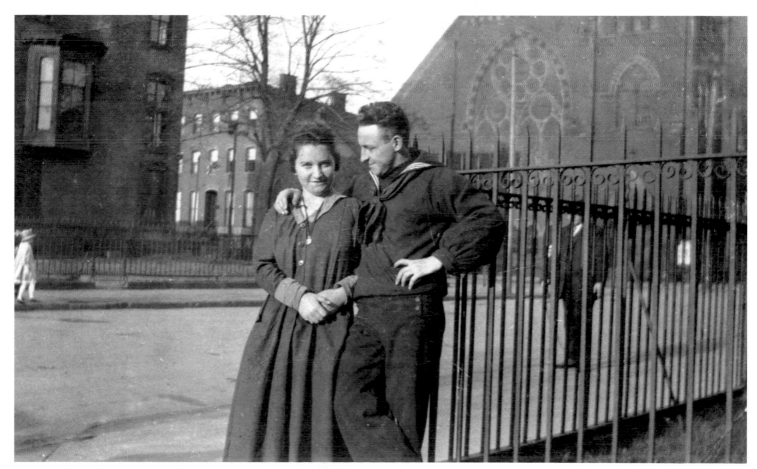

A young sailor smiles at his girl in this ca. 1910 photograph.

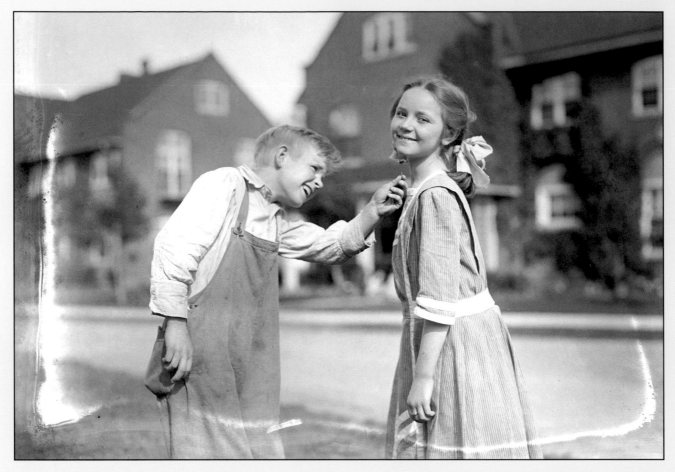

A boy in Rochester, New York, places a buttercup under a girl's chin to see if she likes butter at the Hillside Home for Children.
ALBERT R. STONE

TUESDAY, JANUARY 2, 1883

At school all day: sisters May & Belle & I went to Singing school in the evening at the school-house. Mr. Hittle teaches. Bert Plunket walked home with me. Here are our descriptions. I am fifteen years old, black hair, & big black eyes. My hair curls. Bert is 15, just my height, has blue eyes and light hair. We are both *heavy* for our ages, and everyone says, we are *"an awful cute little couple."* Bert is six months the oldest.

TUES. 9

At school. Went to "Singing in the eve. Bert walked home with me. Irve Schofield and Emery Savage want to go with me and some others too, but I'll stick to Bert, I think.

TUES. 23

At school. Went to "Singing" in the evening with Pa, May & Belle, and Bert Plunket walked home with me. My step-mother says, if I don't quit letting boys walk home with me, she will put us all to bed, for we are only children: *she can't put me to bed, anyhow.*

Martha Farnsworth, 1883

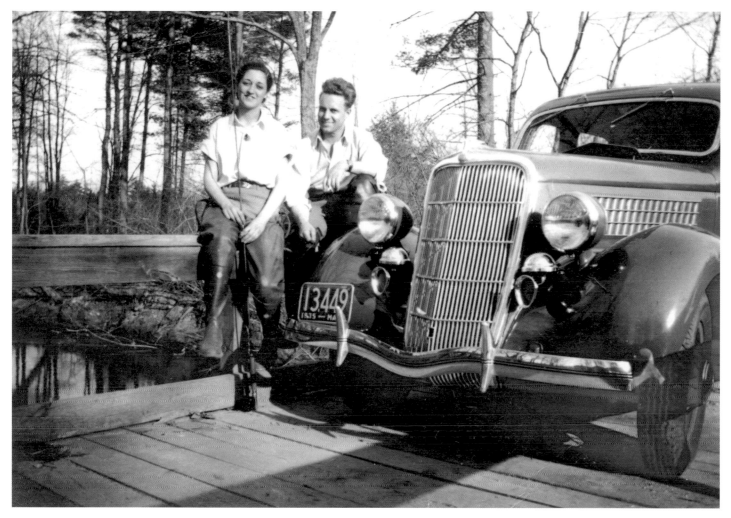

This couple in the 1930s illustrates the new courtship freedom allowed by the availability of the automobile.

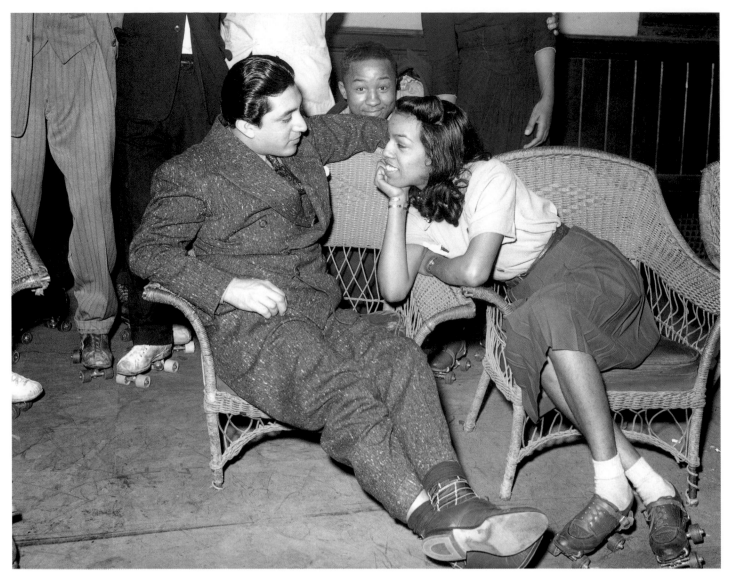

A couple flirts at a roller rink on the South Side of Chicago in 1941. RUSSELL LEE

Diane Epstein dances with her date, ca. 1957.

OK ON WITH THE ME AND JOHN CAUSE I KNOW PPL ARE INTERESTED in my opinion. I love john to death. He's one of my best friends and my sis's bro. I just felt like i could trust him with anythin. I loved to hang, talk, and cuddle with him. Well not until the night of the tot did i like him like in a boyfriend kind of way. he's a charmer and i should've realized by his kisses that he wasnt so sure about the decisions he was making. Trust me I am good at these things, but i guess i just didnt want to admit it. Well, to sum it all up i was really happy and we hung and stuff. then at the end we were "officially" a couple. It felt strange cause i knew that right then and there was where all the fun was gonna end. . . . Today we broke up while me and Justin were fighting. . . . I think the breakup is all for the best. . . . God has a plan and i just have to trust in him. I dont want a relationship right now anyways.

AnAngelWithHornes, age 15, female, from The Open Diary website

A teenage couple kisses on the banks of the Frio Canyon River near Leakey and San Antonio, Texas, in May 1973. MARC ST. GIL

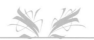

MY MOTHER USED TO COME IN OUR ROOM; THE GIRLS SLEPT in one room and the boys in another. She would come in right before lights out and talk to us. "Don't let what's happening to me happen to you all." Her talks got really intense once my sisters started dating; "Don't let him go out and you don't know where he is, and you don't know how to drive, and one of your kids is sick and you don't know how to get them to the hospital." Let's see, I must have been about ten or eleven when I started hearing this. Like nightly.

Maria Jimenez

A teenage mother buys shoes for her son in Massachusetts in January 1980. BETTYE LANE

EPILOGUE

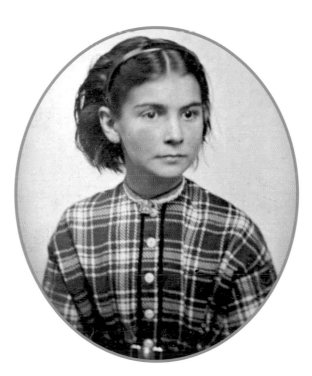

1860s tintype

The idealized image of childhood we carry in our minds is today being held up as a paradigm by legislators and pundits in serious debates. It underlies most public discussion of the problems of children in this country.

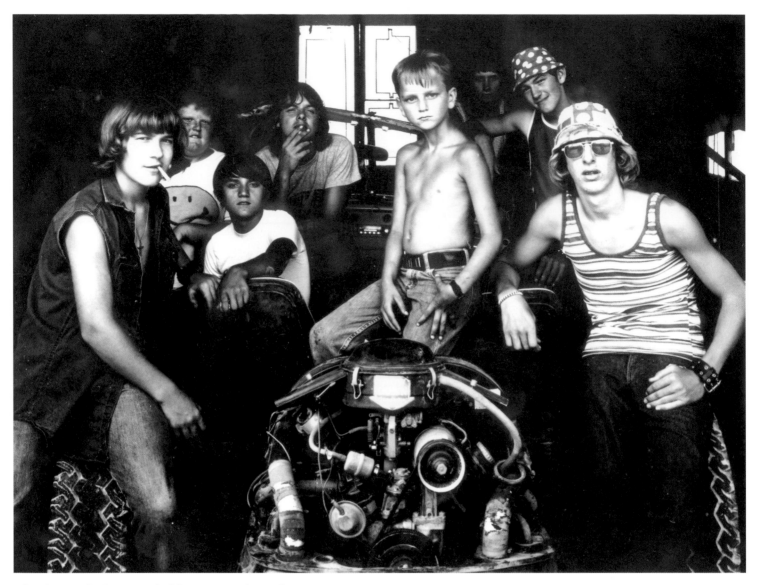

This photograph of a group of adolescents was taken in the 1970s.

Human beings under the age of eighteen are being victimized and demonized, cosseted and excoriated. On one side, politicians and journalists blame our young for violence in the street and the continuation of the welfare system. On another, parents are so fearful of the dangers of the world at large that they hold their children in ever more constraining bonds.

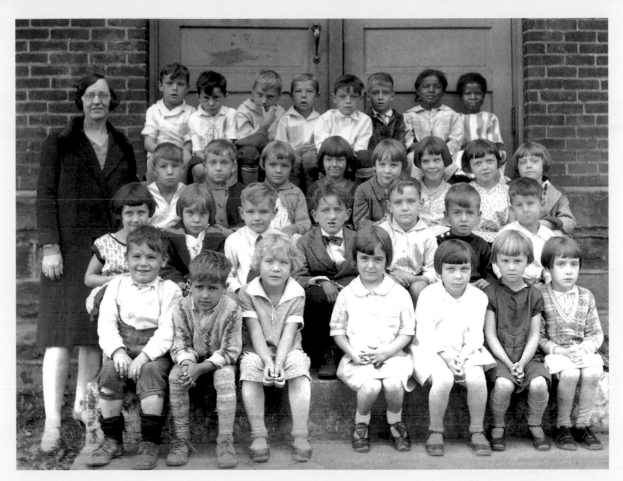

A school portrait from Ohio in the 1920s shows an oddly assorted group of children. Several of them are suffering from physical conditions that would, today, be corrected in early childhood.

We don't seem to know how to raise our children, educate them, or guide them into adulthood. But was there ever a time when we did? And who is "we"? Different regions, ethnicities, and classes have always had very different views on how to raise children—even on what constitutes childhood.

Children who break away from our modern idea of childhood are treated as dangerous aberrations. This is not because children have not always joined gangs, committed crimes, or had babies, as well as played and learned, but because these acts betray our idealized sense of childhood.

Sixteen-year-old Charles Nichols works in a shoemaker's shop in a Colorado reform school in the 1920s.

This photograph of a Salvation Army picnic was printed in the Rochester Herald, *July 16, 1921.* ALBERT R. STONE

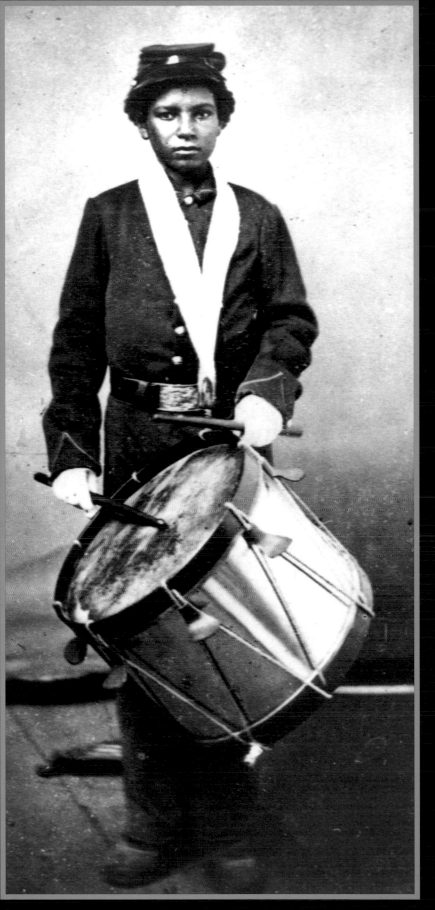

Taylor, a drummer boy during the Civil War, served with the 78th Regiment of the
United States Colored Infantry.

We cannot solve the problems of today's diverse, multicultural, and multi-class children by trying to replicate a single model that never existed as a reality for most children. We need to remember that throughout our history, children have worked, fought, *and* played alongside adults.

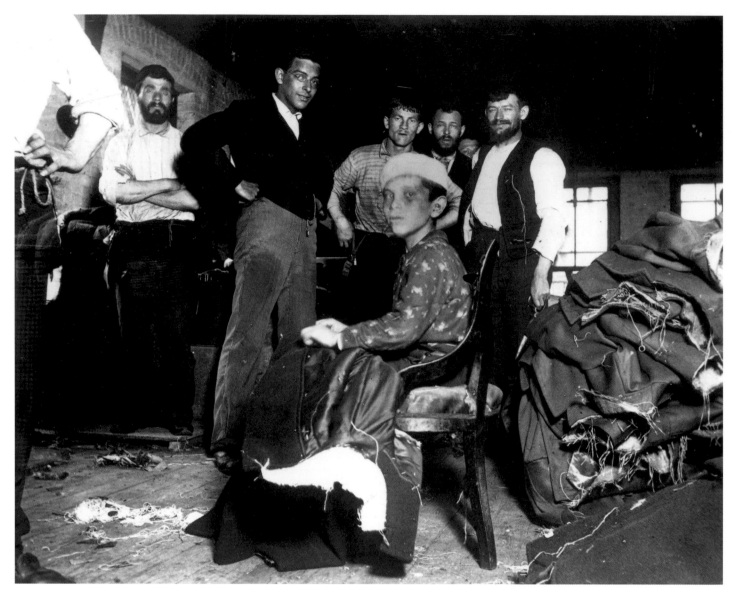

A twelve-year-old boy works in a sweatshop pulling threads, ca.1889. He swore to the photographer that he was sixteen. JACOB RIIS

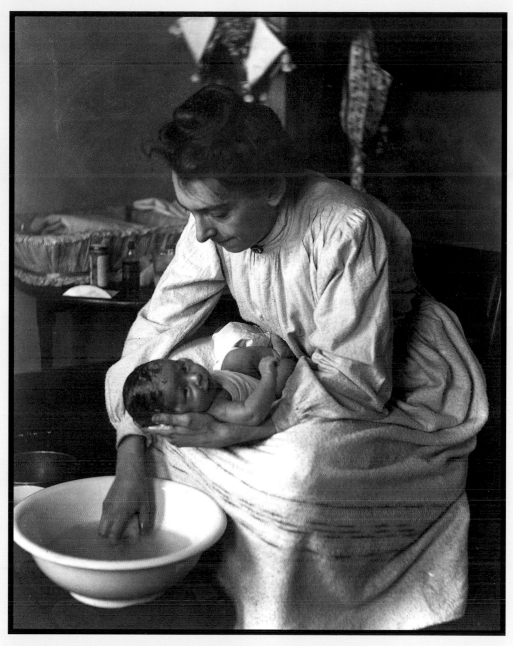

Grace Taft washes her six-week-old daughter, Edna, in February or March of 1903. This image is part of a series taken by Edna's father, Henry Arthur Taft, entitled "How to Bathe a Baby."

There have always been some children who were cruel and violent, some who were exploited, and some who were loved. Child labor and poverty are ongoing problems, neither new nor "over."

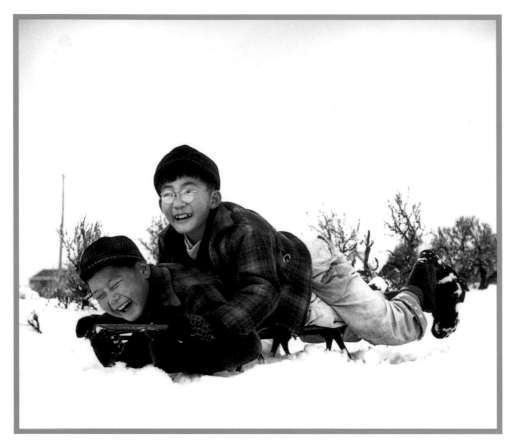

Teshie Boi (bottom) and Henry Kumasaka (top) take up sledding at the Minidoka Relocation Center in Minidoka, Idaho, during World War II. FRANCIS STEWART

Work and hunger and crisis have been the very materials out of which childhood has been woven in our history. These realities are the fabric of the history of childhood, not isolated flaws within it. The image of the happy child playing on a green lawn —while comforting for most, and true for some— is getting in our way.

Addressing the issues of today's youth and children is going to require a change of consciousness. We need knowledge, not chimeras, and knowledge is not merely a matter of statistics and social theory. Changing our largely visceral sense of childhood means changing the images that inhabit our minds and feed our imaginations.

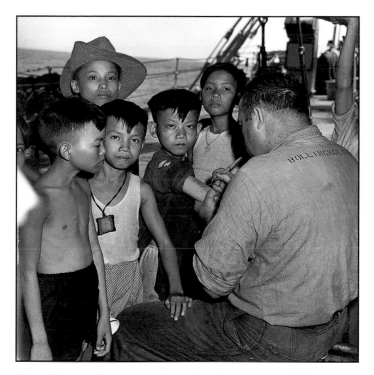

These Vietnamese boys were refugees aboard the USS Bayfield *in September 1954, the year the United States took over the battle against North Vietnam from the French.*

Elizabeth Shick, Jacob Shick, Adrian Nobert, Lauren Poll, and Gabriel Nobert eat popsicles in Shaker Heights, Ohio, in 1998. The neighborhood had raised money to send Andrew Poll, his sister, and his parents to a conference on osteogenesis imperfecta. This is the party the Polls threw for the neighborhood to say thank you.

National Museum of the American Indian, Smithsonian Institution, Cultural Resource Center, Suitland, Maryland

National Portrait Gallery, Washington, D.C., http://portraits.npg.si.edu/

Nebraska State Historical Society, http://www.nebraskahistory.org/lib-arch/research/photos/index.htm

New York Daily News Archives

New York Public Library
Schomburg Center for Research in Black Culture, http://www.nypl.org/research/sc/sc.html
Print Collection, http://www.nypl.org/research/chss/spe/art/print/print.html

New-York Historical Society, New York, New York

New Deal Network, http://newdeal.feri.org/index.htm

North Dakota State University, North Dakota Institute for Regional Studies, Fargo, Northern Great Plains, Photographs from the Fred Hulstrand and F.A. Pazandak Photograph Collections, http://memory.loc.gov/ammem/award97/ndfahtml/

Old Dartmouth Historical Society/New Bedford Whaling Museum, New Bedford, Massachusetts

Public Library of Charlotte-Mecklenburg County
African American Album, v. 1., http://www.cmstory.org/african/album/volume1
African African American Album, v. 2., http://www.cmstory.org/aaa2/menu.htm

Quinault Museum, Quinault, Washington

Rochester Museum & Science Center, Rochester, New York

Rochester Images, Central Library of Rochester and Monroe County, New York, http://www.rochester.lib.ny.us/rochimag/

Seaver Center for Western History Research, Los Angeles, California

Smithsonian Institution Research Information System, http://www.siris.si.edu/

Texas Humanities Resource Center, http://www.humanities-interactive.org/nonjavaindex.html#exhibit

U.S. Army Military History Institute, Carlisle, Pennsylvania

University of California, Berkeley
Bancroft Library
Phoebe A. Hearst Museum of Anthropology

University of North Carolina, Chapel Hill
Southern Historical Collection
North Carolina Collection

University of Texas at Austin, Center for American History, South Texas Border, Photographs from the Robert Runyon Collection, http://memory.loc.gov/ammem/award97/txuhtml/runyhome.html

University of Virginia Library, Holsinger Studio Collection, http://www.lib.virginia.edu/speccol/holsinger/

University of Washington Libraries Digital Collection, http://content.lib.washington.edu/advanced-search.html

Valentine Museum, Richmond, Virginia

Virginia Tech Image Base, http://imagebase.lib.vt.edu/

Winterthur Museum, Winterthur, Delaware

Wyoming State Archives, Laramie

FAMILIES AND INDIVIDUALS

We used images from numerous individuals who allowed us access to their own photographs, from family albums to priceless historical collections.

Andra Medea
Ann Henry
Benedict J. Fernandez
Bettye Lane
Carmen Eckman
Carolina Velasquez
Carroll Parrott Blue
Cathie Lyons
Currie Ballard
Chonita Earle
David Richmond
Dave Buchen
Deena Valdez
Diane Epstein
Eunice Hundseth
Gayle Calabrese
Ilka Hartmann
Jeffry Scott
Jim Newberry
Karen Kring
Kathleen Praxel
Kathy Clayton
Kay Berkson
Lavinia Prescott Ferguson and Patricia Olson-Prescott
Lydia Ann Douglas/Peazey Head Productions
Mary Christiansen and Jigger Davis
Michael Taylor
Nadia Oehlsen
Nan Rutledge
Nestor Hernandez
Phyllis Miller
Ralph Carlson
Sumpter Priddy III
The Falk Family
The Austin Family
The Grobman Family
The Neel Family
The Nobert Family
The Nowak Family
The Thompson Family
The Tofflemire-Bundy Family
Vera Viditz-Ward
Yale Strom
and the Estate of Charles "Teenie" Harris

BOOKS

In addition to searching through archives and family collections, the editors looked through many different books for potentially suitable images. Not all the books listed here supplied images for *America's Children*, but they were all useful.

Abby Aldrich Rockefeller Folk Art Center. *American Folk Portraits:*

Paintings and Drawings from the Abby Aldrich Rockefeller Folk Art Center. Boston: New York Graphic Society, 1981.

Albright, Peggy, with a foreword by Joanna Cohan Scherer. *Crow Indian Photographer: The Work of Richard Throssel.* Albuquerque, N.M.: University of New Mexico Press, 1997.

Alland, Alexander, Sr., with a preface by Ansel Adams. *Jacob A. Riis: Photographer & Citizen.* Millerton, N.Y.: Aperture, 1974.

Bartoletti, Susan Campbell. *Kids on Strike!* New York.: Houghton Mifflin Company, 1999.

Berlo, Janet Catherine, ed. *Plains Indian Drawings, 1865–1935: Pages from a Visual History.* New York: Harry N. Abrams in association with the American Federation of Arts and the Drawing Center, 1996.

Bettmann, Otto L. *The Good Old Days—They Were Terrible!* New York: Random House, 1974.

Bishop, Eleanor C. *Ponies, Patriots and Powder Monkeys: A History of Children in America's Armed Forces.* Del Mar, Calif.: Bishop Press, 1982.

Boime, Albert. *The Art of Exclusion : Representing Blacks in the Nineteenth Century.* Washington. Smithsonian Institution Press, 1990.

Brant, Sandra and Elissa Cullman. *Small Folk: A Celebration of Childhood in America.* New York: E. P. Dutton: Museum of American Folk Art, 1980.

Brilliant, Richard, ed., with an essay by Ellen Smith. *Facing the New World: Jewish Portraits in Colonial and Federal America.* New York: Prestel and Jewish Museum, 1997.

Bustard, Bruce I. *Picturing the Century: One Hundred Years of Photography from the National Archives.* Seattle: University of Washington Press, in association with the National Archives Trust Fund Board, 1999.

Cable, Mary. *American Manners and Morals: A Picture History of How We Behaved and Misbehaved.* New York: American Heritage Publishing Company, 1969.

Campbell, Edward D. C., Jr., with Kym S. Rice. *Before Freedom Came: African-American Life in the Antebellum South: to Accompany an Exhibition Organized by the Museum of the Confederacy.* Richmond: The Museum; Charlottesville: University Press of Virginia, 1991.

Centuries of Childhood in New York: A Celebration on the Occasion of the 275th Anniversary of Trinity School. New York: New-York Historical Society, Trinity School, 1984.

Da Costa Nunes, Jadviga M., and Ferris Olin. *Baroness Hyde de Neuville: Sketches of America 1807–1822.* New Brunswick, N.J.: Jane Voorhees Zimmerli Art Museum, Rutgers, State University of New Jersey; New York: New-York Historical Society, 1984.

Deak, Gloria-Gilda. *Picturing America, 1497–1899: Prints, Maps and Drawings Bearing on the New World Discoveries and on the Development of the Territory that is now the United States.* Princeton, N.J.: Princeton University Press, 1988.

Dicker, Laverne Mau, with a preface by Thomas W. Chinn. *The Chinese in San Francisco: A Pictorial History.* New York: Dover Publications, Inc., 1979.

Freedman, Russell. *Kids at Work: Lewis Hine and the Crusade Against Child Labor.* New York: Clarion Books, 1994.

Genthe, Arnold, with text by Will Irwin. *Old Chinatown: A Book of Pictures,* New York: M. Kennerley, 1913.

Goldberg, Vicki. *Lewis W. Hine: Children at Work.* Munich; New York: Prestel Verlag, 1999.

Handlin, Oscar. *A Pictorial History of Immigration.* New York: Crown Publishers, Inc., 1972.

Harding, Anneliese. *John Lewis Krimmel: Genre Artist of the Early Republic.* Winterthur, Del.: Winterthur Publications, 1994.

Haviland, William A., and Marjory W. Power. *The Original Vermonters: Native Inhabitants, Past and Present.* Hanover, N.H., and London: University Press of New England, 1981.

Hirschfelder, Arlene B., with a foreword by Beverly Wright. *Native Americans.* London: Dorling Kindersley Publishing, Inc., 2000.

Hughes, Langston, and Milton Meltzer. *A Pictorial History of African Americans.* 6th updated ed. New York: Crown Publishers, 1995.

Jennings, Peter, and Todd Brewster; photographs edited by Katherine Bourbeau. *The Century.* New York: Doubleday, 1998.

Johnson, Thomas L. and Phillip C. Dunn, eds. *A True Likeness : The Black South of Richard Samuel Roberts, 1920–1936.* Columbia, S.C.: Bruccoli Clark; Chapel Hill, N.C.: Algonquin Books of Chapel Hill, 1986.

Johnson, Tim, ed. *Spirit Capture: Photographs from the National Museum of the American Indian.* Washington D.C.: Smithsonian Institution Press in association with the National Museum of the American Indian, 1998.

Luchetti, Cathy, in collaboration with Carol Olwell. *Women of the West.* 1st Orion edition. New York: Orion Books, 1992.

Peavy, Linda S., and Ursula Smith, with a foreword by Elliott West. *Frontier Children.* Norman: University of Oklahoma Press, 1999.

Rochlin, Harriet. *Pioneer Jews: A New Life in the Far West.* Boston: Houghton Mifflin Company, 1984.

Rumford, Beatrix T., and Caroline J. Weekley. *Treasures of American Folk Art from the Abby Aldrich Rockefeller Folk Art Center.* Boston: Little, Brown in association with the Colonial Williamsburg Foundation, 1989.

Sandler, Martin W., with an introduction by James Billington. *Pioneers: A Library of Congress Book.* New York: HarperCollins Publishers, 1995.

———. *Immigrants: A Library of Congress Book.* New York: HarperCollins Publishers, 1994.

Shadows in Silver; a Record of Virginia, 1850–1900, in Contemporary Photographs Taken by George and Huestis Cook. New York: Scribner, 1954.

Spargo, John, with an introduction by Robert Hunter. *The Bitter Cry of the Children.* New York: The Macmillan Company, 1906.

Strom, Yale. *Quilted Landscape: Conversations with Young Immigrants.* New York: Simon & Schuster Books for Young Readers, 1996.

Szabo, Joyce M. *Howling Wolf and the History of Ledger Art.* Albuquerque, N.M.: University of New Mexico Press, 1994.

Trachtenberg, Alan, with a foreword by Walter Rosenblum. *America & Lewis Hine.* New York: Aperture Foundation, Inc., 1977.

Through Indian Eyes: The Untold Story of Native American Peoples. Pleasantville, N.Y.: Readers Digest Association, 1995.

Tirsch, Ignacio, narrative by Doyce B. Nunis, Jr., translation by Elsbeth Schulz-Bischof. *The Drawings of Ignacio Tirsch: A Jesuit Missionary in Baja California.* Los Angeles: Dawson's Book Shop, 1972.

Ward, Geoffrey C.; based on a documentary film script by Geoffrey C. Ward and Dayton Duncan; with a preface by Stephen Ives and Ken Burns. *The West: An Illustrated History.* Boston: Little, Brown, 1996.

Weegee's New York: Photographs 1935–1960. With an introduction by John Coplans. New York: te Neues Publishing Company; A Schirmer/Mosel Production, 1982/1996.

Williamson, Stanford Winfield. *With Grief Acquainted.* Chicago: Follett, 1964.

Willis, Deborah. *Reflections in Black: A History of Black Photographers, 1840 to the Present.* New York: W. W. Norton & Company, 2000.

Yung, Judi. *Chinese Women of America: A Pictorial History.* Seattle: Published for the Chinese Cultural Foundation of San Francisco by University of Washington Press, 1986.

TEXT SOURCES

The text passages in *America's Children* were taken from these sources.

BOOKS

Anderson, Chester G., ed. *Growing up in Minnesota: Ten Writers Remember Their Childhoods.* Minneapolis: University of Minnesota Press, 1976.

Bartoletti, Susan Campbell. *Growing up in Coal Country.* Boston: Houghton Mifflin Co., 1996.

Bishop, Eleanor C. *Ponies, Patriots, and Powder Monkeys: A History of Children in America's Armed Forces, 1776–1916.* Del Mar, Calif.: Bishop Press, 1982.

Blackwell, Alice Stone. *Growing up in Boston's Gilded Age: The Journal of Alice Stone Blackwell, 1872–1874.* Edited by Marlene Deahl Merrill. New Haven: Yale University Press, 1990.

Clark-Lewis, Elizabeth. *Living In, Living Out: African American Domestics and the Great Migration.* New York: Kodansha International, 1996.

Davis, Marilyn P. *Mexican Voices/American Dreams: An Oral History of Mexican Immigration to the United States.* New York: Henry Holt, 1990.

Graham, Judith S. *Puritan Family Life: The Diary of Samuel Sewall.* Boston: Northeastern University Press, 2000.

Hampsten, Elizabeth. *Settlers' Children: Growing up on the Great Plains.* Norman: University of Oklahoma Press, 1991.

Hart, Albert Bushnell, ed., with Blanche E. Hazard. *Colonial Children.* New York: Macmillan, 1901. Available through Electronic Text Center, University of Virginia Library.

Hunter, Latoya. *The Diary of Latoya Hunter: My First Year in Junior High.* New York: Crown, 1992.

I Was a Slave: True Stories told by former American Slaves in the 1930s: Chapter 5: The Lives of Slave Children. Compiled by Donna Wyant Howell. Washington, D.C.: American Legacy Books, 1997.

Katz, William Loren. *Eyewitness: A Living Documentary of the African American Contribution to American History.* 1st Touchstone edition. New York: Simon & Schuster, 1995.

King, Wilma. *Stolen Childhood: Slave Youth in Nineteenth-Century America.* Bloomington, Ind.: Indiana University Press, 1995.

Kusz, Natalie. *Road Song.* New York: Farrar Straus Giroux, 1990.

Letters from Immigrant Girls to Newspapers. From American Journey Online: The Women in America. Woodbridge, Conn.: Primary Source Media, 1999. Reproduced in Student Resource Center. Farmington Hills, Mich.: Gale Group, December, 2000.

Lane, Lunsford. *The Narrative of Lunsford Lane, Formerly of Raleigh, N.C. Embracing an Account of His Early Life, the Redemption by Purchase of Himself and Family from Slavery, and His Banishment from the Place of His Birth for the Crime of Wearing a Colored Skin. Published by Himself.* Boston: J. G. Torrey, Printer, 1842. Electronic Text, University of North Carolina at Chapel Hill Libraries: Documenting the American South.

Mellon, James, ed. *Bullwhip Days: The Slaves Remember.* New York: Weidenfeld & Nicolson, 1988.

Mineham, Thomas. *Boy and Girl Tramps of America.* Farrar and Rinehart. New York: 1934. Americana Library edition, introduction by Donald W. Whisenhunt. Seattle: University of Washington Press, 1976.

Murray, Pauli. *Pauli Murray: The Autobiography of a Black Activist, Feminist, Lawyer, Priest, and Poet* (formerly *Song in a Weary Throat*). Knoxville: University of Tennessee Press, 1989.

Nunis, Doyce B., Jr., ed.; pictorial editor, Jennifer A. Watts. *Women in the Life of Southern California.* Los Angeles: Historical Society of Southern California, 1996.

Nunis, Doyce B., Jr., ed., with a foreword by Honorable Señor Eduardo Garrigues. *Southern California's Spanish Heritage: An Anthology.* Los Angeles: Historical Society of Southern California, 1992.

O'Connor, Stephen. *Orphan Trains: The Story of Charles Loring Brace and the Children He Saved and Failed.* Boston: Houghton Mifflin, 2001.

Peavy, Linda S., and Ursula Smith, with a foreword by Elliott West. *Frontier Children.* Norman: University of Oklahoma Press, 1999.

Pennington, James W. C. *The Fugitive Blacksmith or, Events in the History of James W.C. Pennington, 2nd ed.* London, 1849.

Rae, Noel, ed. *Witnessing America: The Library of Congress Book of Firsthand Accounts of Life in America 1600–1900.* New York: Penguin Reference, 1996.

Raymundo, Angeles Monrayo. *Diary of Angeles Monrayo Raymundo.* Reproduced in Student Resource Center. Farmington Hills, Mich.: Gale Group, December 2000.

Register, Cheri. *"Are Those Kids Yours?": American Families with Children Adopted from Other Countries.* New York: Free Press, 1991.

Ross, Lillian. "Letter." *St. Nicholas,* February 1909.

Helen A. Russell, "My Journey to Ellis Island." *St. Nicholas,* August 1907.

Sloane, Eric. *Diary of an Early American Boy, Noah Blake, 1805.* New York: W. Funk, 1962.

Sterling, Dorothy, ed. *We Are Your Sisters: Black Women in the Nineteenth Century.* New York: Norton, 1984.

Taulbert, Clifton L. *Once Upon a Time When We Were Colored.* Tulsa, Okla.: Council Oak Books, 1989.

Taylor, Susie Baker King. *Reminiscences of My Life in Camp with the 33rd U. S. Colored Troops, Late 1st South Carolina Volunteers,* 1902. Published as *A Black Woman's Civil War Memoirs,* ed. Patricia W.

Romero, with an introduction by Willie Lee Rose. New York: Markus Wiener Publishing, 1988.

Tuttle, William M. *"Daddy's Gone to War": The Second World War in the Lives of America's Children.* New York: Oxford University Press, 1993.

Walker, Rebecca. *Black, White, and Jewish: Autobiography of a Shifting Self.* New York: Riverhead Books, 2001.

Wallace, Katie Darling. *Child of Glencoe: Civil War Journal of Katie Darling Wallace.* Edited by Eleanor P. Cross and Charles B. Cross, Jr. Chesapeake: Norfolk County Historical Society of Chesapeake, Virginia, 1983.

Weiser, Glenn. "Woodstock '69 Remembered." Glenn Weiser Website. celticguitarmusic.com.

"We Made Do," oral history project of the Mooresville High School in Mooresville, Indiana.

Werner, Emmy E. *Through the Eyes of Innocents: Children Witness World War II.* Boulder: Westview Press, 2000.

———, *Pioneer Children on the Journey West.* Boulder: Westview Press, 1995.

———, *Reluctant Witnesses: Children's Voices from the Civil War.* Boulder: Westview Press, 1998.

Wheeler, Kathryn. *Diary of Kathryn Wheeler.* Claremont, Calif., 1918. Austin/Thompson Collection.

Winslow, Anna Green. *Diary of Anna Green Winslow, a Boston School Girl of 1771,* ed. by Alice Morse Earle. Boston and New York: Houghton, Mifflin and Company, 1894.

Wister, Sarah. *Sally Wister's Journal.* Edited by Albert Cook Myers. New York: New York Times, 1969.

Wormser, Richard. *Growing Up in the Great Depression.* Atheneum. New York: 1994.

OTHER SOURCES

EXHIBIT

Berkson, Kay, with Jill Rohde and Brenda Berman. *Changing Worlds—From Around the World to a Chicago Neighborhood: Stories and Portraits.* Created by Changing Worlds, a not-for-profit organization. Funded by the Mayer and Morris Kaplan Family Foundation and the Field Foundation of Illinois, Inc.

ONLINE SOURCES

OpenDiary.com

Diaryland.com

Civil Rights in Mississippi Digital Archive, University of Southern Mississippi Libraries and Center for Oral History and Cultural Heritage, www.lib.usm.edu

RESEARCH SOURCES

In addition to those listed in the bibliographies above, these are the primary publications consulted for the introductions and captions in *America's Children.*

Axtell, Horace P., and Margo Aragon. *A Little Bit of Wisdom: Conversations with a Nez Perce Elder.* Lewiston, Idaho: Confluence Press, 1997.

Bakeless, John Edwin. *America as Seen by Its First Explorers: The Eyes of Discovery.* Mineola, N.Y.: Dover Publications, 1989.

Barrett, Tracy. *Growing up in Colonial America.* Brookfield, Conn.: Millbrook Press, 1995.

Berlin, Ira, ed. *Free at Last: A Documentary History of Slavery, Freedom, and the Civil War.* New York: The New Press, 1992.

Cahn, Rhoda, and William Cahn. *No Time for School, No Time for Play; the Story of Child Labor in America.* New York: J. Messner, 1972.

Coles, Robert. *Uprooted Children; The Early Life of Migrant Farm Workers.* Pittsburgh: University of Pittsburgh Press, 1970.

Commager, Henry Steele, ed. *The Blue and the Gray: The Story of the Civil War as Told by Participants.* Indianapolis. Bobbs-Merrill, 1950.

Davies, Jon, and Norman Dennis. "From the Tyranny of Rules to the Whim of Relationships: The Family in Modern Society." *The World & I,* vol. 10, Dec. 1, 1995, p. 312.

Day, Alexandra, Cooper Edens, and Welleran Poltarnees. *Children from the Golden Age, 1880–1930.* San Diego: Green Tiger Press, 1987.

Earle, Alice Morse, with an introduction by Jack Larkin. *Child Life in Colonial Days.* Stockbridge: Berkshire House, 1993.

Freedman, Russell. *Kids at Work: Lewis Hine and the Crusade Against Child Labor.* New York: Clarion Books, 1994.

Ginzberg, Eli, ed. *The Nation's Children.* New Brunswick: Transaction Books, 1986, 1960.

Griswold, Robert L. *Fatherhood in America: A History.* New York: BasicBooks, 1993.

Gutman, Herbert. *The Black Family in Slavery and Freedom, 1750–1925.* New York: Vintage, 1977.

Hine, Darlene Clark, and Kathleen Thompson. *A Shining Thread of Hope: The History of Black Women in America.* New York: Broadway Books, 1996.

Hine, Darlene Clark, Elsa Barkley-Brown, and Rosalyn Terborg-Penn, eds. *Black Women in America: An Historical Encyclopedia.* Brooklyn: Carlson Publishing, 1992.

Holland, Ruth Robins. *Mill Child.* New York: Crowell-Collier Press, 1970.

King, Wilma. *Stolen Childhood: Slave Youth in Nineteenth-Century America.* Bloomington, Ind.: Indiana University Press, 1995.

Konner, Melvin. *Childhood.* Boston: Little, Brown, 1991.

James Mellon, ed. *Bullwhip Days: The Slaves Remember.* New York: Weidenfeld & Nicolson, 1988.

Mintz, Steven and Susan Kellogg. *Domestic Revolutions: A Social History of American Family Life.* New York: Free Press, 1988.

Nightingale, Carl Husemoller. *On the Edge: A History of Poor Black Children and Their American Dreams.* New York: Basic Books, 1993.

Postman, Neil. *The Disappearance of Childhood.* New York: Delacorte Press, 1982.

Riis, Jacob A. *How the Other Half Lives; Studies among the Tenements of New York.* With 100 photographs from the Jacob A. Riis Collection, the Museum of the City of New York, and a new pref. by Charles A. Madison. New York: Dover, 1971

Santiago, Esmeralda. *When I was Puerto Rican.* Reading, Mass.: Addison-Wesley, 1993.

Spargo, John, with an introduction by Robert Hunter. *The Bitter Cry of the Children.* New York: Macmillan, 1915.

Stacey, Judith. *In the Name of the Family: Rethinking Family Values in the Postmodern Age.* Boston: Beacon Press, 1996

Leon Stein, ed. *Out of the Sweatshop: The Struggle for Industrial Democracy.* New York: Quadrangle/New Times Book Company, 1977.

Stevenson, Brenda E. *Life in Black and White: Family and Community in the Slave South.* New York: Oxford, 1996.

Toynton, Evelyn. *Growing up in America, 1830-1860.* Brookfield, Conn.: Millbrook Press, 1995.

Wormser, Richard. *American Childhoods: Three Centuries of Youth at Risk.* New York: Walker and Co., 1996.

ILLUSTRATION CREDITS

PAGE

13 Courtesy of Anne Tofflemire.

14 Courtesy of David Richmond.

15 BOTTOM Courtesy of the photographer.

16 Courtesy of the Thompson family.

17 FSA/OWI Collection, Library of Congress, negative # LC-USF34-032714-D.

18 Courtesy of the photographer.

19 Courtesy of Mary Christiansen, Quinault, Wash., and Jigger Davis, Neilton, Wash.

20 TOP Courtesy of Ann Henry.

20 BOTTOM Austin/Thompson Collection.

21 TOP Austin/Thompson Collection.

21 BOTTOM Austin/Thompson Collection.

22 TOP Courtesy, National Museum of the American Indian, Smithsonian Institution, negative # P25571.

22 BOTTOM Immigration and Naturalization Service, San Francisco District Office, National Archives and Records Administration, Pacific Region, negative # NRHS-85-INSSFDEPCAS-12017 (2617)-1.

23 Courtesy of the Grobman family.

27 TOP Library of Congress, negative # LC-USZ62-585.

27 BOTTOM Florida Photographic Collection, Florida State Archives, image # rc11031.

28 TOP Print courtesy of the Texas Council for the Humanities. Permission granted by Museo de America, Madrid.

28 BOTTOM Library of Congress.

29 TOP The Metropolitan Museum of Art, negative # L36249.

29 BOTTOM Harmon Foundation Collection, National Archives and Records Administration, negative # NWDNS-H-HN-JOHNST-1.

30 Collection of the New-York Historical Society, I.D. # 37258.

31 Collection of the New-York Historical Society, I.D. #s 2841, 2842, 2843.

32 Library of Congress, negative # LC-USZC4-4575.

33 TOP Florida Photographic Collection, Florida State Archives, image rc18140.

33 BOTTOM Gayle Calabrese Collection.

34 Western History/Genealogy Dept., Denver Public Library, call # B-207.

35 North Dakota State University, North Dakota Institute for Regional Studies, Fargo, reproduction # Hult.243.

36 Courtesy of Bill Grobman.

37 TOP Austin/Thompson Collection.

37 BOTTOM Courtesy, Colorado Historical Society, negative # CHS-X3534.

38 TOP Lindsey Collection, Library of Congress, negative # LC-USZ62-30488.

38–39 Kansas State Historical Society, Topeka, negative # ATSF5/21.148.

40 TOP Courtesy of Phyllis Miller.

40 BOTTOM Austin/Thompson Collection.

41 Florida Photographic Collection, Florida State Archives, image # N045538.

42 TOP Courtesy of Ann Henry.

42 BOTTOM Manuscripts, Special Collections, University Archives Division, University of Washington Libraries, negative # Cobb 4175.

43 TOP Museum of the City of New York, negative # 90.13.3.118.

43 BOTTOM From the Albert R. Stone Negative Collection, Rochester Museum and Science Center, Rochester, N.Y., image # sct07613.

44 Courtesy of the Prescott family.

45 TOP Austin/Thompson Collection.

45 BOTTOM Courtesy of the Thompson family.

46 TOP The Charles L. Todd and Robert Sonkin Migrant Worker Collection, Library of Congress, American Folklife Center.

46 BOTTOM FSA/OWI Collection, Library of Congress, negative # LC-USF33-011299-M2

47 FSA/OWI Collection, Library of Congress, negative # LC-USF34-044910-D.

48 California Heritage Collection, Bancroft Library, University of California, Berkeley, image # 1967.014 8CC-697.

49 Courtesy of the Nowak family.

50 Department of Labor and Commerce, Children's Bureau, National Archives and Records Administration, negative # 102-G-1-15.

51 TOP Austin/Thompson Collection.

51 BOTTOM Bureau of Agricultural Economics, National Archives and Records Administration, negative # NWDNS-83-G-44371.

52 Courtesy of the photographer.

53 Courtesy of the photographer.

54 TOP Courtesy of the photographer.

54 BOTTOM Department of Agriculture, Environmental Protection Agency, National Archives and Records Administration, negative # NWDNS-412-DA-11062.

55 Department of Agriculture, Environmental Protection Agency, National Archives and Records Administration, negative # NWDNS-412-DA-13842.

56 TOP Courtesy of the photographer.

56 BOTTOM Courtesy of the Thompson family.

57 Austin/Thompson Collection.

58 TOP Courtesy of the Austin-Nobert family.

58 BOTTOM Courtesy of the family and the photographer.

124 TOP Austin/Thompson Collection.

124 BOTTOM The Bancroft Library, University of California, Berkeley, image # 1905.00002.

125 Manuscripts, Special Collections, University Archives Division, University of Washington Libraries, negative # Cobb 2787.

126 TOP Austin/Thompson Collection.

126 BOTTOM Courtesy National Museum of the American Indian, Smithsonian Institution, negative # N35450.

127 Courtesy of the Nowak family.

131 TOP From *The American Magazine*, March 1746, The Metropolitan Museum of Art, Bequest of Charles Allen Munn, 1924, image # 24.90.1923.

131 BOTTOM Courtesy of the Hagley Museum, Library of Congress, negative # LC-USZ62-44709.

132 TOP *De Español y Mulata*, Morisco Castes, Artist Anonymous, School of Miguel Cabrera, Denver Art Museum Collection: Gift of W. Sherwood Schoch, call # 1983.600, © Denver Art Museum, 2002.

132 BOTTOM Library of Congress, negative # LC-USZ62-43972.

133 Florida Photographic Collection, Florida State Archives, image # PR00813.

134 Austin/Thompson Collection.

135 Library of Congress, negative # LC-B8171-4016.

136 TOP Western History/Genealogy Dept., Denver Public Library, call # X-21930.

136 BOTTOM Florida Photographic Collection, Florida State Archives, image # PR00850.

137 Manuscripts, Special Collections, University Archives Division, University of Washington Libraries, negative # Hegg 412A.

138 TOP Office of the Chief of Engineers, National Archives and Records Administration, negative # 77-OMI-62.

138 BOTTOM Manuscripts, Special Collections, University Archives Division, University of Washington Libraries, negative # Hegg 3209.

139 Austin/Thompson Collection.

140 TOP Austin/Thompson Collection.

140 BOTTOM Austin/Thompson Collection.

141 Alaska-Yukon-Pacific Exposition Collection, Manuscripts, Special Collections, University Archives Division, University of Washington Libraries, negative # Nowell x2787.

142–143 Department of Labor and Commerce, Children's Bureau, National Archives and Records Administration, negative # NWDNS-102-LH-1942.

144 Chicago Historical Society, negative # ICHi-03200.

145 Department of Labor and Commerce, Children's Bureau, National Archives and Records Administration, negative # NWDNS-102-LH-271.

146 TOP New Bedford Whaling Museum, negative # 1275.

146 BOTTOM Department of Labor and Commerce, Children's Bureau, National Archives and Records Administration, negative # NWDNS-102-LH-2858.

147 Cook Collection, Valentine Museum/Richmond History Center, Richmond, Virginia, negative # 1462.

148 TOP National Photo Company Collection, Library of Congress, negative # LC-USZ62-69050.

148 BOTTOM Library of Congress, negative # LC-G4032-0171.

149 Department of Labor and Commerce, Children's Bureau, National Archives and Records Administration, negative # NWDNS-102-LH-640.

150 Austin/Thompson Collection.

151 *American Missionary* Magazine Collection, Amistad Research Center.

152 TOP Manuscripts, Special Collections, University Archives Division, University of Washington Libraries, negative # NA2502.

152 BOTTOM Department of Labor, Wage and Hour Division, National Archives and Records Administration, negative # 155-CL-9-1.

153 War Department, Historical Section, National Archives and Records Administration, negative # NWDNS-165-WW-595A (3).

154 TOP Western History/Genealogy Dept., Denver Public Library, call # K-258.

154 BOTTOM Department of Agriculture, Bureau of Agricultural Economics, National Archives and Records Administration, negative # NWDNS-83-G-41810.

155 TOP FSA/OWI Collection, Library of Congress, negative # LC-USF34-041012-D.

155 BOTTOM National Youth Administration, Franklin D. Roosevelt Library, National Archives and Records Administration, negative # NLR-PHOCO-A-5251(106).

156 TOP Department of Labor, Wage and Hour Division, National Archives and Records Administration, negative # 155-CL-11-1.

156 BOTTOM FSA/OWI Collection, Library of Congress, negative # LC-USW3-011869-D.

157 Department of Labor, Wage and Hour Division, National Archives and Records Administration, negative # 155-CL-7-3.

158 TOP Department of Labor, Wage and Hour Division, National Archives and Records Administration, negative # 155-CL-1-7.

158 BOTTOM FSA/OWI Collection, Library of Congress, negative # LC-USW3-006341-D.

159 TOP Photograph and Prints Division, Schomburg Center for Research in Black Culture, The New York Public Library, Astor Lenox and Tilden Foundations, negative # SC-CN-93-0112.

159 BOTTOM Courtesy of the photographer.

160 TOP Courtesy of the photographer.

160 BOTTOM LEFT Courtesy of the Bundy family.

160 BOTTOM RIGHT Courtesy of the photographer.

161 Courtesy of the photographer.

162 Minnesota Historical Society, negative # 62061.

163 Courtesy of the Phoebe Apperson Hearst Museum of Anthropology and the Regents of the University of California, photographed by Alfred L. Kroeber, University of California, Berkeley, catalogue # 15-3685, iv 6.

164 TOP Library of Congress, negative # LC-USZ62-22845.

164 BOTTOM From *The Bitter Cry of the Children*, by John Spargo.

165 TOP International Center for Photography/Getty Images.

165 BOTTOM War Relocation Authority Photographs of Japanese-American Evacuation and Resettlement, BANC PIC 1967.014—PIC, The Bancroft Library, University of California, Berkeley, Series 6, Volume 16, Section B, WRA no. H-452.

169 Collection of the New-York Historical Society, I.D. # 1953.223.

170 TOP From *American Manners and Morals*.

170 BOTTOM Library of Congress.

171 Department of Manuscripts, National Library of the Czech Republic.

172 The Metropolitan Museum of Art, Gift of I. N. Phelps Stokes, Edward S. Hawes, Alice Mary Hawes, Marion Augusta Hawes, 1937 (37.14.22), negative # MM85581 B.

173 Secretary of the Interior, National Archives and Records Administration, negative # NWDNS-48-RST-7B-97.

174 TOP Library of Congress, negative # LC-USZ62-120768.

174 BOTTOM Winter Count of Baptiste Good, or High Hawk, c. 1888, Ledger Book, pencil, colored pencil, ink, Denver Art Museum Collection: Acquired by Exchange, call # 1963.272 VOL. 41, © Denver Art Museum 2002.

175 Courtesy National Museum of the American Indian, Smithsonian Institution, negative # N36025.

176 TOP Wyoming State Archives, Department of State Parks and Cultural Resources, negative # 5239.

176 BOTTOM Library of Congress, negative # LC-USZ62-34556.

177 Children's Aid Society, Library of Congress, negative # LC-USZ62-25607.

178 Austin/Thompson Collection.

179 TOP Penn School Papers, Southern Historical Collection, The Library of the University of North Carolina, Chapel Hill, negative # SHC-3615-1-27 (R) a, Permission granted by the Penn Center, Inc., St. Helena Island, S.C.

179 BOTTOM Washington Localities Collection, Manuscripts, Special Collections, University Archives Division, University of Washington Libraries.

180 TOP Austin/Thompson Collection.

180 BOTTOM Austin/Thompson Collection.

181 Courtesy of the Thompson family.

182 Library of Congress, negative # LC-USZ62-94391.

183 TOP Museum of History and Industry, Seattle, accession # 88.33.136.

183 BOTTOM Chicago Historical Society, negative # ICHi 13757.

184 Department of Agriculture, Bureau of Agricultural Economics, National Archives and Records Administration, negative # NWDNS-83-G-41960.

185 Department of Agriculture, Bureau of Agricultural Economics, National Archives and Records Administration, negative # NWDNS-83-G-41825.

186 Courtesy of the Thompson family.

187 Department of the Interior, War Relocation Authority, National Archives and Records Administration, negative # NWDNS-210-G-A72.

188 FSA/OWI Collection, Library of Congress, negative # LC-USF34-052286-D.

189 TOP Florida Photographic Collection, Florida State Archives, image # rc17812.

189 BOTTOM Florida Photographic Collection, Florida State Archives, image # sp01573.

190 Courtesy of the Robinson-Spangler Carolina Room's *Charlotte Observer* Photograph Collection, Public Library of Charlotte and Mecklenburg County.

191 Courtesy of the *Chicago Sun-Times*.

192 TOP Courtesy of the photographer.

192 BOTTOM Courtesy of Mary Christiansen, Quinault, Wash., and Jigger Davis, Neilton, Wash.

193 Courtesy of the photographer.

194 Austin/Thompson Collection.

195 TOP Austin/Thompson Collection.

195 BOTTOM Austin/Thompson Collection.

196 TOP Western History/Genealogy Dept., Denver Public Library, call # X-21658.

196 BOTTOM Department of Labor and Commerce, National Archives and Records Administration, negative # 155-CL-1-27.

197 Courtesy of Carolina Velasquez.

201 Yale Collection of Western Americana, Beinecke Rare Book and Manuscript Library, Yale University, call # WA MSS S-1174.

202 TOP Library of Congress, negative # LC-USZ62-31015.

202 BOTTOM From *Message from the President . . . Communicating a Report of an Expedition . . .* Yale Collection of Western Americana, Beinecke Rare Book and Manuscript Library, Yale University.

203 TOP Library of Congress, negative # LC-USZ62-121734.

203 BOTTOM Bancroft Library, University of California, Berkeley.

204 TOP Library of Congress, negative # LC-USZ62-17228.

204 BOTTOM Detroit Publishing Company Collection, Library of Congress, negative # LC-D4-30806.

205 North Dakota State University, North Dakota Institute for Regional Studies, Fargo, reproduction # Hult.363.

206 TOP Florida Photographic Collection, Florida State Archives, image # pr01551.

206 BOTTOM LEFT Manuscripts, Special Collections, University Archives Division, University of Washington Libraries, negative # NA1304.

206 BOTTOM RIGHT Austin/Thompson Collection.

207 Courtesy of Ann Henry.

208 Austin/Thompson Collection.

209 From the Albert R. Stone Negative Collection, Rochester Museum and Science Center, Rochester, N.Y., image # sct05996.

210 Courtesy of David Richmond.

211 TOP Bain Collection, Library of Congress, negative # LC-USZ62-119372.

211 BOTTOM Bain Collection, Library of Congress, negative # LC-USZ62-68427.

212 TOP Byron Company, Detroit Publishing Company Collection, Library of Congress, negative # LC-D401-13645.

212 BOTTOM Roy D. Graves Pictorial Collection, BANC PIC 1905.17500BALB [70], The Bancroft Library, University of California, Berkeley.

213 From the Albert R. Stone Negative Collection, Rochester Museum and Science Center, Rochester, N.Y., image # sct06365.

214 TOP Florida Photographic Collection, Florida State Archives, image # n033065.

214 BOTTOM From the Albert R. Stone Negative Collection, Rochester Museum and Science Center, Rochester, New York, image # sct06301

215 TOP Austin/Thompson Collection.

215 BOTTOM Photographs of San Francisco's Chinatown, BANC

PIC 1996.014—PIC, The Bancroft Library, University of California, Berkeley, image # 20.

216 Austin/Thompson Collection.

217 Department of Labor and Commerce, Children's Bureau, National Archives and Records Administration, negative # 102-G-13-11.

218 TOP Bureau of Indian Affairs, National Archives and Records Administration, negative # 75-AO-19-7.

218 BOTTOM Courtesy of Kathy Clayton.

219 TOP LEFT Courtesy of the Thompson family.

219 TOP RIGHT Courtesy of the Austin family.

219 BOTTOM Courtesy of the Charles Harris Estate.

220 Digital Library and Archives, University Libraries, Virginia Polytechnic Institute and State University, URN: ep086.

221 Digital Library and Archives, University Libraries, Virginia Polytechnic Institute and State University, URN: ep088.

222 International Center for Photography/Getty Images.

223 Bureau of Indian Affairs, National Archives and Records Administration, negative # 75-AO-36-roll 27-7.

224 TOP Department of Agriculture, Environmental Protection Agency, National Archives and Records Administration, negative # NWDNS-412-DA-13479.

224 BOTTOM Department of Agriculture, Environmental Protection Agency, National Archives and Records Administration, negative # NWDNS-412-DA-13440.

225 TOP Florida Photographic Collection, Florida State Archives, image # pr08214.

225 BOTTOM Courtesy of the photographer.

226 Courtesy of the photographer.

227 Courtesy of the photographer.

228 From the Albert R. Stone Negative Collection, Rochester Museum and Science Center, Rochester, New York, image # sct01001.

229 TOP Lewis Hine Collection, Library of Congress.

229 BOTTOM Courtesy of Stanley L. Falk.

230 TOP FSA/OWI Collection, Library of Congress, negative # LC-USF34-052272-D.

230 BOTTOM Courtesy of the Irwin Family.

231 TOP Courtesy of the photographer.

231 BOTTOM Photograph and Prints Division, Schomburg Center for Research in Black Culture, The New York Public Library, Astor Lenox and Tilden Foundations.

235 TOP Chicago Historical Society, negative # ICHi-08785.

235 BOTTOM From *The Story of America in Pictures*.

236 TOP Anne S. K. Brown Military Collection, Brown University Library.

236 BOTTOM From *Recueil D'estampes Representant Les Differents* . . . , by Nicholas Ponce, Rare Books Division, Library of Congress, negative # LC-USZ62-31958.

237 TOP LEFT Collection of the New-York Historical Society, I.D. # 33994.

237 TOP RIGHT From *The Underground Railroad*, by William Still.

237 BOTTOM Minnesota Historical Society, negative # 54471.

238 TOP From *Reminiscences of My Life in Camp* . . . , Library of Congress.

238 BOTTOM Library of Congress, negative # LC-B8171-0518.

239 Library of Congress, negative # LC-B8171-3175.

240 BOTTOM Minnesota Historical Society, negative # 8322.

240–241 TOP Office of the Chief Signal Officer, National Archives and Records Administration, negative # NWDNS-111-SC-85682.

241 BOTTOM Wyoming State Archives, Department of State Parks and Cultural Resources, negative # 415.

242 Courtesy of U.S. Army Military History Institute.

244 Courtesy of Currie Ballard, Langston University.

245 Chicago Historical Society, negative # ICHi-24545.

246 TOP *New York Daily News*.

246 BOTTOM War Department, Historical Section, National Archives and Records Administration, negative #: NWDNS-165-WW-127(24).

247 Library of Congress, negative # LC-B201-2684-2.

248 TOP FSA/OWI Collection, Library of Congress, negative # LC-USZ62-99342.

248 BOTTOM International News Photo, FSA/OWI Collection, Library of Congress, negative # LC-USF34-000593-ZE.

249 FSA/OWI Collection, Library of Congress, negative # LC-USZ6-1025.

250 Franklin D. Roosevelt Library, National Archives and Records Administration, negative # NLR-PHOCO-A-65701(43).

251 © Bettmann/CORBIS, image # BE027703.

252 *Seattle Post-Intelligencer* photo, Library of Congress, negative # LC-USZ62-95994.

253 International Center for Photography/Getty Images.

254 *New York World-Telegram & Sun* Collection, Library of Congress, negative # LC-USZ62-111241.

255 TOP FSA/OWI Collection, Library of Congress, negative # LC-USF34-083984-C.

255 BOTTOM *St. Paul Dispatch & Pioneer Press*, Minnesota Historical Society, negative # 66937.

256 United States Information Agency, National Archives and Records Administration, negative # NWDNS-306-SSM-4C(19)1.

257 Austin/Thompson Collection.

258 TOP © Bettmann/CORBIS, image # U1768131.

258 BOTTOM Courtesy of the photographer.

259 TOP Western History/Genealogy Dept., Denver Public Library, call # X-21575.

259 BOTTOM Courtesy of the photographer.

260 TOP Department of Agriculture, Environmental Protection Agency, National Archives and Records Administration, negative # NWDNS-412-DA-12453.

260 BOTTOM Florida Photographic Collection, Florida State Archives, negative # PT01855.

261 TOP Courtesy of the photographer.

261 BOTTOM Courtesy of the photographer.

262 TOP Courtesy of the photographer.

262 BOTTOM Courtesy of the photographer.

263 From "Threads of Love: A Tapestry of Remembrance—The NAMES Project AIDS Memorial Quilt," a video project. Used by permission of the photographer and the General Board of Global Ministries of the United Methodist Church.

264 Courtesy of the photographer.

266 Manuscripts, Special Collections, University Archives Division, University of Washington Libraries, negative # NA603.

267 TOP Courtesy of the Nowak Family.

267 BOTTOM Holsinger Studio Collection (# 9862), The Albert and Shirley Small Special Collections Library, University of Virginia Library, negative # X5680A.

268 TOP Austin/Thompson Collection.

268 BOTTOM Department of Justice, Bureau of Prisons, United States Penitentiary, Leavenworth, Kans., Central Plains Region, National Archives and Records Administration, negative # NRE-129-LFP(CF)-5250.

269 Courtesy of Carmen Eckman.

273 Missouri Historical Society. Wo Haw 41. Accession # 1882.18.41.

274 Courtesy of Chonita L. Earle.

275 TOP Library of Congress, negative # LC-USZ62-20622.

275 BOTTOM Austin/Thompson Collection.

276 From the Albert R. Stone Negative Collection, Rochester Museum and Science Center, Rochester, New York, image # sct06202.

277 Austin/Thompson Collection.

278 TOP FSA/OWI Collection, Library of Congress, negative # LC-USF34-038591-D.

278 BOTTOM Courtesy of Diane Epstein.

279 Department of Agriculture, Environmental Protection Agency, National Archives and Records Administration, negative # NWDNS-412-DA-12449.

280 Courtesy of the photographer.

281 Austin/Thompson Collection.

282 Austin/Thompson Collection.

283 Austin/Thompson Collection.

284 TOP Library of Congress, negative # LC-USZ62-70049.

284 BOTTOM From the Albert R. Stone Negative Collection, Rochester Museum and Science Center, Rochester, New York, image # sct02200.

285 War Department, National Archives and Records Administration, negative # NWDNS-165-JT-302.

286 Library of Congress, negative # LC-USZ62-10109.

287 Courtesy of Ann Henry.

288 Department of the Interior, War Relocation Authority, National Archives and Records Administration, negative # NWDNS-210-G-A728.

289 TOP Department of the Navy, National Archives and Records Administration, negative # RG-80-G-644520.

289 BOTTOM Courtesy of the Austin-Nobert family.

290 Courtesy of the photographer.

ABOUT THE AUTHORS

Kathleen Thompson and Hilary Mac Austin are coeditors of two other documentary works: *The Face of Our Past: Images of Black Women from Colonial America to the Present* (Indiana University Press, 1999) and *Children of the Depression* (IUP, 2001). They are founding members of the organization OneHistory, which is dedicated to making heard the many voices of American history.

Kathleen Thompson is coauthor with Darlene Clark Hine of *A Shining Thread of Hope: The History of Black Women in America* (Broadway Books, 1996). She also cowrote, with Andra Medea, the feminist classic *Against Rape*, which was published in 1974 by Farrar, Straus & Giroux and continued in print for eighteen years. Thompson was a major contributor to Carlson Publishing's *Black Women in America: An Historical Encyclopedia* and editor in chief of Facts on File's *Encyclopedia of Black Women*. She has received numerous awards for her work, including Best Books for Youth from the ALA and the Gold Camera Award from the U.S. Industrial Film Festival, but the one she treasures most is the ban on *Against Rape* by the apartheid government of South Africa.

Hilary Mac Austin was photo researcher for *A Shining Thread of Hope* and *Jewish Women in America: An Historical Encyclopedia* and a contributor to the latter, as well as to Facts on File's *Encyclopedia of Black Women*, the *American Irish Desk Reference*, and the *American Jewish Desk Reference*. For the last ten years, she has worked with the Philip Lief Group; Sense and Nonsense, Inc.; Visual Education Corporation; SRA (Science Research Associates); Bantam/Doubleday/Dell; Carlson Publishing; and others.